RUGGED KNITS

ANDREA RANGEL

24 PRACTICAL PROJECTS FOR EVERYDAY LIVING

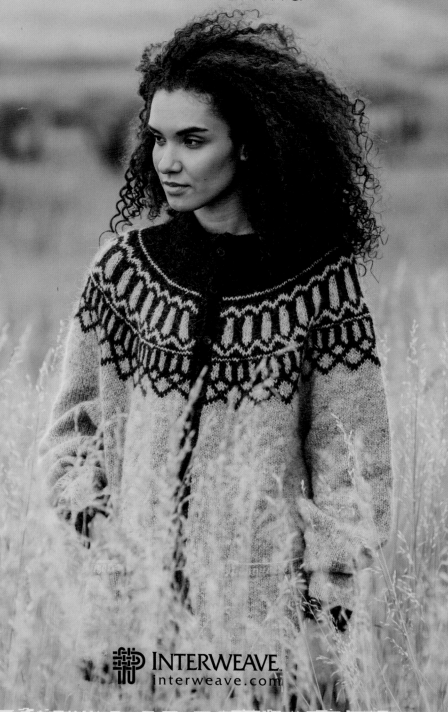

INTERWEAVE.
interweave.com

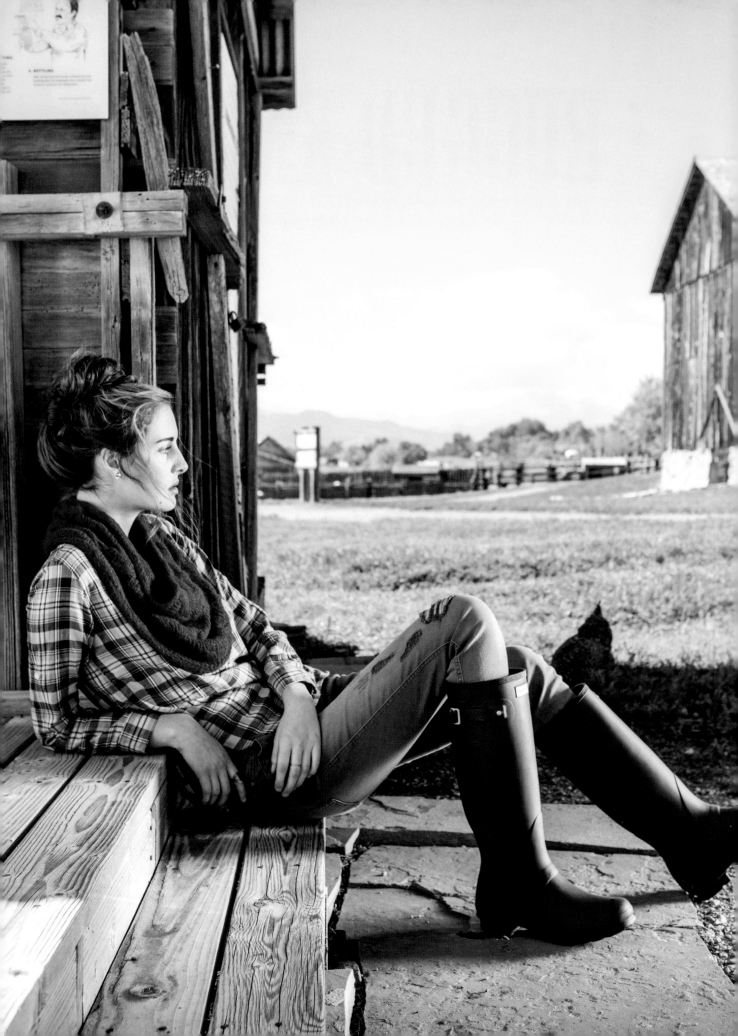

CONTENTS

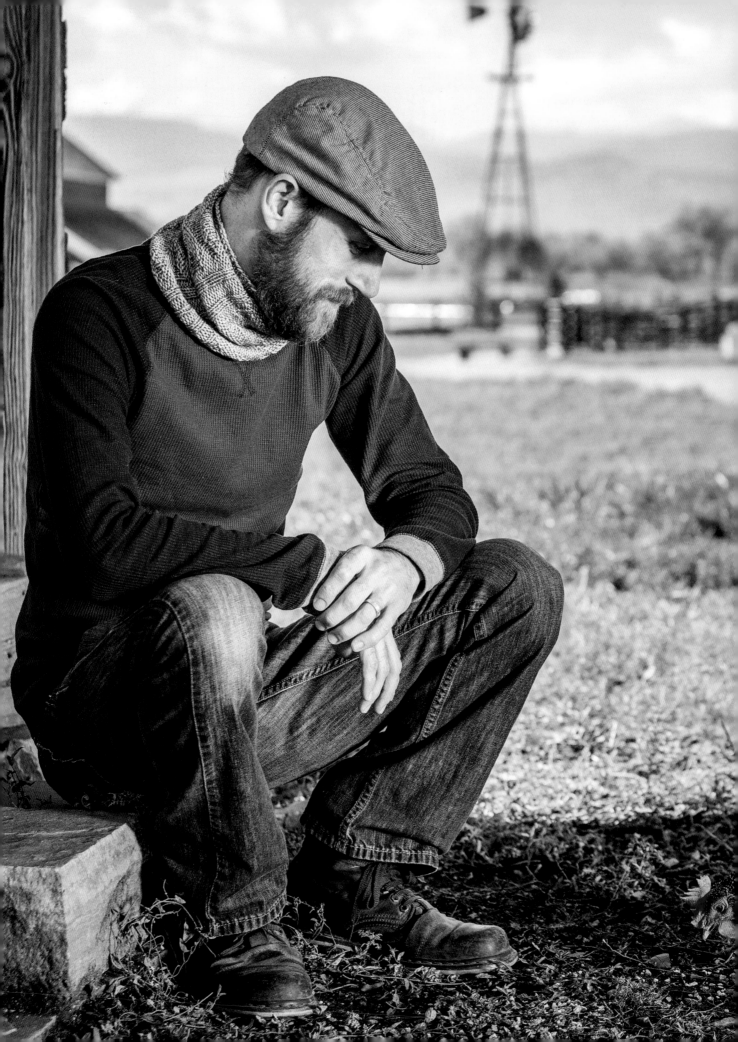

INTRODUCTION

I've lived—and knit—in a lot of different climates. When I was in southern Arizona, light shawls and tanks came off of my needles. In Jordan, where my husband and I were Peace Corps volunteers, I knit heavy mittens and bulky sweaters, as Jordan is surprisingly the coldest and snowiest place I've ever lived. And in the Pacific Northwest, I've made myself countless sweaters, shawls, leggings, socks, and almost anything else you can knit. Maybe that's why I decided to stay in this part of the world—it's excellent for knitting. I've been described as "crunchy" before, and most people who know me are aware that I'm pretty low maintenance and prefer chunky boots and sensible clothes that allow me to be active. I bike for transportation, which means everything I wear needs to be practical. I want my knitwear to work with all my pursuits, so I'm drawn to knitting functionally for an active lifestyle— think hiking, cycling, and camping. But if you look over my portfolio, you'll notice a whole lot of very pretty things, too. I knit lace in every weight and in many different shapes. I love bright, eye-catching colors and revel in fine details. While I strive for utility, I also want to infuse each piece with beauty and luxury. This collection is an expression of my design philosophy. It's full of garments and accessories that are made to be functional (I really do envision you wearing that sweater while doing farm chores), but they're strongly inspired by the visual richness that knitting can offer. Why not add some beautiful colorwork to that rustic sweater coat? Why not add a bit of luxury to your favorite sweatshirt by knitting it in a silk/camel/alpaca blend that you'll never want to take off? All of these garments and accessories are designed for you to wear in your everyday life. Please take them camping, hiking, and biking. And when you get home, wear them to your fancy New Year's party, too.

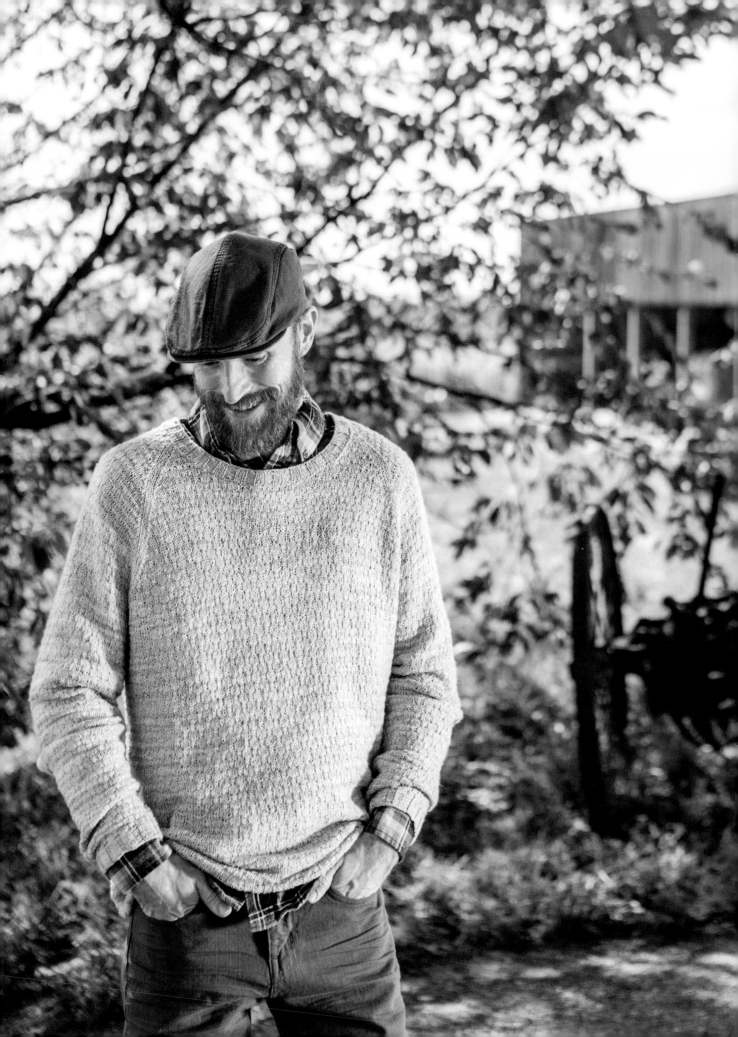

MEN'S SILHOUETTE
BASE LAYER

This sweater is the knitter's version of the perfect thermal base layer. A three-season pullover, it includes some great features: seamless construction; a light, warm fabric; and a comfortably snug fit. But this men's version (see women's version, page 12) is shaped specifically to fit a man's proportions, longer sleeves, deeper armholes, and reverse A-line body shaping.

Finished Sizes
36 (39½, 44¾, 48¼, 51¾, 55¼)" (91.5 [100.5, 113.5, 122.5, 131.5, 140.5] cm) chest circumference and 26¼ (26¾, 27½, 28¾, 29½, 30¼)" (66.5 [68, 70, 75, 77] cm) long.

Intended to be worn with 1–3" (2.5–7.5 cm) of positive ease.

Shown in size 44¾" (113.5 cm).

Yarn
1537 (1685, 1908, 2057, 2206, 2355) yd (1405 [1541, 1745, 1881, 2017, 2153] m)) fingering weight (#1 Super Fine).

Shown here: Anzula Cloud (80% superwash merino wool, 10% cashmere, 10% nylon; 575 yd [526 m]/114 g): color Seaside, 3 (3, 4, 4, 4, 5) skeins.

Needles
Size U.S. 3 (3.25 mm) 16" and 32" (40 and 80 cm) long circular (cir) and set of 4 or 5 double-pointed (dpn).

Adjust needle size if necessary to obtain the correct gauge.

Notions
Markers (m); stitch holders or waste yarn; tapestry needle.

Gauge
27½ sts and 38 rows = 4" (10 cm) over Tiny Bowknot patt.

Notes
Pullover is worked in the round from the bottom up. The body is worked first, then the sleeves. Body and sleeves are joined and worked in the round to the neckline. Neckband is then picked up and worked in the round.

Tiny Bowknot Pattern

Worked in Rnds

(multiple of 6 sts + 3)

Rnds 1, 2, 5, and 6: Knit.

Rnd 3: [K3, p3] to last 3 sts, k3.

Rnd 4: [K3, p1, ksb, p1] to last 3 sts, k3.

Rnd 7: [P3, k3] to last 3 sts, p3.

Rnd 8: [P1, ksb, p1, k3] to last 3 sts, p1, ksb, p1.

Rep Rnds 1–8 for patt.

Worked in Rows

Rows 1 and 5: (WS) Purl.

Rows 2 and 6: (RS) Knit.

Row 3: [P3, k3] to last 3 sts, p3.

Row 4: [K3, p1, ksb, p1] to last 3 sts, k3.

Row 7: [K3, p3] to last 3 sts, k3.

Row 8: [P1, ksb, p1, k3] to last 3 sts, p1, ksb, p1.

Rep Rows 1–8 for patt.

ksb (knit into stitch below): Insert right needle tip into row below next stitch on left needle tip, and knit 1, dropping stitch from left needle tip.

Body

With longer cir needle, CO 236 (260, 296, 320, 368) sts. Place marker (pm) for beg of rnd and join for working in rnds, being careful not to twist sts.

HEM

Rnd 1: *P1, (k3, p3) 19 (21, 24, 26, 28, 30) times, k3*, pm for right side; rep from * to *.

Cont in established ribbing until piece measures 1 (1, 1, 1½, 2, 2)" (2.5 [2.5, 2.5, 3.8, 5, 5] cm) from beg.

BODY SECTION

Set-up rnd: *P1, work Rnd 1 of Tiny Bowknot patt to m, sm; rep from * once more.

Cont in established patt until piece measures 5 (5, 5, 5½, 6, 6)" (12.5 [12.5, 12.5, 14, 15, 15] cm) from beg.

SHAPE BODY

Inc rnd: *P1, m1, work in established patt to m, m1, sm; rep from * once more—4 sts inc'd.

Rep Inc Rnd every 48 rnds twice more—248 (272, 308, 332, 356, 380) sts. Work new sts into patt.

Work even until piece measures about 16½ (16½, 16½, 17, 17½, 17½)" (42 [42, 42, 43, 44.5, 44.5] cm) from beg.

Set body aside.

Sleeves

CUFF

With dpn, CO 64 (70, 70, 76, 76, 76) sts. Pm for beg of rnd, and join for working in rnds, being careful not to twist sts.

Rnd 1: P1, [k3, p3] to last 3 sts, k3.

Cont in established ribbing until piece measures 1 (1, 1, 1½, 2, 2)" (2.5 [2.5, 2.5, 3.8, 5, 5] cm) from beg.

MAIN SLEEVE SECTION

Set-up rnd: P1, work Rnd 1 of Tiny Bowknot patt to end.

Work 11 (9, 7, 7, 5, 5) more rnds in established patt.

Shape sleeve

Inc rnd: P1, m1, work in patt to end, m1—2 sts inc'd.

Rep Inc Rnd every 12 (10, 8, 8, 6, 6) rnds 6 (15, 19, 18, 25, 14) more times, then every 10 (0, 0, 6, 0, 4) rnds 7 (0, 0, 2, 0, 18) time(s)—92 (102, 110, 118, 128, 142) sts. Work new sts into patt.

Cont even until piece measures about 18¼ (18¾, 18¾, 19½, 19¾, 20)" (46.5 [47.5, 47.5, 49.5, 50, 51] cm) from beg, ending with rnd 8 (6, 6, 8, 6, 8) of patt rep.

Cut yarn. Place last 7 (8, 9, 10, 11, 12) sts and first 8 (9, 10, 11, 12, 13) sts of rnd onto holder or waste yarn for underarm—77 (85, 91, 97, 105, 117) sts rem.

Yoke

Joining rnd: *Work body in established patt to 7 (8, 9, 10, 11, 12) sts before m, place next 15 (17, 19, 21, 23, 25) sts onto holder or waste yarn removing side m, pm for raglan, work held 77 (85, 91, 97, 105, 117) sleeve sts, pm for raglan; rep from * once more—372 (408, 452, 484, 520, 564) sts; with 109 (119, 135, 145, 155, 165) sts each for front and back, and 77 (85, 91, 97, 105, 117) sts for each sleeve. Join for working in rnds; rnds beg at left front raglan.

ESTABLISH YOKE PATTERN

Next rnd: *K1, work in established patt to 1 st before m, k1; rep from * 3 more times.

Work 2 (2, 2, 2, 0, 0) more rnds even.

Shape raglan

Note: Body and sleeves have different rates of decrease in order to create a better fit. On some rounds you may decrease only on the body or the sleeves, or you may decrease on both. Read through next sections carefully, as neck shaping takes place while the raglan shaping is being worked.

SIZES 36 (39½, 44¾ 48¼)" (91.5 [100.5, 113.5, 122.5] CM) ONLY:
Dec rnd: *K1, k2tog, work in established patt to 3 sts before m, ssk, k1; rep from * 3 more times—8 sts dec'd; 2 sts each on front, back, and each sleeve.

SIZES 51¾ (55¼)" (131.5 [140.5] CM) ONLY:
Dec rnd: *K1, k2tog, work in established patt to 3 sts before m, ssk, k1, sm, work to next marker, sm; rep from * once more—4 sts dec'd; 2 sts each on front and back.

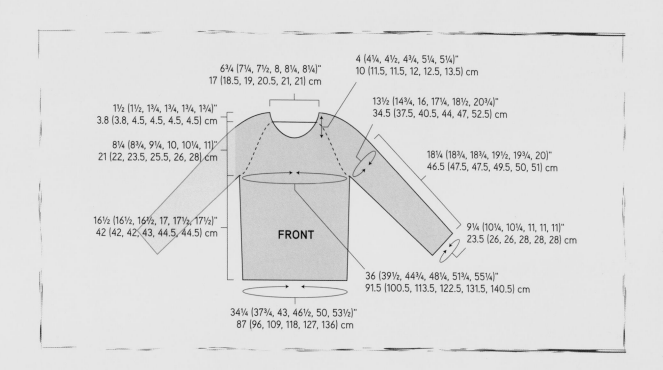

6¾ (7¼, 7½, 8, 8¼, 8¼)"
17 (18.5, 19, 20.5, 21, 21) cm

4 (4¼, 4½, 4¾, 5¼, 5¼)"
10 (11.5, 11.5, 12, 12.5, 13.5) cm

1½ (1½, 1¾, 1¾, 1¾, 1¾)"
3.8 (3.8, 4.5, 4.5, 4.5, 4.5) cm

13½ (14¾, 16, 17¼, 18½, 20¾)"
34.5 (37.5, 40.5, 44, 47, 52.5) cm

8¼ (8¾, 9¼, 10, 10¼, 11)"
21 (22, 23.5, 25.5, 26, 28) cm

18¼ (18¾, 18¾, 19½, 19¾, 20)"
46.5 (47.5, 47.5, 49.5, 50, 51) cm

16½ (16½, 16½, 17, 17½, 17½)"
42 (42, 42, 43, 44.5, 44.5) cm

FRONT

9¼ (10¼, 10¼, 11, 11, 11)"
23.5 (26, 26, 28, 28, 28) cm

36 (39½, 44¾, 48¼, 51¾, 55¼)"
91.5 (100.5, 113.5, 122.5, 131.5, 140.5) cm

34¼ (37¾, 43, 46½, 50, 53½)"
87 (96, 109, 118, 127, 136) cm

ALL SIZES:

Cont dec on body every 4 rnds 7 (6, 1, 1, 0, 0) more times, every 2 rnds/rows 23 (28, 40, 43, 48, 49) times, then every row 0 (0, 0, 0, 0, 4) times.

At the same time, dec on sleeves only every 4 rnds/ rows 10 (9, 9, 9, 8, 5) more times, then every other rnd/ row 17 (22, 24, 27, 32, 41) times.

Shape neck

When 53 (55, 59, 63, 65, 67) rnds have been worked after joining rnd, end with an odd-numbered rnd—232 (252, 260, 276, 292, 316) sts rem; with 71 (77, 79, 85, 89, 97) sts each for front and back, and 45 (49, 51, 53, 57, 61) sts for each sleeve.

Cut yarn. Slip first 27 (30, 30, 33, 34, 38) sts to RH needle without working, rejoin yarn, BO next 17 (17, 19, 19, 21, 21) sts for front neck, work to end—215 (235, 241, 257, 271, 295) sts rem; with 27 (30, 30, 33, 34, 38) sts for each front, 71 (77, 79, 85, 89, 97) sts for back, and 45 (49, 51, 53, 57, 61) sts for each sleeve.

Beg working back and forth.

See page 17 for working shaping rows when 5, 4, 3, 2, or 1 st(s) rem for each front.

Cont raglan shaping and BO at beg of every row 4 sts twice, 3 sts twice, then 2 sts twice.

Dec 1 st each neck edge every RS row 4 (4, 4, 5, 6, 5) times, then every 4 rows 2 (3, 3, 3, 3, 4) times—89 (91, 97, 103, 107, 107) sts rem when all shaping is complete; 0 (1, 1, 1, 1, 0) st(s) rem for each front, 47 (49, 51, 55, 57, 57) sts rem for back, and 21 (21, 23, 23, 25, 25) sts for each sleeve.

Work 1 WS row even.

Next row: (RS), K1, sk2p, work to 3 sts before next m, ssk, k1, work to last 4 sts, k3tog, k1—84 (86, 92, 98, 102, 102) sts rem.

BO all sts in patt.

Finishing

NECKBAND

With smaller cir needle and RS facing, beg at right back raglan, pick up and knit 47 (49, 51, 55, 59, 61) sts along back neck, 19 (19, 21, 21, 23, 23) sts along top of sleeve, 65 (69, 69, 71, 75, 79) sts along front neck, and 19 (19, 21, 21, 23, 23) sts along rem sleeve—150 (156, 162, 168, 180, 186) sts. Pm for beg of rnd and join for working in rnds.

Rnd 1: *K3, p3; rep from *.

Cont in established ribbing until neckband measures 1" (2.5 cm).

BO all sts loosely in patt.

Join underarm sts using Kitchener st (see Techniques). Weave in all loose ends. Block to measurements.

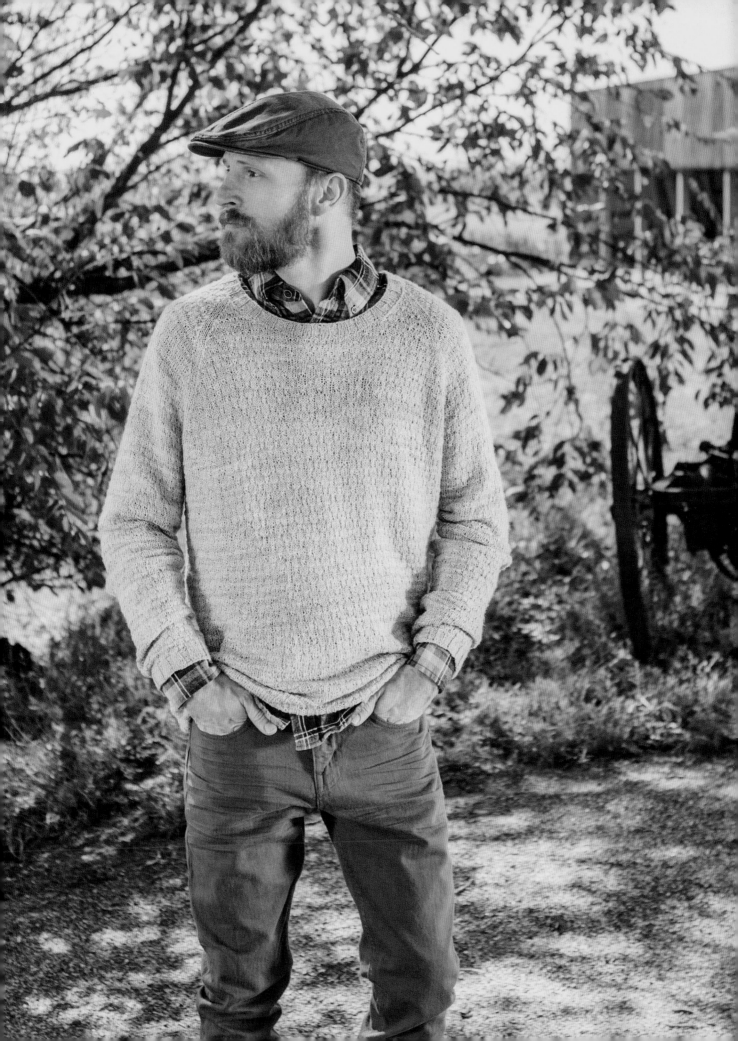

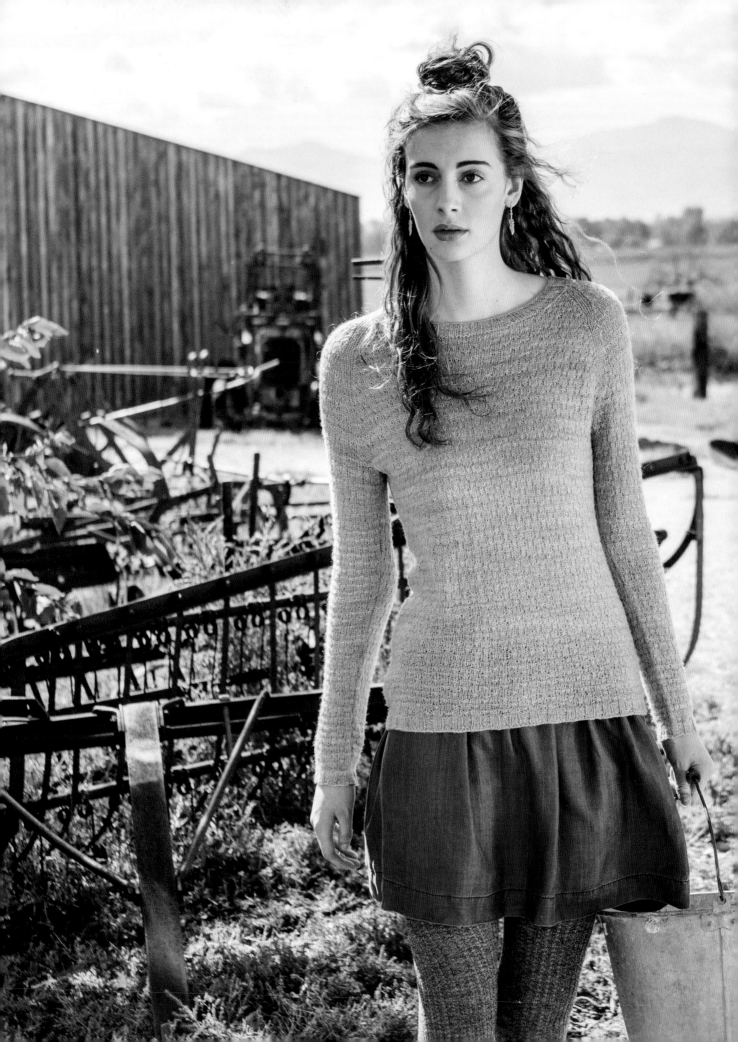

WOMEN'S SILHOUETTE
BASE LAYER

This sweater is the women's version of the sweater on page 6. Make it out of a super-soft fingering-weight yarn such as Anzula Cloud to wear it next to the skin under your heavier vest, sweater, or coat. The lightweight yarn worked in a subtle texture creates a versatile fabric that warms without overheating, so it can be worn from fall to spring. It's worked bottom-up seamlessly with raglan yoke shaping.

Finished Size
32 (35½, 39, 44¼, 47¾, 51¼)" (81.5 (90, 99, 112.5, 121.5, 130) cm bust circumference and 25 (25½, 26, 27½, 28¾, 29)" (63.5 [65, 66, 70, 73, 73.5] cm) long.

Intended to be worn with 1–3" (2.5–7.5 cm) of positive ease.

Shown in size 35½" (90 cm).

Yarn
1120 (1243, 1365, 1548, 1670, 1787) yd (1024 [1136, 1248, 1415, 1527, 1634] m) fingering weight (#1 Super Fine).

Shown here: Anzula Cloud (80% super-wash merino wool, 10% cashmere, 10% nylon; 575 yd [526 m]/114 g): color Avocado, 2 (3, 3, 3, 3, 4) skeins.

Needles
Size U.S. 3 (3.25 mm) 16" and 32" (40 and 80 cm) circular (cir) and set of 4 or 5 double-pointed (dpn).

Adjust needle size if necessary to obtain the correct gauge.

Notions
Markers (m); stitch holders or waste yarn; tapestry needle.

Gauge
27½ sts and 38 rows = 4" (10 cm) over Tiny Bow Knot patt.

Notes
Pullover is worked in the round from the bottom up. The body is worked first, then the sleeves. Body and sleeves are joined and worked in the round to the neckline. Neckband is then picked up and worked in the round.

Tiny Bowknot Pattern

Worked in Rnds

(multiple of 6 sts + 3)

Rnds 1, 2, 5, and 6: Knit.

Rnd 3: [K3, p3] to last 3 sts, k3.

Rnd 4: [K3, p1, ksb, p1] to last 3 sts, k3.

Rnd 7: [P3, k3] to last 3 sts, p3.

Rnd 8: [P1, ksb, p1, k3] to last 3 sts, p1, ksb, p1.

Rep Rnds 1–8 for patt.

Worked in Rows

Rows 1 and 5: (WS) Purl.

Rows 2 and 6: (RS) Knit.

Row 3: [P3, k3] to last 3 sts, p3.

Row 4: [K3, p1, ksb, p1] to last 3 sts, k3.

Row 7: [K3, p3] to last 3 sts, k3.

Row 8: [P1, ksb, p1, k3] to last 3 sts, p1, ksb, p1.

Rep Rows 1–8 for patt.

ksb (knit into stitch below): Insert right needle tip into row below next stitch on left needle tip, and knit 1, dropping stitch from left needle tip.

Body

With longer cir needle, CO 212 (236, 260, 296, 320, 344) sts. Place marker (pm) for beg of rnd and join for working in rnds, being careful not to twist sts.

HEM

Rnd 1: *P1, [k3, p3] 17 (19, 21, 24, 26, 28) times, k3*, pm for right side; rep from * to *.

Cont in established ribbing until piece measures 1 (1, 1, 1½, 2, 2)" (2.5 [2.5, 2.5, 3.8, 5, 5] cm) from beg.

BODY SECTION

Set-up rnd: *P1, work rnd 1 of Tiny Bowknot patt to m, sm; rep from * once more.

Cont in established patt until piece measures 4 (4, 4, 4½, 5, 5)" (10 [10, 10, 11.5, 12.5, 12.5] cm) from beg.

SHAPE WAIST

Dec rnd: *P1, ssk, work in established patt to 2 sts before m, k2tog, sm; rep from * once more—4 sts dec'd.

Rep Dec Rnd every 30 rnds twice more—200 (224, 248, 284, 308, 332) sts rem.

SHAPE BUST

Work 9 rnds even.

Inc rnd: *P1, m1, work in established patt to m, m1, sm; rep from * once more—4 sts inc'd.

Rep Inc Rnd every 10 rnds 4 more times—220 (244, 268, 304, 328, 352) sts.

Cont even until piece measures about 16 (16, 16, 16¾, 17½, 17½)" (40.5 [40.5, 40.5, 42.5, 44.5, 44.5] cm) from beg.

Set body aside.

Sleeves

CUFF

With dpn, CO 58 (58, 64, 64, 70, 70) sts. Pm for beg of rnd, and join for working in rnds, being careful not to twist sts.

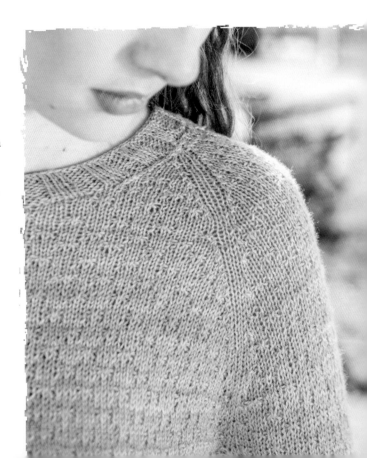

Rnd 1: P1, [k3, p3] to last 3 sts, k3.

Cont established ribbing until piece measures 1 (1, 1, 1½, 2, 2)" (2.5 [2.5, 2.5, 3.8, 5, 5] cm) from beg.

MAIN SLEEVE SECTION
Set-up rnd: P1, work rnd 1 of Tiny Bowknot patt to end.

Continue working in established pattern, working each successive rnd of the Tiny Bowknot patt.

Work 13 (11, 11, 7, 5, 5) more rnds in established patt.

Shape sleeve
Inc rnd: P1, m1, work in patt to end, m1—2 sts inc'd.

Rep Inc Rnd every 14 (12, 12, 8, 6, 6) rnds 4 (5, 5, 14, 22, 16) more times, then every 12 (10, 10, 6, 0, 4) rnds 5 (6, 6, 4, 0, 10) times—78 (82, 88, 102, 116, 124) sts.

Cont even until piece measures about 16¾ (17½, 17½, 18¼, 18¼, 18¼)" (42.5 [44.5, 44.5, 46.5, 46.5, 46.5] cm) from beg, ending with rep rnd 2 (2, 2, 4, 6, 6).

Cut yarn. Place last 7 (7, 8, 9, 10, 10) sts and first 8 (8, 9, 10, 11, 11) sts of rnd onto holder or waste yarn for underarm—63 (67, 71, 83, 95, 103) sts rem.

Yoke
Joining rnd: *Work body in established patt to 7 (7, 8, 9, 10, 10) sts before side m, place next 15 (15, 17, 19, 21, 21) sts onto holder or waste yarn removing side m, pm for raglan, work held 63 (67, 71, 83, 95, 103) sleeve sts in established patt, pm for raglan; rep from * once more—316 (348, 376, 432, 476, 516) sts; with 95 (107, 117, 133, 143, 155) sts each for front and back, and 63 (67, 71, 83, 95, 103) sts for each sleeve. Join for working in rnds; rnds beg at left front raglan.

ESTABLISH YOKE PATTERN
Next rnd: *K1, work in established patt to 1 st before m, k1, sm; rep from * 3 more times.

Work 2 more rnds.

Shape raglan
Note: Body and sleeves have different rates of decrease in order to create a better fit. On some rounds you may decrease only on the body or the sleeves, or you may decrease on both. Read through next sections carefully, as neck shaping takes place while the raglan shaping is being worked.

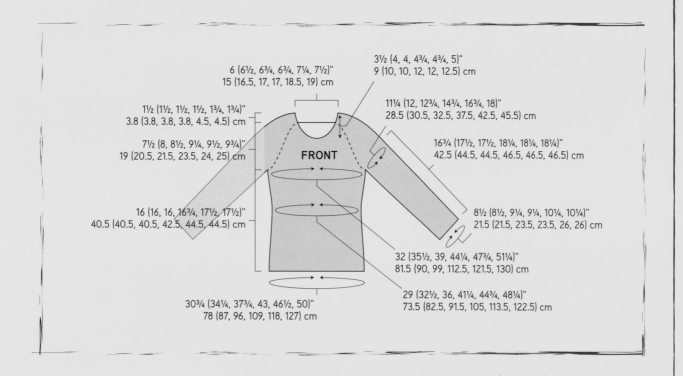

6 (6½, 6¾, 6¾, 7¼, 7½)"
15 (16.5, 17, 17, 18.5, 19) cm

3½ (4, 4, 4¾, 4¾, 5)"
9 (10, 10, 12, 12, 12.5) cm

1½ (1½, 1½, 1½, 1¾, 1¾)"
3.8 (3.8, 3.8, 3.8, 4.5, 4.5) cm

11¼ (12, 12¾, 14¾, 16¾, 18)"
28.5 (30.5, 32.5, 37.5, 42.5, 45.5) cm

7½ (8, 8½, 9¼, 9½, 9¾)"
19 (20.5, 21.5, 23.5, 24, 25) cm

FRONT

16¾ (17½, 17½, 18¼, 18¼, 18¼)"
42.5 (44.5, 44.5, 46.5, 46.5, 46.5) cm

16 (16, 16, 16¾, 17½, 17½)"
40.5 (40.5, 40.5, 42.5, 44.5, 44.5) cm

8½ (8½, 9¼, 9¼, 10¼, 10¼)"
21.5 (21.5, 23.5, 23.5, 26, 26) cm

32 (35½, 39, 44¼, 47¾, 51¼)"
81.5 (90, 99, 112.5, 121.5, 130) cm

30¾ (34¼, 37¾, 43, 46½, 50)"
78 (87, 96, 109, 118, 127) cm

29 (32½, 36, 41¼, 44¾, 48¼)"
73.5 (82.5, 91.5, 105, 113.5, 122.5) cm

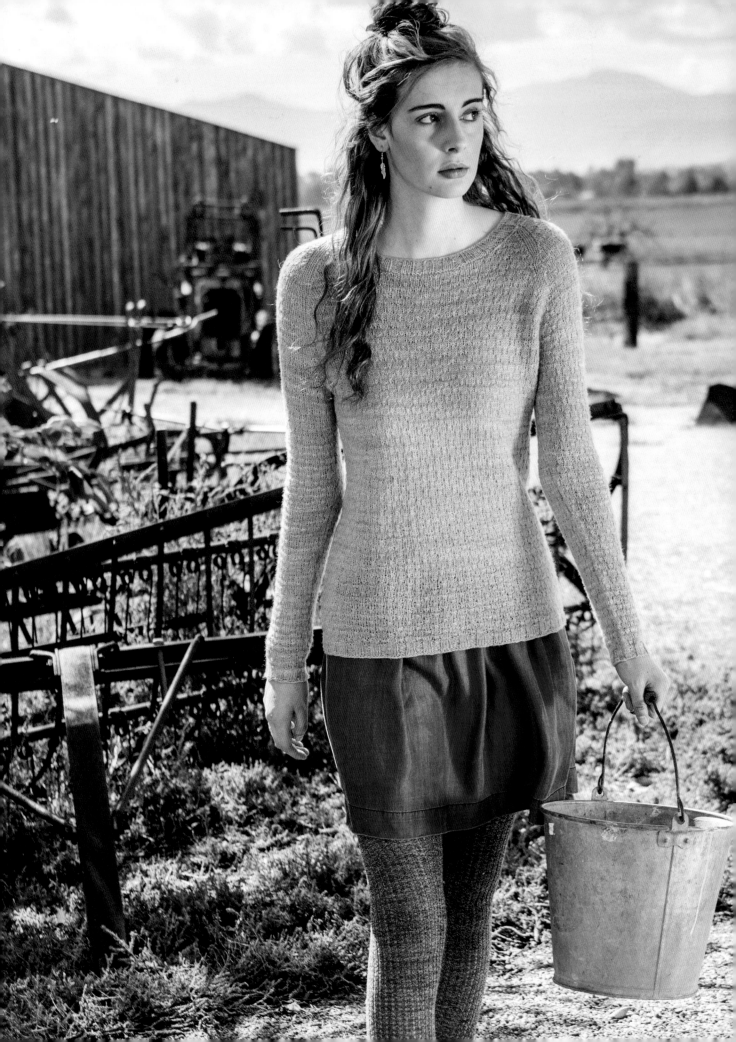

Dec rnd: *K1, k2tog, work to 3 sts before m, ssk, k1, sm; rep from * 3 more times—8 sts dec'd; 2 sts each on front, back, and each sleeve.

Cont dec on front and back every 4 (4, 4, 2, 2, 2) rnds/rows 7 (6, 4, 40, 40, 37) more times, then every 2 (2, 2, 1, 1, 1) rnd(s)/row(s) 19 (24, 30, 2, 6, 14) times.

At the same time, dec on sleeves only every 4 rnds/rows 12 (13, 14, 11, 8, 5) more times, then every other rnd/row 9 (10, 10, 19, 27, 34) times.

Shape neck

When 47 (53, 55, 55, 59, 59) rnds have been worked after joining rnd, end with an odd-numbered rnd—212 (220, 236, 260, 276, 300) sts rem; with 65 (69, 73, 79, 85, 97) sts each for front and back, and 41 (41, 45, 51, 53, 53) sts for each sleeve.

Cut yarn. Slip first 25 (26, 28, 31, 34, 39) sts to RH needle without working, rejoin yarn, BO next 15 (17, 17, 17, 17, 19) sts for front neck, *work to 3 sts before m, ssk, k1, sm, k1, k2tog; rep from * 3 more times, work to end—189 (195, 211, 235, 251, 273) sts rem; with 24 (25, 27, 30, 33, 38) sts for each front, 63 (67, 71, 77, 83, 95) sts for back, and 39 (39, 43, 49, 51, 51) sts for each sleeve.

Beg working back and forth.

Cont raglan shaping as established, BO at beg of every row 4 sts twice, 3 sts twice, then 2 sts twice. Dec 1 st each neck edge every RS row 2 (2, 4, 3, 4, 3) times, then every 4 (4, 4, 6, 4, 4) rows 2 (3, 2, 3, 3, 4) times as follows: K1, ssk, work as established to last 3 sts, k2tog, k1—79 (83, 89, 89, 95, 97) sts rem when all shaping is complete; no sts rem for fronts, 41 (45, 47, 47, 49, 51) sts for back, and 19 (19, 21, 21, 23, 23) sts for each sleeve.

At the same time, if 5 sts rem at each front neck, and you need to dec 2 sts before first m and after last m, dec as follows: K1, sk2p, k1, sm, work to last 4 sts, k3tog, k1.

If 4 sts rem at each front neck, and you need to dec 2 sts before first m and after last m, dec as follows: K1, sk2p, sm, work to last 4 sts, k3tog, k1.

If 3 sts rem at each front neck, and you need to dec 2 sts before first m and after last m, dec as follows: K1, sk2p and remove m, k2tog, work to last 6 sts, ssk, k3tog and remove m, k1.

If 3 sts rem at each front neck, and you need to dec 1 st before first m and after last m, dec as follows: K1, ssk, work to last 3 sts, k2tog, k1.

If 2 sts rem at each front neck, and you need to dec 2 sts before first m and after last m, dec as follows: Sk2p and remove m, work to last 3 sts, k3tog and remove m.

If 2 sts rem at each front neck, and you need to dec 1 st before first m and after last m, dec as follows: Ssk, work to last 2 sts, k2tog.

If 1 st rem at each front neck edge, and you need to dec that st at each end of row, dec as follows: Ssk and remove m, work to last 2 sts, k2tog and remove m.

Work 1 WS row even.

Next row: (RS) K1, sk2p, work to 3 sts before next m, ssk, k1, work in pattern to last 4 sts, k3tog, k1—74 (78, 84, 84, 90, 92) sts rem.

BO all sts in patt.

Finishing
NECKBAND

With shorter cir needle and RS facing, beg at right back, pick up and knit 40 (44, 46, 46, 48, 50) sts along back neck, 17 (17, 19, 19, 21, 21) sts along left sleeve, 58 (60, 60, 60, 66, 70) sts along front neck, and 17 (17, 19, 19, 21, 21) sts along right sleeve—132 (138, 144, 144, 156, 162) sts. Pm for beg of rnd and join for working in rnds.

Rnd 1: *K3, p3; rep from *.

Cont in established ribbing until neckband measures about 1" (2.5 cm).

BO all sts loosely in patt.

Join underarm sts using Kitchener st (see Techniques).

Weave in all loose ends. Block to measurements.

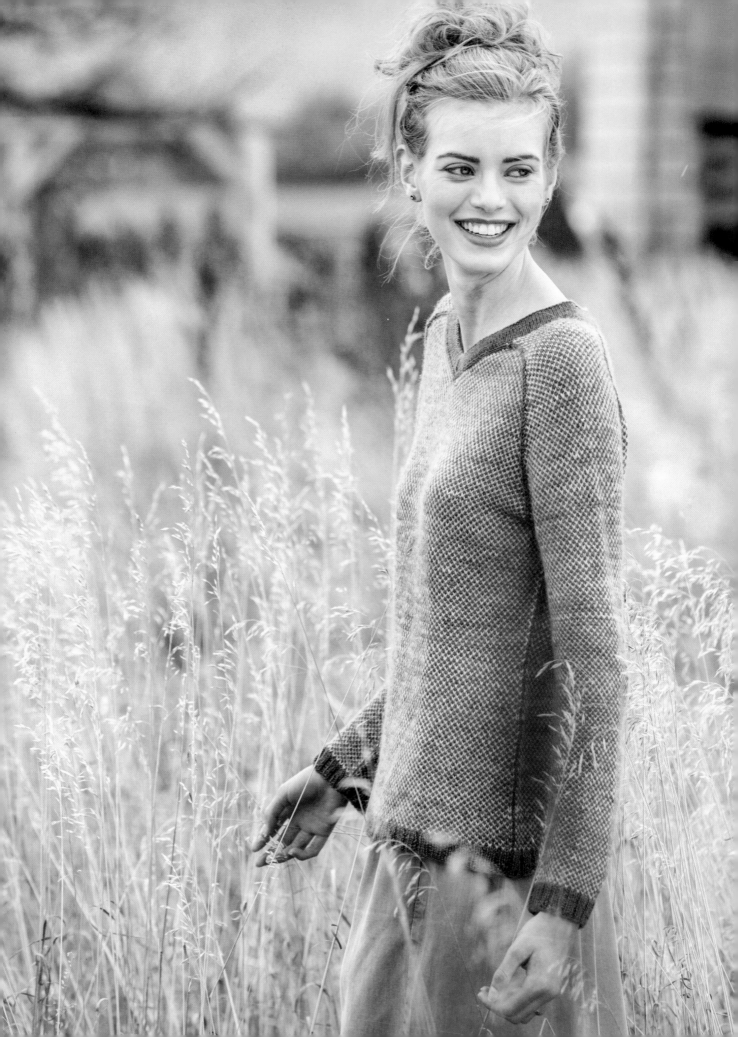

HAZY CLOUD
PULLOVER

A two-colorcheck, the most basic of colorwork patterns, creates a fabric that is spongy and supple. Even though the yarn here incorporates lush fibers with high drape, such as silk, the resultant fabric keeps its shape thanks to the interlocking of the strands of each color. That means you can make an incredibly soft, glowing sweater seamlessly. This is the ultimate sweatshirt—elegant and sophisticated, but still relaxed and luxuriously soft. It's worked from the bottom up with gentle waist shaping; the seamless yoke is a combination raglan/saddle- shoulder construction for a flattering fit. The V-neck is shaped with steek stitches that are reinforced and cut, while the hemmed neckband is picked up and worked after the rest of the sweater is finished.

Notes

Pullover is worked in the round from the bottom up. The body is worked first, then the sleeves. Body and sleeves are joined and worked in the round to the neck. Steek stitches are added, and the remainder of the yoke is worked in the round. The V-neck steek is reinforced and cut, and the turned-hem neckband is picked up and worked, ending by encasing the steek edge.

Many knitters work more tightly in stranded colorwork than in plain stockinette stitch or ribbing; a larger needle is recommended for colorwork. Swatch in the color pattern and ribbing to determine if a larger needle is necessary.Be sure to swatch in the round and block your swatch before measuring.

For this pattern, it's particularly important to maintain one color as dominant in order to create a uniform fabric. The sample shows the contrasting color as dominant.

Finished Size

33 (36¾, 40¾, 44½, 48½, 52¼)" (84 [93.5, 103.5, 113, 123, 132.5] cm) bust circumference and 26 (26¾, 27¾, 28¼, 29, 29¼)" (66 [68, 70.5, 72.5, 73.5, 74.5] cm) long.

Intended to be worn with 4–6" (10–15 cm) of positive ease.

Shown in size 36¾" (93.5 cm).

Yarn

Sportweight (#2 Fine) yarn in 2 colors:

Main Color (MC): 734 (823, 924, 1013, 1,114, 1203) yd (671 [752, 845, 926, 1018, 1100] m).

Contrast Color (CC): 651 (730, 820, 898, 988, 1087) yd (595 [667, 750, 821, 903, 994] m).

Shown here: The Fibre Company Road to China Light (65% baby alpaca, 15% silk, 10% camel, 10% cashmere; 159 yd [145 m]/50 g): colors Lapis (MC), 5 (6, 6, 7, 7, 8) skeins; Riverstone (CC), 5 (5, 6, 6, 7, 7) skeins.

Needles

Size U.S. 2 (2.75 mm) 24" and 32" (60 and 80 cm) circular (cir) and set of 4 or 5 double-pointed (dpn).

Size U.S. 5 (3.75 mm) 32" (80 cm) circular (cir) and set of 4 or 5 double-pointed (dpn).

Adjust needle sizes if necessary to obtain the correct gauge.

Notions

Markers (m); stitch holders or waste yarn; tapestry needle; small amount of fingering-weight yarn in coordinating color for steek reinforcing; size C-2 (2.25 mm) crochet hook for steek reinforcing.

Gauge

31 sts and 28 rnds = 4" (10 cm) over Checked Color patt using larger needles.

k1CC: Knit 1 using CC.

k1MC: Knit 1 using mC.

k2togMC: Knit 2 together using mC.

k3togMC: Knit 3 together using mC.

sk2pMC: [Slip 1, knit 2 together, pass slipped stitch over] using mC.

sskMC: Ssk (see glossary) using MC.

Body

With longer, smaller cir needle and mC, CO 248 (276, 308, 336, 368, 396) sts. Place marker (pm) for beg of rnd and join for working in rnds, being careful not to twist sts.

HEM

Rnd 1: *K2, p2; rep from *.

Cont in established ribbing until piece measures 1 (1, 1½, 1½, 2, 2)" (2.5 [2.5, 3.8, 3.8, 5, 5] cm).

SET UP COLOR PATTERN

Change to larger cir needle.

Set-up rnd: *[K1MC, k1CC] 62 (69, 77, 84, 92, 99) times*, pm; rep from * to * once more.

Next rnd: *K1MC, [k1MC, k1CC] to 1 st before m, k1MC, sm; rep from * once more.

Next rnd: *[K1MC, k1CC] to m, sm; rep from * once more.

Rep last 2 rnds for patt.

SHAPE WAIST

Work 11 more rnds as established.

Dec rnd: *K1MC, ssk with CC, work in established patt to 2 sts before m, k2tog with CC; rep from * once more—4 sts dec'd.

Rep Dec Rnd every 14 rnds 3 more times, maintaining color patt each dec rnd—232 (260, 292, 320, 352, 380) sts rem.

SHAPE BUST

Work 5 rnds even.

Inc rnd: *K1MC, yo in correct color to maintain color patt, work in established patt to m, yo in correct color to maintain color patt; rep from * once more—4 sts inc'd.

Next rnd: *K1MC, k1-tbl in correct color to maintain color patt, work in established patt to yo before next m,

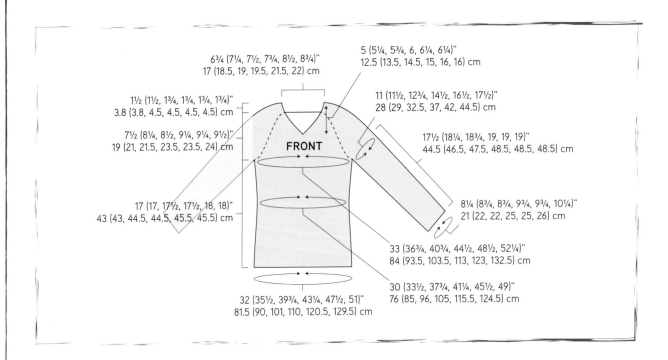

6¾ (7¼, 7½, 7¾, 8½, 8¾)"
17 (18.5, 19, 19.5, 21.5, 22) cm

5 (5¼, 5¾, 6, 6¼, 6¼)"
12.5 (13.5, 14.5, 15, 16, 16) cm

1½ (1½, 1¾, 1¾, 1¾, 1¾)"
3.8 (3.8, 4.5, 4.5, 4.5, 4.5) cm

11 (11½, 12¾, 14½, 16½, 17½)"
28 (29, 32.5, 37, 42, 44.5) cm

7½ (8¼, 8½, 9¼, 9¼, 9½)"
19 (21, 21.5, 23.5, 23.5, 24) cm

FRONT

17½ (18¼, 18¾, 19, 19, 19)"
44.5 (46.5, 47.5, 48.5, 48.5, 48.5) cm

17 (17, 17½, 17½, 18, 18)"
43 (43, 44.5, 44.5, 45.5, 45.5) cm

8¼ (8¾, 8¾, 9¾, 9¾, 10¼)"
21 (22, 22, 25, 25, 26) cm

33 (36¾, 40¾, 44½, 48½, 52¼)"
84 (93.5, 103.5, 113, 123, 132.5) cm

30 (33½, 37¾, 41¼, 45½, 49)"
76 (85, 96, 105, 115.5, 124.5) cm

32 (35½, 39¾, 43¼, 47½, 51)"
81.5 (90, 101, 110, 120.5, 129.5) cm

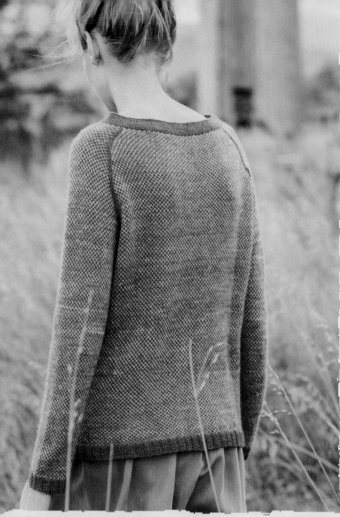

k1-tbl in correct color to maintain color patt; rep from * once more.

Rep Inc Rnd every 6 rnds 5 more times—256 (284, 316, 344, 376, 404) sts.

Cont even until piece measures 17 (17, 17½, 17½, 18, 18)" (43 [43, 44.5, 44.5, 45.5, 45.5] cm) from beg.

Set body aside.

Sleeves

CUFF

With smaller dpn and mC, CO 64 (68, 68, 76, 76, 80) sts. Evenly distribute sts over 3 or 4 dpn. Pm for beg of rnd, and join for working in rnds, being careful not to twist sts.

Rnd 1: *K2, p2; rep from *.

Cont in established ribbing until piece measures 1 (1, 1½, 1½, 2, 2)" (2.5 [2.5, 3.8, 3.8, 5, 5] cm).

MAIN SLEEVE SECTION
Change to larger dpn.

Rnd 1: [K1MC, k1CC] around.

Rnd 2: K1MC, [k1MC, k1CC] to last st, k1MC.

Rep last 2 rnds for patt.

Shape sleeve

Work 7 (7, 5, 5, 3, 1) more rnd(s) in established patt.

Inc rnd: K1MC, yo in correct color to maintain color patt, work in established patt to end, yo in correct color to maintain color patt—2 sts inc'd.

Next rnd: K1MC, k1-tbl in correct color to maintain color patt, work in established patt to yo before next m, k1-tbl in correct color to maintain color patt; rep from * once more.

Rep Inc Rnd every 10 (10, 8, 8, 6, 4) rnds 8 (10, 10, 2, 3, 27) more times, then every 8 (0, 6, 6, 4, 0) rnds 2 (0, 4, 15, 22, 0) times—86 (90, 98, 112, 128, 136) sts.

Work even until piece measures 17½ (18¼, 18¾, 19, 19, 19)" (44.5 [46.5, 47.5, 48.5, 48.5, 48.5] cm) from beg.

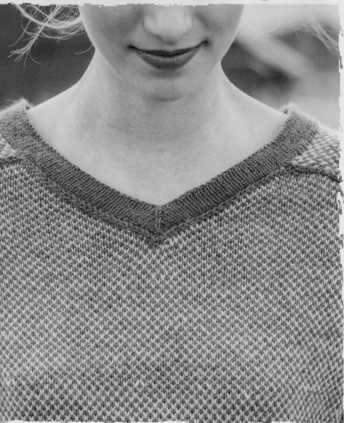

Place last 7 (8, 9, 10, 11, 12) sts and first 8 (9, 10, 11, 12, 13) sts onto holder or waste yarn for underarm—71 (73, 79, 91, 105, 111) sts rem on needles.

Yoke

Joining rnd: *Work body in established patt to 7 (8, 9, 10, 11, 12) sts before m, place next 15 (17, 19, 21, 23, 25) sts onto holder or waste yarn removing m, pm for raglan, work held 71 (73, 79, 91, 105, 111) sleeve sts, pm for raglan; rep from * once more—368 (396, 436, 484, 540, 576) sts; with 113 (125, 139, 151, 165, 177) sts each for front and back, and 71 (73, 79, 91, 105, 111) sts for each sleeve. Join for working in rnds; rnds beg at right back raglan.

ESTABLISH YOKE PATTERN

Set-up rnd: *K1MC and place removable m on this st, work in established patt to 1 st before m, k1MC and place removable m on this st, remove m from needle, work sleeve sts in established patt; rep from * once more. make sure removable m at beg of rnd is a unique color to make it easier to keep track of beg of rnd.

Keeping marked sts in mC, work 2 more rnds even. Move m up every few rnds.

SHAPE RAGLAN AND NECKLINE

Note: The sleeve caps, front and back, and V-neck are worked *at the same time,* but at different rates of decrease. Carefully read through the following instructions before proceeding. Once the neck shaping has begun, the beginning of the round is moved to the center front.

Dec rnd 1: *SskMC, work in established patt to 1 st before next marked st, k2togMC, work to next marked st; rep from * once more—4 sts dec'd; 2 sts each on front and back.

Dec rnd 2: Place last st of rnd back on left needle tip, *sk2pMC, work in established patt to 1 st before next marked st; rep from * 2 more times, work to end—8 sts dec'd; 2 sts each on front and back, and 2 sts on each sleeve.

Cont dec on front and back every rnd 2 (2, 4, 6, 8, 10) more times, every other rnd 18 (20, 16, 15, 10, 7) times, then every rnd 8 (10, 18, 22, 30, 36) times. *At the same time,* cont dec on each sleeve every other rnd 22 (23, 25, 27, 21, 20) more times, then every rnd 0 (0, 0, 4, 16, 20) times.

Note: When Dec Rnd falls on sleeves only, work as follows: Sl 1, *work in established patt to marked st, sskMC, work to 1 st before next marked st, k2togMC; rep from * once more, working last dec with last st of second sleeve and slipped st from beg of rnd.

Shape V-neck

At the same time, when 26 (30, 31, 34, 33, 34) rnds have been worked, shape neck—264 (276, 312, 340, 400, 416) sts rem; with 85 (93, 105, 111, 125, 129) sts each for front and back, and 47 (45, 51, 59, 75, 79) sts for each sleeve.

Cut yarns and sl 47 (45, 51, 59, 75, 79) sleeve sts from right needle tip to left needle tip, then sl 43 (47, 53, 56, 63, 65) front sts from right needle tip to left needle tip, pm on right needle tip. Using both colors and backward-loop method (see Techniques), CO 7 sts onto right needle tip, alternating colors, pm, sskMC, *work to marked st and work raglan dec if needed; rep from * 3 more times, work to CO sts—1 st dec'd at right front neck. Steek sts are new beg of rnd.

Neck dec rnd: (K1CC, k1MC) 3 times, k1CC, sm, sskMC, work in established color and raglan patts to last 2 sts, k2togMC—1 st dec at each neck edge.

Working steek sts in vertical stripes as established to distinguish them from checked patt, cont dec at neck edge every rnd 22 (24, 25, 26, 28, 29) more times—116 (120, 126, 128, 136, 138) sts rem; 3 sts for each front, 53 (57, 59, 61, 65, 67) sts for back, 25 (25, 27, 27, 29, 29) sts for each sleeve, and 7 steek sts. Cut CC.

BO rnd: With mC only, BO 7 steek sts, sk2pMC, BO to last 3 sts, k3togMC, cut yarn and draw tail through rem st.

Finishing

NECKLINE

Reinforce and cut steek (see Techniques).

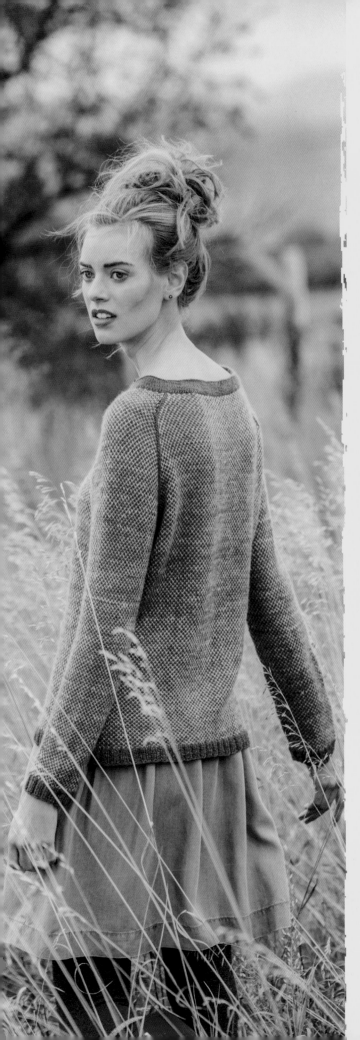

Be particularly careful, as the suggested yarn is somewhat slippery.

Neckband

With shorter, smaller cir needle and mC, with RS facing, beg at back left raglan, pick up and knit 25 (25, 27, 27, 29, 29) sts along left sleeve, 22 (24, 25, 26, 27, 30) sts along left front neck, 1 st at bottom of V, 22 (24, 25, 26, 27, 30) sts along right front neck, 25 (25, 27, 27, 29, 29) sts along right sleeve, and 53 (57, 59, 61, 65, 67) sts along back neck (1 st for every BO st and about 1 st for every row along steeked edges)—148 (156, 164, 168, 178, 186) sts. Pm for beg of rnd and join for working in rnds.

Rnd 1: Knit to 1 st before st at bottom of V, ssk, and place removable marker on this st, knit to end—147 (155, 163, 167, 177, 185) sts rem.

Next rnd: Knit.

Dec rnd: Knit to 1 st before marked st, s2kp, knit to end—2 sts dec'd.

Rep last 2 rnds 3 more times—139 (147, 155, 159, 169, 177) sts rem.

Next (fold) rnd: Purl.

Facing

Inc rnd: Knit to 1 st before marked st, m1L, k1, m1R, knit to end—2 sts inc'd.

Next rnd: Knit.

Rep last 2 rnds 3 more times—147 (155, 163, 167, 177, 185) sts.

BO all sts loosely. Fold facing to WS along fold rnd, making sure to place cut steek between neckband and facing. Whipstitch (see Techniques). BO edge to inside along neckband pick-up row.

JOIN UNDERARMS

Turn piece with WS facing. Place held body and sleeve sts onto 2 larger dpn. With mC, use three-needle bind-off (see Techniques) to join underarms.

Weave in all loose ends. Block to measurements.

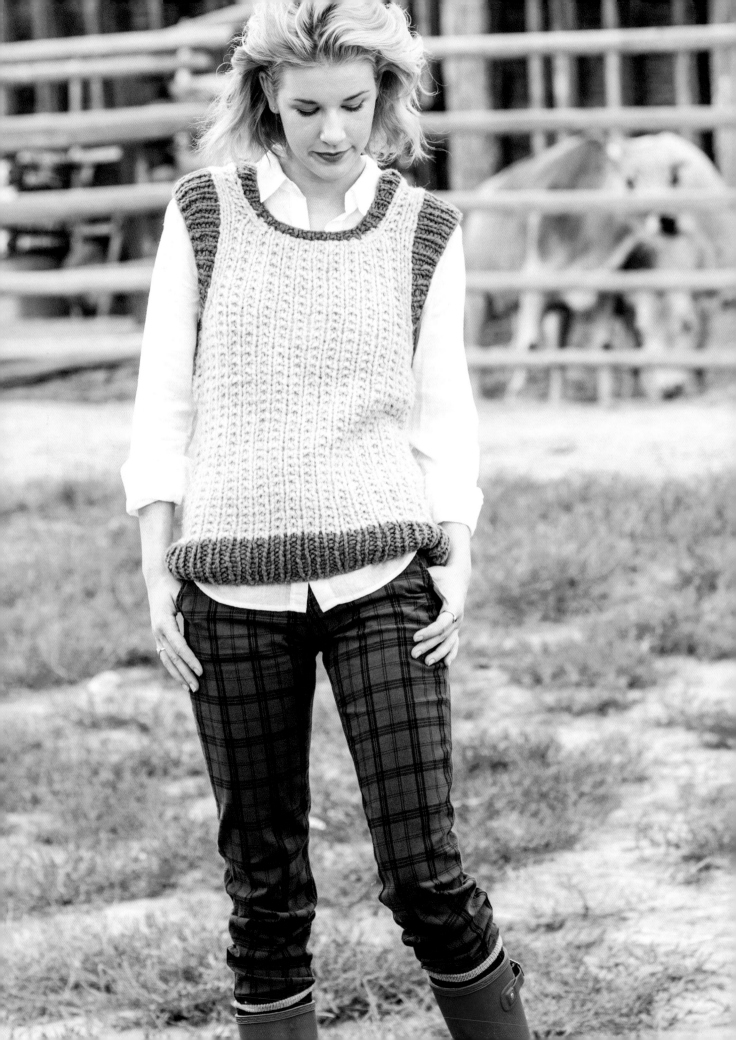

TEXTURED WISP

VEST

This textured vest works up quickly in super-bulky yarn. The neckband and armhole edgings are worked using short-row shaping for a slimming look. Use a lofty, light wool such as Imperial Yarn Bulky 2 Strand to create a thick and cozy vest.

Finished Size

32 (35½, 41, 44½, 48, 51½)" (81.5 [90, 104, 113, 122, 131] cm) bust circumference and 25 (25½, 26¼, 26¼, 27, 27½)" (63.5 [65, 66.5, 66.5, 68.5, 70] cm) long.

Shown in size 35½" (90 cm).

Intended to be worn with 1–3" (2.5–7.5 cm) of positive ease.

Yarn

Bulky weight (#6 Super Bulky).

Main Color (MC): 296 (330, 378, 410, 442, 475) yd (271 [302, 345, 375, 404, 434] m).

Contrast Color (CC): 69 (74, 88, 95, 106, 111) yd (63 [67, 80, 87, 97, 101] m).

Shown here: Imperial Yarn Bulky 2 Strand (100% wool; 200 yd/4 oz cake): colors #02 Pearl gray (MC), 2 (2, 2, 3, 3, 3) cakes; #46 Quail (CC), 1 cake.

Needles

Size U.S. 11 (8 mm) 16" and 32" (40 and 80 cm) circular (cir).

Adjust needle size if necessary to obtain the correct gauge.

Notions

Markers (m); stitch holders; 3 size U.S. 11 (8 mm) double-pointed needles (dpn) for shoulder bind-off; tapestry needle.

Gauge

9 sts and 16½ rows = 4" (10 cm) over Broken Rib patt.

Notes

Vest is worked in the round from the bottom up. Shoulders are joined using three-needle bind-off. Armhole and neckline edgings are picked up and worked after joining shoulders and are shaped using short-rows.

Broken Rib

Worked in Rnds

(multiple of 2 sts)

Rnd 1: Knit.

Rnd 2: *K1, p1; rep from *.

Rep Rnds 1–2 for patt.

Worked in Rows

(multiple of 2 sts + 1)

Row 1: (RS) *K1, p1; rep from * to last st, k1.

Row 2: Purl.

Rep Rows 1–2 for patt.

Body

With longer cir needle and CC, CO 72 (80, 92, 100, 108, 116) sts. Place marker (pm) for beg of rnd and join for working in rnds, being careful not to twist sts.

RIBBED HEM

Rnd 1: *K1, p1; rep from *.

Rep Rnd 1 until piece measures 2½ (2½, 2¾, 2¾, 3, 3)" (6.5 [6.5, 7, 7, 7.5, 7.5] cm) from beg.

MAIN BODY SECTION

Change to MC.

Set-up rnd: K36 (40, 46, 50, 54, 58), pm, knit to end.

Work in Broken Rib in rnds for 21 rnds; piece should measure about 7¾ (7¾, 8, 8, 8¼, 8¼)" (19.5 [19.5, 20.5, 20.5, 21, 21] cm) from beg, ending with Rnd 1 of patt.

SHAPE WAIST

Next (dec) rnd: *K1, ssk, knit to 2 sts before m, k2tog; rep from * once more—68 (76, 88, 96, 104, 112) sts rem.

Next rnd: *K2, (p1, k1) to m, sm; rep from * once more.

Next rnd: Knit.

Work 11 more rnds as established; piece should measure 11¼ (11¼, 11½, 11½, 11¾, 11¾)" (28.5 [28.5, 29, 29, 30, 30] cm) from beg.

SHAPE BUST

Next (inc) rnd: *K1, m1, knit to m, m1, sm; rep from * once more—72 (80, 92, 100, 108, 116) sts.

Next rnd: *K1, p1; rep from *.

Next rnd: Knit.

Work 13 more rnds as established, ending last rnd 2 (2, 3, 3, 3, 3) sts before end of rnd.

Armholes

DIVIDE FRONT AND BACK IN NEXT RND AS FOLLOWS

Next rnd: *Knit to 2 (2, 3, 3, 3, 3) sts before m, BO 5 (5, 7, 7, 7, 7) for armhole, removing m; rep from * once more—31 (35, 39, 43, 47, 51) sts rem each for front and back. Place front sts onto holder.

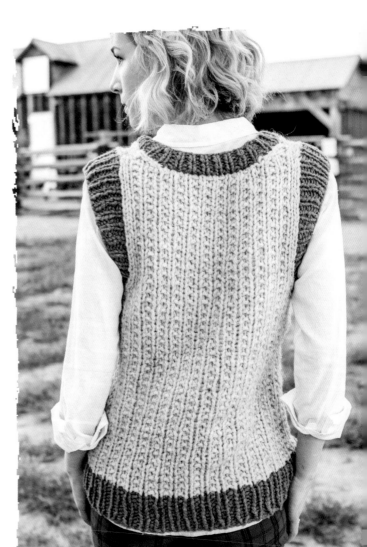

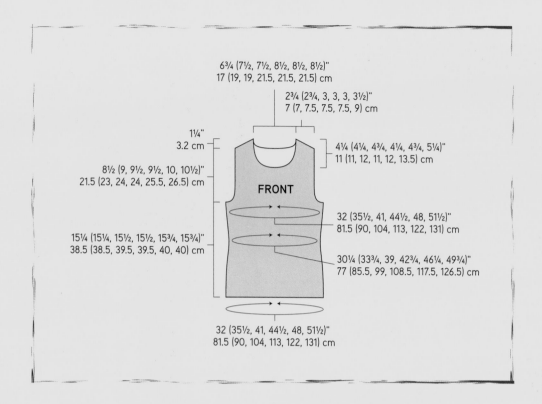

6¾ (7½, 7½, 8½, 8½, 8½)"
17 (19, 19, 21.5, 21.5, 21.5) cm

2¾ (2¾, 3, 3, 3, 3½)"
7 (7, 7.5, 7.5, 7.5, 9) cm

1¼"
3.2 cm

4¼ (4¼, 4¾, 4¼, 4¾, 5¼)"
11 (11, 12, 11, 12, 13.5) cm

8½ (9, 9½, 9½, 10, 10½)"
21.5 (23, 24, 24, 25.5, 26.5) cm

FRONT

32 (35½, 41, 44½, 48, 51½)"
81.5 (90, 104, 113, 122, 131) cm

15¼ (15¼, 15½, 15½, 15¾, 15¾)"
38.5 (38.5, 39.5, 39.5, 40, 40) cm

30¼ (33¾, 39, 42¾, 46¼, 49¾)"
77 (85.5, 99, 108.5, 117.5, 126.5) cm

32 (35½, 41, 44½, 48, 51½)"
81.5 (90, 104, 113, 122, 131) cm

Back

SHAPE ARMHOLES

SIZES 32 (35½)" (81.5 [90] CM) ONLY:

Next (dec) row: (RS) K1, ssk, work in established patt to last 3 sts, k2tog, k1—2 sts dec'd.

Next row: Purl.

Rep last 2 rows 1 (2) more time(s)—27 (29) sts rem.

SIZES 41 (44½, 48, 51½)" (104 [113, 122, 131] CM) ONLY:

Next (dec) row: (RS) K1, ssk, work in established patt to last 3 sts, k2tog, k1—2 sts dec'd.

Next (dec) row: (WS) P1, p2tog, purl to last 3 sts, ssp, p1—2 sts dec'd.

Rep last 2 rows 1 (1, 2, 3) more time(s), then rep RS Dec Row 0 (1, 1, 0) more time—31 (33, 33, 35) sts rem.

ALL SIZES:

Working first st and last st of every row in St st (knit on RS, purl on WS), cont even until armhole measures 8¼ (8¾, 9¼, 9¼, 9¾, 10¼)" (21 [22, 23.5, 23.5, 25, 26] cm), ending with a WS row.

SHAPE NECK AND SHOULDERS

Next row (RS): Work 8 (8, 9, 9, 9, 10) sts in established patt, BO next 11 (13, 13, 15, 15, 15) in patt for neck, then work to end—8 (8, 9, 9, 9, 10) sts rem each shoulder. Place sts for right shoulder onto holder.

Shape left shoulder using short-rows

Rows 1, 3, and 5: (WS) Purl.

Row 2: (RS) K1, ssk, work 3 (3, 4, 4, 4, 4) sts, w&t (see Techniques).

Row 4: K1, ssk, work 0 (0, 1, 1, 1, 0) st(s), w&t.

Row 6: Work in patt over all sts, picking up wraps and working them together with the sts they wrap.

Cut yarn, leaving 12" (30.5 cm) tail. Place rem 6 (6, 7, 7, 7, 8) sts onto holder.

Shape right shoulder using short-rows

Return held sts for right shoulder to shorter cir needle. With WS facing, join mC at neck edge.

Row 1: (WS) P1, p2tog, p3 (3, 4, 4, 4, 4) sts, w&t.

Rows 2, 4, and 6: (RS) Work in established patt.

Row 3: P1, p2tog, p0 (0, 1, 1, 1, 0), w&t.

Row 5: Purl to end, picking up wraps and working them together with the sts they wrap.

Cut yarn, leaving 12" (30.5 cm) tail. Place rem 6 (6, 7, 7, 7, 8) sts onto holder.

Front

SHAPE ARMHOLES

Shape armholes as for back—27 (29, 31, 33, 33, 35) sts rem. Cont even until armhole measures 5½ (6, 6, 6½, 6½, 6½)" (14 [15, 15, 16.5, 16.5, 16.5] cm), ending with a WS row.

SHAPE NECKLINE

Next row: Work 8 (9, 10, 10, 10, 11) sts in established patt, BO next 11 (11, 11, 13, 13, 13) in patt, then work to end—8 (9, 10, 10, 10, 11) sts rem for each side. Place sts for left shoulder onto holder.

SHAPE RIGHT NECKLINE

Dec row: (WS) Purl to last 3 sts, ssp, p1—1 st dec'd.

Dec row: (RS) K1, ssk, work in established patt to end—1 st dec'd.

Rep WS Dec Row 0 (1, 1, 1, 1, 1) more time(s)—6 (6, 7, 7, 7, 8) sts rem.

Working first st and last st of every row in St st, cont even until armhole measures 8¼ (8¾, 9¼, 9¼, 9¾, 10¼)" (21 [22, 23.5, 23.5, 25, 26] cm), ending with a WS row.

SHAPE RIGHT SHOULDER

Row 1: (RS) Work 4 (4, 5, 5, 5, 5) sts in established patt, w&t.

Rows 2, 4, and 6: Purl.

Row 3: Work 2 (2, 3, 3, 3, 2) sts in patt, w&t.

Row 5: Work in patt to end, picking up wraps and working them together with the sts they wrap.

Cut yarn, leaving 6" (15 cm) tail. Place sts onto holder.

SHAPE LEFT NECKLINE

Return held sts for left shoulder to shorter cir needle. With WS facing, join mC to neck edge.

Dec row: (WS) P1, p2tog, purl to end—1 st dec'd.

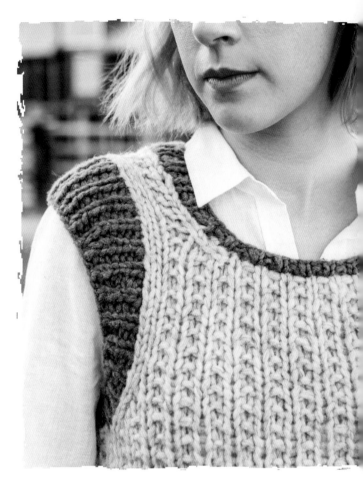

Dec row: (RS) Work in established patt to last 3 sts, k2tog, k1—1 st dec'd.

Rep WS Dec Row 0 (1, 1, 1, 1, 1) more time(s)—6 (6, 7, 7, 7, 8) sts rem.

Working first st and last st of every row in St st, cont even until armhole measures 8¼ (8¾, 9¼, 9¼, 9¾, 10¼)" (21 [22, 23.5, 23.5, 25, 26] cm), ending with a RS row.

SHAPE LEFT SHOULDER

Row 1: (WS) P4 (4, 5, 5, 5, 5), w&t.

Rows 2 and 4: Work in established patt to end.

Row 3: P2 (2, 3, 3, 3, 2), w&t.

Row 5: Purl to end, picking up wraps and working them together with the sts they wrap.

Cut yarn, leaving 6" (15 cm) tail. Place rem sts onto dpn.

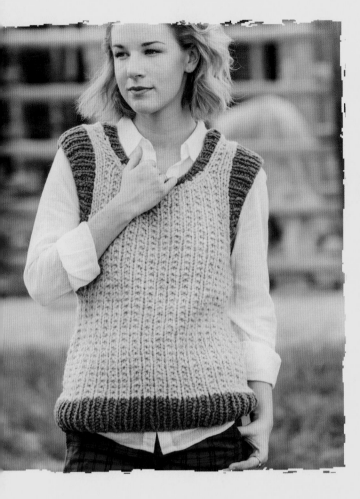

Make sure you have an even number of sts. If not, knit the first 2 sts of the next rnd together to get an even number. Pm for beg of rnd and join for working in rnds.

Shape neckline edging using short-rows

Short-row 1: (RS) Work in K1, P1 Rib to 2 sts before left front neck m, w&t.

Short-row 2: (WS) Work in established patt to 2 sts before right front neck m, working past beg-of-rnd m, w&t.

Short-row 3: Work in patt to 6 sts before wrapped st at left front neck, w&t.

Short-row 4: Work in patt to 6 sts before wrapped st at right front neck, w&t.

Next rnd: Work in patt to beg-of-rnd m, then work to end of rnd, picking up wraps and working them together with the sts they wrap and removing m as you come to them.

BO all sts in patt.

ARMHOLE EDGINGS

With shorter cir needle and CC, with RS facing, beg at center of underarm BO sts, pick up and knit 1 st for each BO st, then 2 sts for every 3 rows around arm-hole, then pick up and knit 1 st for each BO st to center of underarm. Make sure you have an even number of sts. Pm for beg of rnd and join for working in rnds.

Shape armhole using short-rows

Short-rows 1 and 2: Work in K1, P1 rib to last 8 sts, w&t.

Short-rows 3 and 4: Work in rib to 6 sts before wrapped st, w&t.

Short-rows 5 and 6: Rep Rows 3 and 4 once more.

Next Rnd: Work in established patt to end of rnd, picking up wraps and working them together with the sts they wrap.

Rep last rnd once more.

Work 1 rnd in rib over all sts.

BO all sts in patt.

Weave in ends. Block to measurements.

Finishing

JOIN SHOULDERS

Turn vest inside out. Place held Back Left Shoulder sts onto 2nd dpn. Join shoulders using three-needle bind-off (see Techniques), using longer tail on Back Left Shoulder. Join Right Shoulders in same way.

NECKBAND

With shorter cir needle and CC, with RS facing, beg at Right Shoulder Seam and pick up and knit 2 sts for every 3 rows along shaped back neck edge, 1 st in each BO st of back neck edge, pick up and knit 2 sts for every 3 rows along shaped back neck edge and front neck edge, pm for left front neck, pick up and knit 1 st in each BO st of front neck edge, pm for right front neck, pick up and knit 2 sts for every 3 rows along shaped front neck edge, being careful to pick up the same number of sts as along left front neck edge.

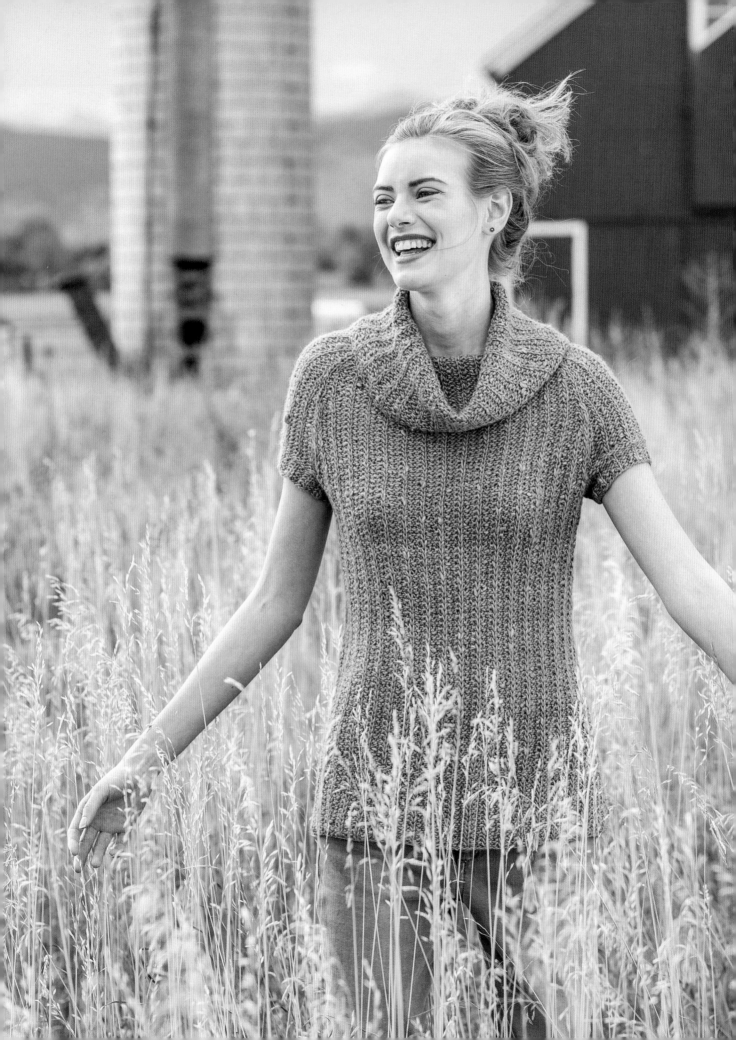

BRIGHT RIVER

COWL-NECK SWEATER

Chic, sexy, and stylish, this is a handknit luxury version of the classic insulated vest. The simple but fetching Cartridge Belt Rib stitch draws in to create a shapely garment that can be worn alone or over your favorite wool base layer. Add a winter coat for comfort in the chilliest weather or wear it with a skirt for holiday get-togethers. It's worked in the round from the bottom up with waist shaping and a raglan yoke. The cowl neck is picked up and shaped with graduating needle sizes.

Finished Size

27¼ (31¼, 35¼, 39¼, 42½, 46½)" (69 [79.5, 89.5, 99.5, 108, 118] cm) bust circumference and 25¾ (26½, 27, 27¾, 28¾, 29¼)" (65.5 [67.5, 68.5, 70.5, 73, 74.5] cm) long.

Shown in size 31¼" (79.5) cm.

Intended to be worn with 0–2" (0–5 cm) of negative ease.

Yarn

843 (939, 1,113, 1,250, 1,442, 1,617) yd (771 [858, 1,017, 1,143, 1,318, 1,478] m) Aran weight (#4 medium).

Shown here: The Fibre Company Terra (40% baby alpaca, 40% merino wool, 20% silk; 98 yd [89 m]/50 g): color Olive Leaf, 9 (10, 12, 13, 15, 17) skeins.

Needles

Size U.S. 7 (4.5 mm) 16" and 24" (40 and 60 cm) circular (cir) and set of 4 or 5 double-pointed (dpn).

Size U.S. 8 (5 mm) 24" (60 cm) circular (cir).

Size U.S. 9 (5.5 mm) 24" (60 cm) circular (cir).

Adjust needle sizes if necessary to obtain the correct gauge.

Notions

Markers (m); stitch holders or waste yarn; tapestry needle.

Gauge

20 sts and 30 rnds = 4" (10 cm) over Cartridge Belt Rib using smallest needle.

Notes

Vest is worked in the round from the bottom up. The body is worked first, then the sleeves. Body and sleeves are joined, then worked in the round to the neck. Stitches for the cowl are picked up along the neckline and worked in the round.

Body

With longer size U.S. 7 (4.5 mm) cir needle, CO 144 (168, 184, 200, 224, 240) sts. Place marker (pm) for beg of rnd and join for working in rnds, being careful not to twist sts.

HEM—ESTABLISH CARTRIDGE BELT RIB PATTERN

Set-up rnd: *K1, pm, [k3, sl 1 wyf] 17 (20, 22, 24, 27, 29) times, k3, pm; rep from * once more.

Rnd 1: *K1, sm, [p1, sl 1 wyb, p2] to 3 sts before m, p1, sl 1 wyb, p1, sm; rep from * once more.

Rnd 2: *Sl 1 wyb, sm, [k3, sl 1 wyf] to 3 sts before m, k3, sm; rep from * once more.

Rep Rnds 1 and 2 until piece measures 3½ (3½, 4, 4½, 5, 5½)" (9 [9, 10, 11.5, 12.5, 14] cm) from beg, ending with Rnd 2 of patt.

Purl 2 rnds.

SHAPE WAIST

Work 12 (10, 12, 16, 10, 12) more rnds in Cartridge Belt Rib as established for hem, ending with Rnd 2 of patt.

Note: To maintain pattern while decreasing, work decreases as k2tog or p2tog after markers, and ssk or ssp before markers.

Next (dec) rnd: *K1, sm, k2tog, work in established patt to 2 sts before m, ssk, sm; rep from * once more—4 sts dec'd.

Rep Dec Rnd every 12 (10, 12, 14, 10, 12) rnds 1 (1, 1, 2, 1, 1) more time(s), then every 10 (8, 10, 0, 8, 10) rnds 2 (3, 2, 0, 3, 2) times—128 (148, 168, 188, 204, 224) sts rem.

SHAPE BUST

Work 19 rnds even.

Next (inc) rnd: *K1, sm, m1, work in established patt to m, m1, sm; rep from * once more—4 sts inc'd.

Rep last 20 rnds once more—136 (156, 176, 196, 212, 232) sts.

Work 10 rnds even. Piece should measure 16½ (16½, 17, 17½, 18, 18½)" (42 [42, 43, 44.5, 45.5, 47] cm) from beg.

Set aside.

Sleeves

With dpn, CO 41 (45, 49, 57, 69, 73) sts. Pm for beg of rnd, and join for working in rnds, being careful not to twist sts.

Rnd 1: *K2, sl 1 wyf, k1; rep from * to last st, k1.

Rnd 2: *Sl 1 wyb, p3; rep from * to last st, sl 1 wyb.

Rep Rnds 1 and 2 until piece measures 1 (1, 2, 2, 2¾, 2¾)" (2.5 [2.5, 5, 5, 7, 7] cm) from beg.

Purl 2 rnds. Cut yarn.

Place last 5 (6, 5, 6, 6, 5) sts from right needle tip and first 6 (7, 6, 7, 7, 6) sts from left needle tip onto holder or waste yarn for underarm—30 (32, 38, 44, 56, 62) sts rem.

Yoke

JOIN BODY AND SLEEVES

Next rnd: With RS of body facing, *k1, sm, work in established patt to 5 (6, 5, 6, 6, 5) sts before next m, removing m, place next 11 (13, 11, 13, 13, 11) sts onto holder or waste yarn for armhole, pm, work 30 (32, 38, 44, 56, 62) sleeve sts, pm; rep from * once more, pm for new beg of rnd—174 (194, 230, 258, 298, 334) sts; 57 (65, 77, 85, 93, 105) sts each for front and back, and 30 (32, 38, 44, 56, 62) sts for each sleeve.

SHAPE RAGLAN YOKE

Cont in established patt, slipping m as you come to them, knitting or slipping first st and last st of each body section to create a clean raglan line. Change to

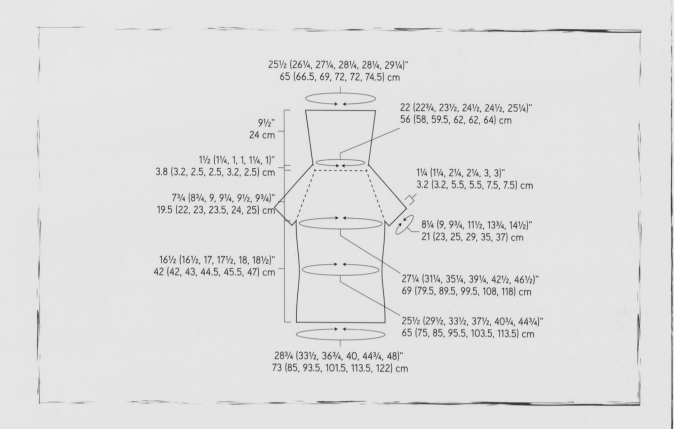

25½ (26¼, 27¼, 28¼, 28¼, 29¼)"
65 (66.5, 69, 72, 72, 74.5) cm

22 (22¾, 23½, 24½, 24½, 25¼)"
56 (58, 59.5, 62, 62, 64) cm

9½"
24 cm

1½ (1¼, 1, 1, 1¼, 1)"
3.8 (3.2, 2.5, 2.5, 3.2, 2.5) cm

1¼ (1¼, 2¼, 2¼, 3, 3)"
3.2 (3.2, 5.5, 5.5, 7.5, 7.5) cm

7¾ (8¾, 9, 9¼, 9½, 9¾)"
19.5 (22, 23, 23.5, 24, 25) cm

8¼ (9, 9¾, 11½, 13¾, 14½)"
21 (23, 25, 29, 35, 37) cm

16½ (16½, 17, 17½, 18, 18½)"
42 (42, 43, 44.5, 45.5, 47) cm

27¼ (31¼, 35¼, 39¼, 42½, 46½)"
69 (79.5, 89.5, 99.5, 108, 118) cm

25½ (29½, 33½, 37½, 40¾, 44¾)"
65 (75, 85, 95.5, 103.5, 113.5) cm

28¾ (33½, 36¾, 40, 44¾, 48)"
73 (85, 93.5, 101.5, 113.5, 122) cm

shorter, smallest cir needle when there are too few sts to work comfortably on longer needle.

Work 7 (7, 5, 3, 3, 3) rnds even.

Decrease for yoke

Next (dec) rnd: *K1, ssk, work in established patt to 3 sts before m, k2tog, k1, sm, ssk, work in patt to 2 sts before m, k2tog, sm; rep from * once more—8 sts dec'd.

Rep Dec Rnd every 8 (8, 6, 4, 4, 4) rnds 4 (1, 4, 16, 12, 9) more time(s), then every 6 (6, 4, 0, 2, 2) rnds 3 (8, 9, 0, 9, 16) times— 110 (114, 118, 122, 122, 126) sts rem; 41 (45, 49, 51, 49, 53) sts each for front and back, and 14 (12, 10, 10, 12, 10) sts for each sleeve.

BO all sts kwise. Do not cut yarn, but enlarge last st and draw ball of yarn through enlarged st. Pull to fasten off last st. *Note:* Binding off before picking up stitches for the cowl gives needed structure and stability at the neckline.

Cowl

With shorter, smallest cir needle and RS facing, pick up and knit 1 st in every BO st, and dec 2 sts evenly spaced—108 (112, 116, 120, 120, 124) sts.

Rnd 1: *K3, sl 1 wyf; rep from *.

Rnd 2: *P1, sl 1 wyb, p2; rep from *.

Rep Rnds 1–2 until cowl measures 6" (15 cm).

Change to size U.S. 8 (5 mm) cir needle. Cont in established patt until cowl measures 8" (20.5 cm).

Change to size U.S. 9 (5.5 mm) cir needle. Cont in established patt until cowl measures 9½" (24 cm).

BO all sts loosely kwise.

Finishing

Graft underarms using Kitchener st (see Techniques).

Weave in all loose ends. Block to measurements.

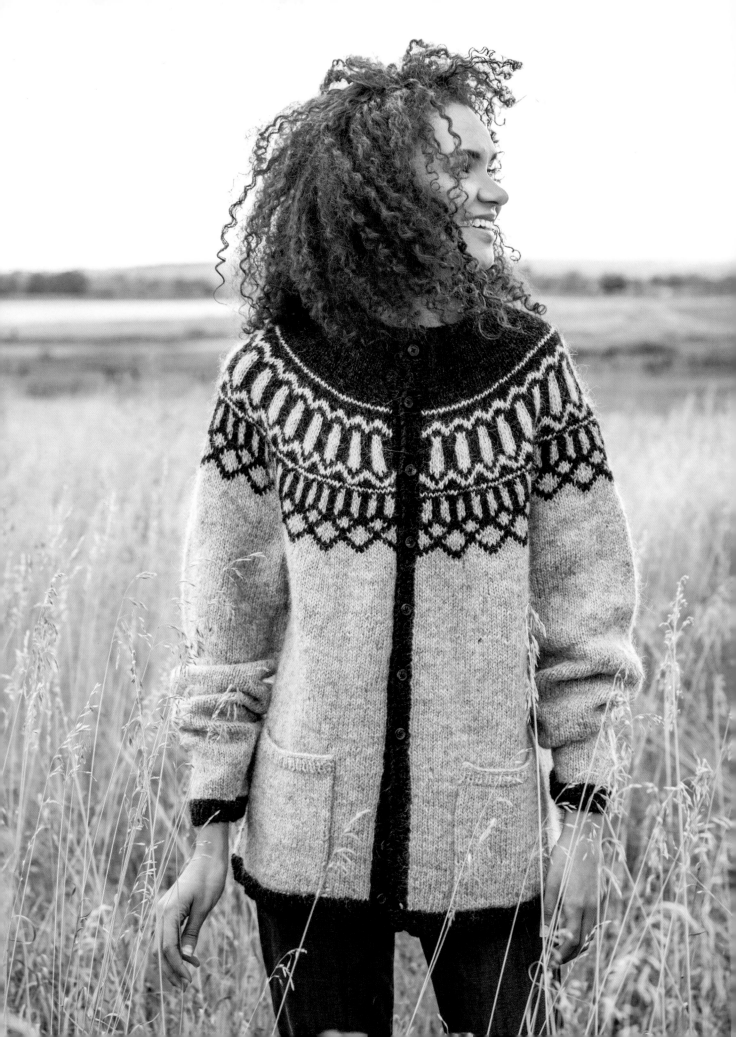

WOOLEN EXPLORER
CARDIGAN

This unisex cardigan was inspired by the Lopapeysa tradition of decoratively yoked Icelandic sweaters. Ístex's Lettlopi yarn, a worsted, creates a fabric that is incredibly warm and sturdy enough for farm chores, camping, and trekking, and will remain beautiful for generations. It's worked in the round and then a steek is cut open to separate the fronts. Deep pockets make it that much more functional.

Notes

Body and sleeves are worked in the round from the bottom up to the armholes, then joined with the sleeves to work the yoke. Two sections of short-row shaping, one before the color pattern and one after, create a comfortable fit in the shoulders and along the neckline. After the steek is reinforced and cut, stitches are picked up for the butttonbands..

The fit is designed to be relaxed. This pattern is unisex except for the sleeve lengths—different increase-rate instructions give the men's version a longer sleeve.

Many knitters work more tightly in stranded colorwork than in plain stockinette stitch or ribbing; a larger needle is recommended for colorwork. Swatch in both color pattern and stockinette to determine if a larger needle is necessary.

Read all chart rows from right to left on every round.

Finished Size

33¾ (37¾, 41¼, 45¼, 49¼, 53, 57)" (85.5 [96, 105, 115, 125, 134.5, 145] cm) bust/chest circumference with 1" (2.5 cm) overlap and 26 (26¾, 27¼, 28½, 29¼, 29¾, 30½)" (66 [68, 69, 72.5, 74.5, 75.5, 77.5] cm) long.

Intended to be worn with "2–4" (5–10 cm) of positive ease for standard fit or 9–13 in (23–33) cm for oversized fit. Shown with oversized fit.

Shown in size 45¼" (115 cm).

Yarn

Worsted weight (#4 medium).

Main Color (MC): 811 (907, 993, 1089, 1185, 1270, 1366) yd (741 [829, 908, 996, 1083, 1161, 1249] m).

Contrast Color 1 (CC1): 280 (313, 343, 376, 409, 439, 472) yd (256 [286, 313, 344, 374, 401, 431] m).

Contrast Color 2 (CC2): 93 (104, 114, 125, 136, 146, 157) yd (85 [95, 104, 114, 124, 133, 143] m).

Shown here: Ístex Lettlopi (100% wool; 109 yd [100 m]/50 g skein): colors #0086 Light Beige Heather (MC), 8 (9, 10, 10, 11, 12, 13) skeins; #0005 Black Heather (CC1), 3 (3, 4, 4, 4, 5, 5) skeins; #0054 Light Ash Heather (CC2), 1 (1, 2, 2, 2, 2, 2) skein(s).

Needles

Size U.S. 6 (4 mm): 16" and 32" (40 and 80 cm) long circular (cir) and set of 4 or 5 double-pointed (dpn).

Size U.S. 8 (5 mm): 24" and 32" (60 and 80 cm) long circular (cir) and set of 4 or 5 double-pointed (dpn).

Adjust needle sizes if necessary to obtain the correct gauges.

Notions

Stitch markers (m); stitch holders; waste yarn; size C-2 (2.75 mm) crochet hook; tapestry needle; ten ⁹⁄₁₆" (14 mm) buttons.

Gauge

18 sts and 26 rows = 4" (10 cm) over St st using smaller needles.

18 sts and 24 rows = 4" (10 cm) over Color Patt using larger needles.

Ribbed Cabled Cast-On

This cast-on looks very similar to a tubular cast-on without the need for waste yarn or working any extra rows. First, make a slipknot, place it onto needle, and hold needle in left hand.

Set-up: Insert right needle tip into first stitch as if to knit, wrap yarn and draw through, then place this new loop loosely onto the left needle tip.

Step 1: With yarn in back, insert right needle tip between previous 2 stitches from front to back.

Wrap yarn knitwise and draw through. Place the new loop loosely onto the left needle tip.

Step 2: Bring yarn to front. Insert right needle tip between 2 stitches on left needle tip from back to front. Wrap yarn purlwise and draw through. Place the new loop loosely onto the left needle tip.

Repeat Steps 1–2 for Ribbed Cabled Cast-On.

Pocket linings (make 2)

With mC and shorter, smaller cir needle, CO 25 (25, 27, 27, 29, 29, 31) sts. Do not join. Beg with a WS row, work 39 (39, 41, 41, 41, 42, 42) rows in St st (knit RS rows, purl WS rows). Place sts onto holder or waste yarn.

Body

HEM

With longer, smaller cir needle and CC1, CO 152 (170, 186, 204, 222, 238, 256) using Ribbed Cable CO method (see Stitch guide). Place marker (pm) for beg of rnd and join for working in rnds, being careful not to twist sts.

Rnd 1: *K1, p1; rep from * to last 5 sts, pm, k5 (steek sts).

Rep Rnd 1 until piece measures ¾ (¾, 1, 1, 1, 1¼, 1¼)" (2 [2, 2.5, 2.5, 2.5, 3.2, 3.2] cm) from CO.

MAIN BODY

Change to mC. Work 39 (39, 41, 41, 41, 42, 42) rnds in St st (knit every rnd).

Pocket inserts

Next rnd: K5 (7, 8, 10, 12, 13, 15), BO 25 (25, 27, 27, 29, 29, 31), knit to last 35 (37, 40, 42, 46, 47, 51) sts, BO 25 (25, 27, 27, 29, 29, 31), knit to end—102 (120, 132, 150, 164, 180, 194) sts rem.

Joining rnd: *Knit to pocket gap, place held 25 (25, 27, 27, 29, 29, 31) sts for pocket on left needle tip with RS facing, knit pocket sts; rep from * once more, knit to end—152 (170, 186, 204, 222, 238, 256) sts.

Cont even until piece measures 15¼ (15½, 15¾, 16, 16¼, 16½, 16¾)" (38.5 [39.5, 40, 40.5, 41.5, 42, 42.5] cm) from CO. Set aside.

Sleeves

CUFF

With smaller dpn and CC1, CO 44 (46, 48, 48, 50, 50, 52) sts using Ribbed Cable CO method. Pm for beg of rnd, and join for working in rnds, being careful not to twist sts.

Rnd 1: *K1, p1; rep from *.

Rep Rnd 1 until piece measures ¾ (¾, 1, 1, 1, 1¼, 1¼)" (2 [2, 2.5, 2.5, 2.5, 3.2, 3.2] cm) from CO.

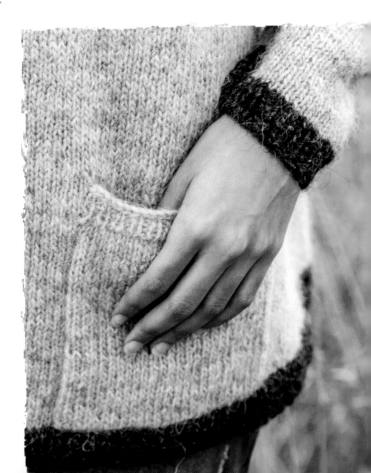

SHAPE SLEEVE

Change to MC..

Women's version

Knit 11 (7, 7, 5, 5, 3, 3) rnds.

Inc rnd: K1, m1, knit to last st, m1, k1—2 sts inc'd.

Rep Inc Rnd every 12 (8, 8, 6, 6, 4, 4) rnds 7 (2, 11, 7, 13, 8, 8) more times, then every 0 (10, 0, 8, 8, 6, 6) rnds 0 (7, 0, 6, 2, 9, 10) times—60 (66, 72, 76, 82, 86, 90) sts. Change to shorter, smaller cir needle when there are too many sts to work comfortably on dpn.

Cont even until piece measures 17 (17, 17½, 17½, 18, 18, 18¼)" (43 [43, 44.5, 44.5, 45.5, 45.5, 46.5] cm) from CO.

Men's version

Knit 11 (9, 7, 5, 5, 3, 3) rnds.

Inc rnd: K1, m1, knit to last st, m1, k1—2 sts inc'd.

Rep Inc Rnd every 12 (10, 8, 6, 6, 4, 4) rnds 3 (7, 6, 3, 8, 1, 3) more time(s), then every 14 (12, 10, 8, 8, 6, 6) rnds 4 (2, 5, 10, 7, 16, 15) times—60 (66, 72, 76, 82, 86, 90) sts. Change to shorter, smaller cir needle when there are too many sts to work comfortably on dpn.

Cont even until sleeve measures 18 (18, 18½, 18½, 19, 19, 19¼)" (45.5 [45.5, 47, 47, 48.5, 48.5, 49] cm) from CO.

Both versions

Place first 5 (5, 6, 6, 7, 8, 8) sts and last 4 (5, 5, 6, 7, 7, 8) sts onto holder for underarm and rem 51 (56, 61, 64, 68, 71, 74) sts onto waste yarn.

Yoke

JOIN BODY AND SLEEVES

Joining rnd: With longer, smaller cir needle, knit 31 (35, 39, 43, 46, 49, 53) sts for right front, place next 9 (10, 11, 12, 14, 15, 16) sts onto holder for underarm, pm, knit held 51 (56, 61, 64, 68, 71, 74) sts for first sleeve, knit 67 (75, 81, 89, 97, 105, 113) sts for back, place next 9 (10, 11, 12, 14, 15, 16) sts onto holder for underarm, knit held 51 (56, 61, 64, 68, 71, 74) sts for 2nd sleeve, pm, knit to end for left front—236 (262, 286, 308, 330, 350, 372) sts.

SHORT-ROW SHAPING SECTION 1

Short-row 1: (RS) Knit to second m (left front), sm, k6, w&t.

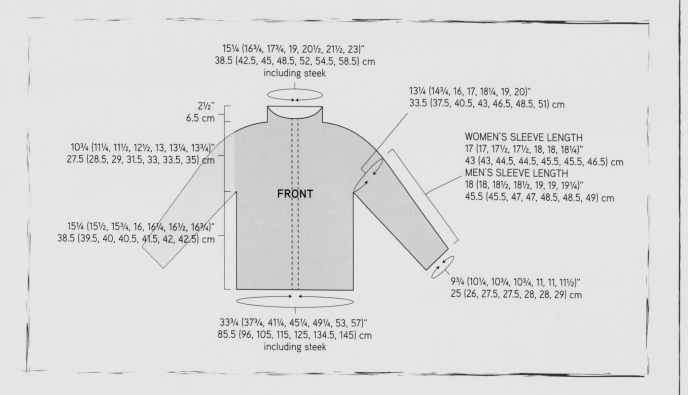

15¼ (16¾, 17¾, 19, 20½, 21½, 23)"
38.5 (42.5, 45, 48.5, 52, 54.5, 58.5) cm
including steek

2½"
6.5 cm

13¼ (14¾, 16, 17, 18¼, 19, 20)"
33.5 (37.5, 40.5, 43, 46.5, 48.5, 51) cm

10¾ (11¼, 11½, 12½, 13, 13¼, 13¾)"
27.5 (28.5, 29, 31.5, 33, 33.5, 35) cm

WOMEN'S SLEEVE LENGTH
17 (17, 17½, 17½, 18, 18, 18¼)"
43 (43, 44.5, 44.5, 45.5, 45.5, 46.5) cm
MEN'S SLEEVE LENGTH
18 (18, 18½, 18½, 19, 19, 19¼)"
45.5 (45.5, 47, 47, 48.5, 48.5, 49) cm

FRONT

15¼ (15½, 15¾, 16, 16¼, 16½, 16¾)"
38.5 (39.5, 40, 40.5, 41.5, 42, 42.5) cm

9¾ (10¼, 10¾, 10¾, 11, 11, 11½)"
25 (26, 27.5, 27.5, 28, 28, 29) cm

33¾ (37¾, 41¼, 45¼, 49¼, 53, 57)"
85.5 (96, 105, 115, 125, 134.5, 145) cm
including steek

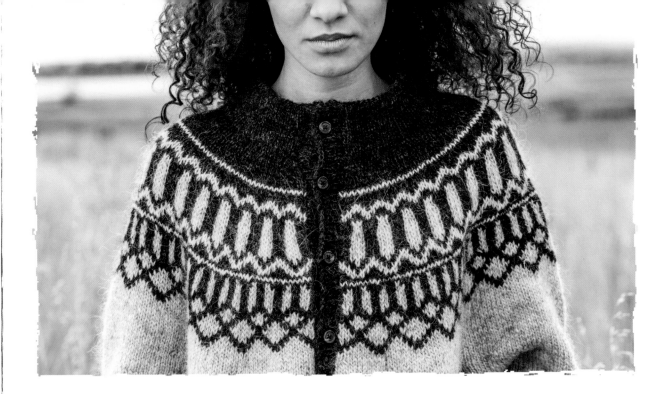

Short-row 2: (WS) (Purl to m, sm) twice, p6, w&t.

Short-row 3: Knit to 6 sts before wrapped st, w&t.

Short-row 4: Purl to 6 sts before wrapped st, w&t.

Rep Short-rows 3 and 4 once more.

Next row: (RS) Knit to end, picking up wraps and working them tog with the st they wrap. Join for working in rnds again.

Next rnd: Knit, picking up rem wraps and work them tog with the sts they wrap.

YOKE

Dec rnd: Knit and dec 6 (5, 2, 6, 1, 3, 7) st(s) evenly around, removing first 2 m as you come to them, leaving beg-of-rnd m and steek m—230 (257, 284, 302, 329, 347, 365) sts rem.

Work 2 (5, 8, 8, 11, 13, 15) rnds even in St st.

Change to longer, larger cir needle.

Color pattern

Set-up rnd: Work rnd 1 of Chart A (A, A, B, B, B, B) 9-st rep to last 14 sts, work 14 sts at left side of chart—205 (229, 253, 269, 293, 309, 325) sts rem.

Work Rnds 2–46 (46, 46, 52, 52, 52, 52) of Color Chart A (A, A, B, B, B, B)—81 (90, 99, 105, 114, 120, 126) sts

rem. Change to smaller cir needle after rnd 34 (34, 34, 37, 37, 37, 37, 37). Change to shorter, smaller cir needle if necessary when there are too few sts to work comfortably on longer cir needle.

Finish yoke

Dec rnd: With CC2 only, k4 (0, 2, 5, 2, 0, 4), [k2tog, k3 (3, 2, 2, 2, 2, 2)] 12 (5, 8, 19, 10, 23, 23) times, [k2tog, k0 (2, 1, 0, 1, 0, 0)] 0 (5, 3, 0, 3, 0, 0) times, [k2tog, k0 (3, 2, 0, 2, 0, 0)] 0 (5, 8, 0, 9, 0, 0) times, knit to end—69 (75, 80, 86, 92, 97, 103) sts rem.

SHORT-ROW SHAPING SECTION 2

Short-row 1: (RS) K53 (58, 62, 67, 72, 76, 81), w&t.

Short-row 2: (WS) P42 (46, 49, 53, 57, 60, 64), w&t.

Short-row 3: Knit to 6 sts before wrapped st, w&t.

Short-row 4: Purl to 6 sts before wrapped st, w&t.

Rep Short-rows 3 and 4 once more.

Next row: Knit to end, picking up wraps and working them tog with the sts they wrap. Join for working in rnds again.

Next rnd: Knit and pick up rem wraps and work them tog with the sts they wrap.

CHART A

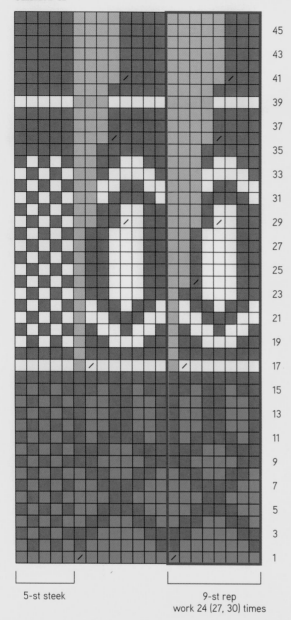

5-st steek

9-st rep
work 24 (27, 30) times

CHART B

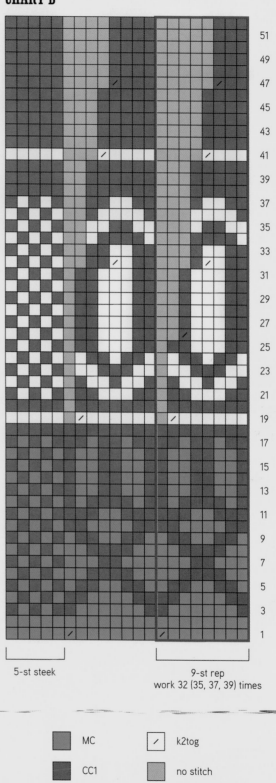

5-st steek

9-st rep
work 32 (35, 37, 39) times

■ MC		⟋ k2tog	
■ CC1		■ no stitch	
□ CC2		□ pattern repeat	

Collar

Place contrasting-color waste yarn to use as a guide for sewing down the collar by threading waste yarn through all sts on needle without removing them.

Knit 17 rnds even, ignoring waste yarn on first rnd and leaving it in place.

Turning rnd: Purl to last 5 steek sts, k5.

Knit 17 rnds.

BO all sts.

Finishing

Reinforce steek using crochet hook and sportweight yarn matching CC1. Cut center of steek.

Fold collar to inside along turning row and whipstitch to WS, using contrasting waste yarn as a guide. Remove waste yarn.

Sew pocket linings to inside using mattress st (see Techniques).

POCKET EDGING (MAKE 2)

With shorter, smaller cir needle and mC, place slipknot on needle, then with RS facing, pick up and knit 25 (25, 27, 27, 29, 29, 31) sts along BO edge of pocket, CO 1 using cable CO method (see Techniques)—27 (27, 29, 29, 31, 31, 33) sts.

Row 1: (WS) P2, (k1, p1) to last st, p1.

Row 2: K2, (p1, k1) to last st, k1.

Rep Rows 1 and 2 once more.

Purl 1 row.

BO all sts knitwise.

Sew sides of edging to front using mattress stitch.

BUTTONBAND AND BUTTONHOLE BAND

For women's version, buttonholes are worked on the right front. For men's version, buttonholes are worked on the left front.

Butttonband

With longer, smaller cir needle and CC1, with RS facing, pick up and knit 107 (109, 115, 119, 123, 125, 129) sts along front edge, being sure to pick up inside steek sts so that the steek sts will not show (one and a half stitches in from the reinforced edge and about 2 sts for every 3 rows). When picking up sts along edge of collar, insert needle tip through both layers.

Row 1: (WS) P2, (k1, p1) to last st, p1.

Row 2: (RS) K2, (p1, k1) to last st, k1.

Rep Rows 1 and 2 twice more.

Next Row: (WS) Purl.

BO all sts knitwise.

Buttonhole band

Pick up 107 (109, 115, 119, 123, 125, 129) sts along rem front edge and work 3 rows same as as for buttonband.

Buttonhole row: (RS) Work 3 (5, 2, 4, 6, 3, 4) sts in est ribbing patt, *bring yarn to front, sl 1, bring yarn to back, (sl 1, psso) twice; turn work and cable CO 3 sts, turn work and bring yarn to back, sl 1 and pass third CO st over slipped st*, work in patt until there are 8 (8, 9, 9, 9, 10, 10) sts past buttonhole; rep from * 8 more times, work from * to * once more for last buttonhole, then work in patt to end.

Next row: (WS) P2, (k1, p1) to last st, p1.

Next row: K2, (p1, k1) to last st, k1.

Next row: Purl.

BO all sts knitwise.

Tack doubled collar edging to inside of button and buttonhole bands

Option: Using CC1, whipstitch around edgings for a neater look. This will add a bit of bulk to the collar. Fold reinforced edge of rem front edges.

Join underarms using three-needle bind-off (see Techniques) on WS.

Weave in ends. Block to measurements.

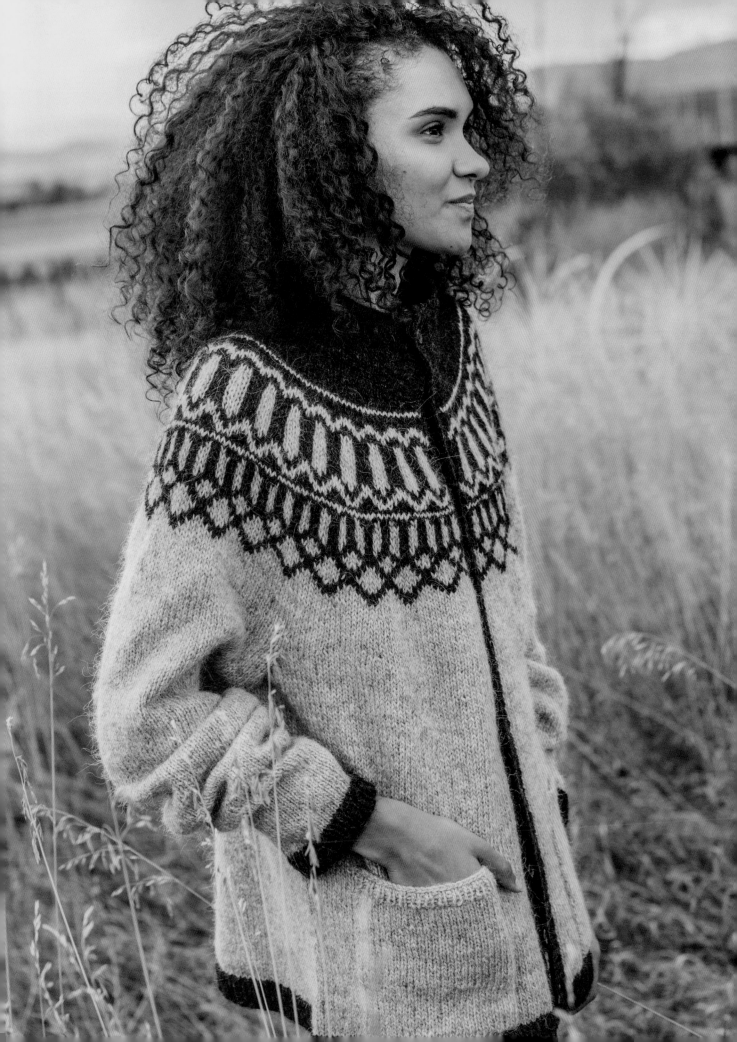

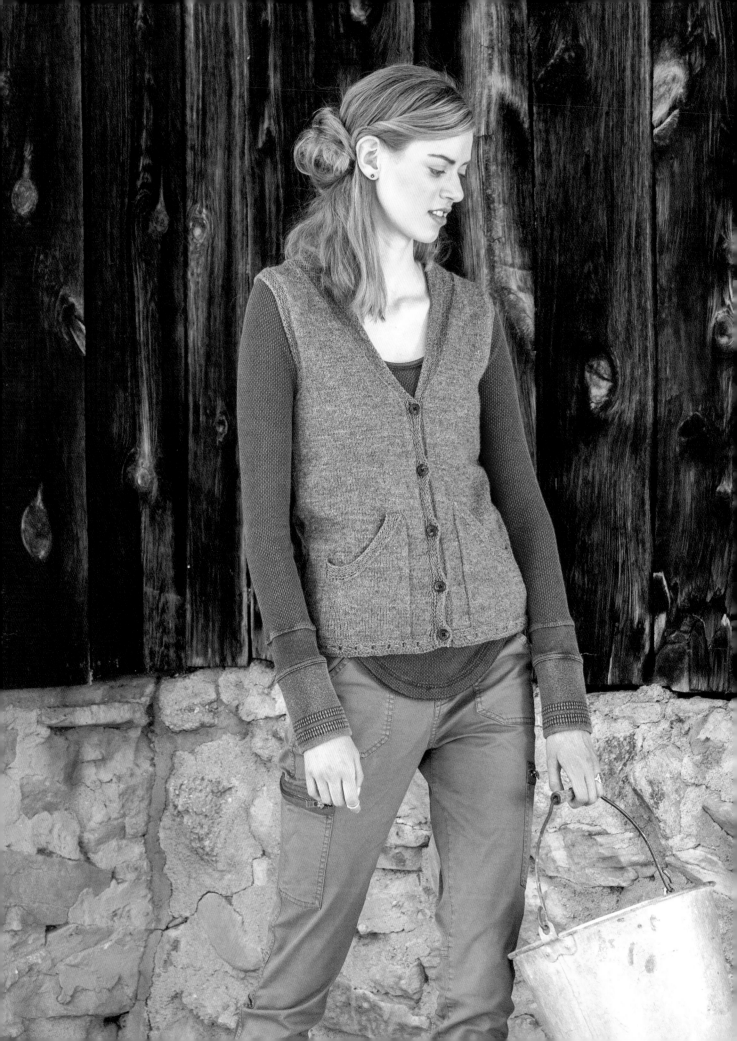

WHEAT CREEK

VEST

Created with serious outdoor activities in mind, this slim vest is the perfect extra layer to keep you toasty without getting in your way while you head out for your morning chores, ride your bike to work, or walk the dog. Practical diagonal pockets, a slim, jaunty shawl collar, and a sweet, subtle hem detail all make a functional and beautiful garment. It's worked in pieces and then seamed for solid, long-lasting structure.

Finished Size

31¾ (35, 38, 41½, 46, 48½)" (80.5 [89, 96.5, 105.5, 117, 123] cm) bust circumference, with ½ (½, ½,¾,¾, 1)" (1.3 [1.3, 1.3, 2, 2, 2.5] cm) overlap and 23 (23½, 24, 24¼, 24¼, 24½)" (58.5 [59.5, 61, 61.5, 61.5, 62] cm) long.

Shown in size 35" (89 cm).

Intended to be worn with 0–2" (0–5 cm) of positive ease.

Yarn

900 (996, 1096, 1193, 1317, 1389) yd (823 [911, 1002, 1091, 1204, 1270] m) Sportweight (#2 Fine).

Shown here: Sincere Sheep Equity Sport (100% wool; 200 yd [183 m]/2 oz [56 g]): color Dark Gray, 5 (5, 6, 6, 7, 7) skeins.

Needles

Size U.S. 2 (2.75 mm): 16" and 60" (40 and 150 cm) long circular (cir) needle.

Size U.S. 4 (3.5 mm) needles.

Adjust needle sizes if necessary to obtain the correct gauge.

Notions

Size U.S. C-2 (2.75 mm) crochet hook; markers (m); stitch holders; waste yarn; tapestry needle; five ⅝" (15 mm) buttons.

Gauge

24½ sts and 40 rows = 4" (10 cm) over St st using larger needle.

Notes

Vest is worked in pieces, beginning with a provisional cast -on. After you complete the pieces and join the shoulders, you pick up and work the front bands and shawl collar.

Crossover Stitch Pattern

(multiple of 5 sts + 2)

Row 1: (WS) P1, *p1 wrapping yarn around needle 3 times; rep from * to last st, p1.

Row 2: (RS) K1, *sl next 5 sts to right needle tip dropping extra wraps, sl 5 elongated sts back to left needle tip, [k5tog tbl, leaving all sts on LH needle, p5tog tbl, leaving all sts on LH needle] twice, k5tog tbl, sl all 5 sts from LH needle; rep from * to last st, k1.

Right front

HEM

With crochet hook, shorter, smaller cir needle, and waste yarn, use crochet provisional cast-on (see Techniques) to CO 47 (52, 57, 62, 67, 72) sts. Do not join. Cut waste yarn and join main yarn. Beg with a WS row and work 10 rows in St st (knit RS rows, purl WS rows).

Next (turning) row: (WS) Knit.

Decorative hem

Row 1: (RS) Knit.

Rows 2 and 3: Purl.

Rows 4 and 5: Work Crossover Stitch Patt.

Rows 6 and 7: Knit.

Rows 8 and 9: Purl.

Join hem

Carefully remove provisional CO and place sts onto larger needle. Turn hem along turning ridge so wrong sides are tog and larger needle is in front and smaller needle is in back.

Joining row: (WS) Using larger needle, *insert right needle tip pwise into first st on both needles, purl sts tog; rep from * to end—47 (52, 57, 62, 67, 72) sts.

SHAPE WAIST

Work 20 rows in St st.

Next (dec) row: (RS) Knit to last 3 sts, k2tog, k1—1 st dec'd.

Rep Dec Row every 20 rows once more, then every 18 rows twice—43 (48, 53, 58, 63, 68) sts rem.

SHAPE BUST

Work 11 rows even.

Next (inc) row: (RS) Knit to last st, m1, k1—1 st inc'd.

Rep Inc Row every 12 rows 3 more times—47 (52, 57, 62, 67, 72) sts.

Work even until piece measures 15" (38 cm) from bottom edge, ending with a RS row.

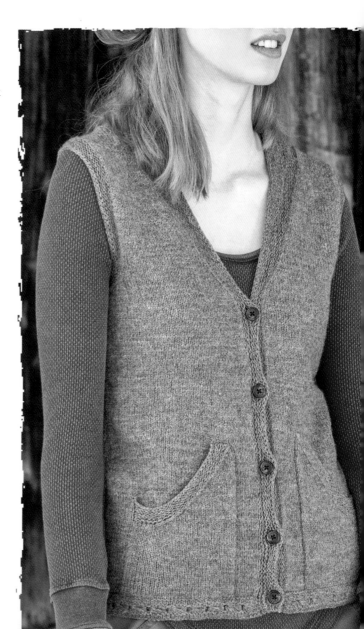

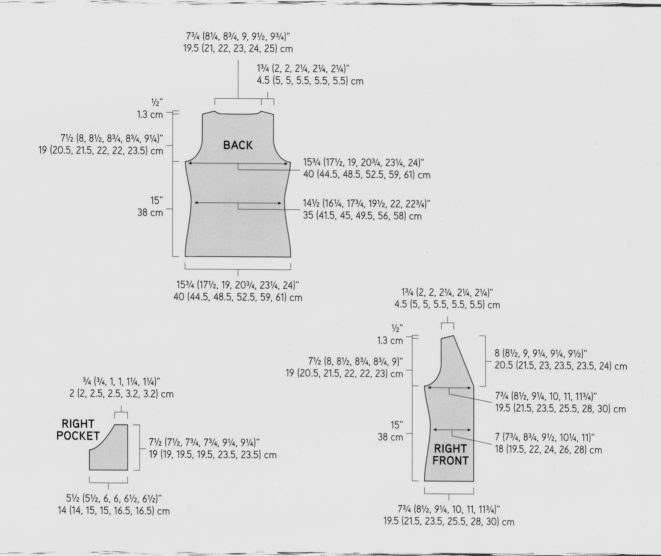

7¾ (8¼, 8¾, 9, 9½, 9¾)"
19.5 (21, 22, 23, 24, 25) cm

1¾ (2, 2, 2¼, 2¼, 2¼)"
4.5 (5, 5, 5.5, 5.5, 5.5) cm

½"
1.3 cm

7½ (8, 8½, 8¾, 8¾, 9¼)"
19 (20.5, 21.5, 22, 22, 23.5) cm

BACK

15¾ (17½, 19, 20¾, 23¼, 24)"
40 (44.5, 48.5, 52.5, 59, 61) cm

14½ (16¼, 17¾, 19½, 22, 22¾)"
35 (41.5, 45, 49.5, 56, 58) cm

15"
38 cm

15¾ (17½, 19, 20¾, 23¼, 24)"
40 (44.5, 48.5, 52.5, 59, 61) cm

1¾ (2, 2, 2¼, 2¼, 2¼)"
4.5 (5, 5, 5.5, 5.5, 5.5) cm

½"
1.3 cm

8 (8½, 9, 9¼, 9¼, 9½)"
20.5 (21.5, 23, 23.5, 23.5, 24) cm

7½ (8, 8½, 8¾, 8¾, 9)"
19 (20.5, 21.5, 22, 22, 23) cm

7¾ (8½, 9¼, 10, 11, 11¾)"
19.5 (21.5, 23.5, 25.5, 28, 30) cm

¾ (¾, 1, 1, 1¼, 1¼)"
2 (2, 2.5, 2.5, 3.2, 3.2) cm

15"
38 cm

7 (7¾, 8¾, 9½, 10¼, 11)"
18 (19.5, 22, 24, 26, 28) cm

RIGHT
POCKET

RIGHT
FRONT

7½ (7½, 7¾, 7¾, 9¼, 9¼)"
19 (19, 19.5, 19.5, 23.5, 23.5) cm

5½ (5½, 6, 6, 6½, 6½)"
14 (14, 15, 15, 16.5, 16.5) cm

7¾ (8½, 9¼, 10, 11, 11¾)"
19.5 (21.5, 23.5, 25.5, 28, 30) cm

SHAPE ARMHOLE AND NECK

Note: Both armhole and neckline shaping are worked at the same time. Read instructions carefully before proceeding.

BO at beg of WS rows 6 (6, 6, 8, 8, 8) sts once, then 0 (0, 0, 4, 5, 6) sts 0 (0, 0, 1, 1, 1) time—41 (46, 51, 50, 54, 58) sts rem.

Dec Row 1: (RS) K1, ssk, knit to last 3 sts, k2tog, k1—2 sts dec'd; 1 st at armhole and 1 st at neck.

Dec Row 2: P1, ssp, purl to end—1 st dec'd at armhole.

Cont dec 1 st at neck edge every RS row 4 (6, 5, 6, 4, 8) more times, then every 4 rows 17 (17, 19, 19, 20, 19)

times. *At the same time,* cont dec 1 st at armhole every row 2 (4, 8, 6, 10, 10) more times, then every RS row 4 (4, 4, 3, 4, 4) times—11 (12, 12, 13, 13, 14) sts rem.

When armhole measures 7¼ (7¾, 8¼, 8½, 8½, 9)" (18.5 [19.5, 21, 21.5, 21.5, 23] cm), ending with a WS row.

SHAPE SHOULDER

Short-row 1: Knit to last 4 (4, 4, 5, 5, 5) sts, w&t (see Techniques).

Short-rows 2 and 4: Purl to end.

Short-row 3: Knit to 4 (4, 4, 4, 4, 5) sts before wrapped st, w&t.

CROSSOVER STITCH PATTERN

| | k on RS, p on WS |
| | purl, wrapping yarn around needle 3 times |

sl 5 sts to RH needle dropping extra wraps, return sts to LH needle, [(k5tog tbl, p5tog tbl) twice, k5tog tlb] in these 5 sts, sl sts from LH needle

pattern repeat

end 3-st rep beg

Next row: Knit to end, picking up wraps and knitting them tog with the sts they wrap.

Next row: Purl.

Place rem sts onto holder or waste yarn.

Left front

HEM
Work hem same as for right front.

SHAPE WAIST
Work 20 rows in St st.

Next (dec) row: (RS) K1, ssk, knit to end—1 st dec'd.

Rep Dec Row every 20 rows once more, then every 18 rows twice—43 (48, 53, 58, 63, 68) sts rem.

SHAPE BUST
Work 11 rows even.

Next (inc) row: (RS) K1, m1, knit to end—1 st inc'd.

Rep Inc Row every 12 rows 3 more times—47 (52, 57, 62, 67, 72) sts.

Cont even until piece measures 15" (38 cm) from bottom edge, ending with a WS row.

SHAPE ARMHOLE AND NECK
Note: Both armhole and neck shaping are worked at the same time. Read instructions carefully before proceeding.

BO at beg of RS rows 6 (6, 6, 8, 8, 8) sts once, then 0 (0, 0, 4, 5, 6) 0 (0, 0, 1, 1, 1) time—41 (46, 51, 50, 54, 58) sts rem.

Purl 1 WS row.

Dec Row 1: (RS) K1, ssk, knit to last 3 sts, k2tog, k1—2 sts dec'd; 1 st at armhole, and 1 st at neck.

Dec Row 2: Purl to last 3 sts, p2tog, p1—1 st dec'd at armhole.

Cont dec 1 st at neck edge every RS row 4 (6, 5, 6, 4, 8) more times, then every 4 rows 17 (17, 19, 19, 20, 19) times. *At the same time,* cont dec 1 st at armhole every row 2 (4, 8, 6, 10, 10) more times, then every RS row 4 (4, 4, 3, 4, 4) times—11 (12, 12, 13, 13, 14) sts rem.

When armhole measures 7¼ (7¾, 8¼, 8½, 8½, 8¾)" (18.5 [19.5, 21, 21.5, 21.5, 22] cm), ending with a RS row. *Note:* Last neck decrease row will be worked on the second short-row of shoulder shaping.

SHAPE SHOULDER USING SHORT-ROWS
Short-row 1: (WS) Purl to last 4 (4, 4, 5, 5, 5) sts, w&t.

Short-rows 2 and 4: Work to end.

Short-row 3: Purl to 4 (4, 4, 4, 4, 5) sts before wrapped st, w&t.

Next row: Purl to end, picking up wraps and purling them tog with the sts they wrap.

Next row: Knit.

Place rem sts onto holder or waste yarn.

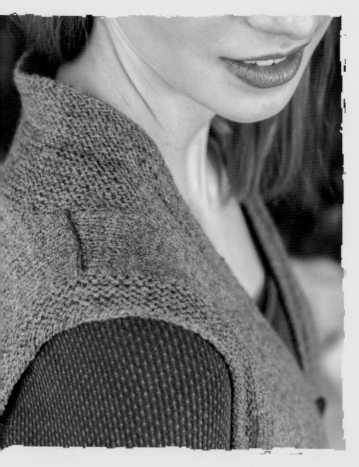

SHAPE BUST

Work 11 rows even.

Next (inc) row: (RS) Knit to m, sm, m1, knit to m, m1, sm, knit to end—2 sts inc'd.

Rep Inc Row every 12 rows 3 more times—97 (107, 117, 127, 142, 147) sts.

Work even until piece measures 15" (38 cm), removing m on first row, ending with a WS row.

SHAPE ARMHOLES

BO 6 (6, 6, 8, 8, 8) sts at beg of next 2 rows, then 0 (0, 0, 4, 5, 6) sts at beg of next 0 (0, 0, 2, 2, 2) rows—85 (95, 105, 103, 116, 119) sts rem.

Dec Row 1: (RS) K1, ssk, knit to last 3 sts, k2tog, k1—2 sts dec'd.

Dec Row 2: P1, ssp, purl to last 3 sts, p2tog, p1—2 sts dec'd.

Cont dec every row 2 (4, 8, 6, 10, 10) more times, then every RS row 4 (4, 4, 3, 4, 4) times—69 (75, 77, 81, 84, 87) sts rem.

Cont even until armhole measures 7½ (8, 8½, 8¾, 8¾, 9)" (19 [20.5, 21.5, 22, 22, 24] cm), ending with a WS row.

SHAPE NECK AND SHOULDERS

Mark center 41 (45, 47, 49, 52, 53) sts for neck.

Next row: (RS) K14 (15, 15, 16, 16, 17), BO marked sts for neck, knit to end—14 (15, 15, 16, 16, 17) sts rem for each shoulder. Place sts for right shoulder onto holder or waste yarn.

Shape left shoulder using short-rows

Purl 1 WS row.

Short-row 1: (RS) K1, ssk, knit to last 4 (4, 4, 5, 5, 5) sts, w&t—1 st dec'd.

Short-rows 2 and 4: Purl to end.

Short-row 3: K1, ssk, knit to 4 (4, 4, 4, 4, 5) sts before wrapped st, w&t—1 st dec'd.

Next row: (RS) K1, ssk, knit to end, picking up wraps and working them tog with the sts they wrap—11 (12, 12, 13, 13, 14) sts rem. Place rem sts onto holder or waste yarn.

Back

HEM

With crochet hook, shorter, smaller cir needle, and waste yarn, use crochet provisional cast-on to CO 97 (107, 117, 127, 142, 147) sts. Do not join.

Work hem same as for fronts.

SHAPE WAIST

Work 19 rows in St st.

Set-up row: (WS) P26 (28, 30, 32, 36, 38), place marker (pm), p45 (51, 57, 63, 70, 71), pm, knit to end.

Next (dec) row: (RS) Knit to m, sm, ssk, knit to 2 sts before m, k2tog, sm, knit to end—2 sts dec'd.

Rep Dec Row every 20 rows once more, then every 18 rows twice—89 (99, 109, 119, 134, 139) sts rem.

Shape right shoulder using short-rows

Return held 14 (15, 15, 16, 16, 17) sts for right shoulder onto larger needle. With RS facing, join yarn at armhole.

Knit 1 RS row.

Short-row 1: (WS) P1, p2tog, purl to last 4 (4, 4, 5, 5, 5) sts, w&t—1 st dec'd.

Short-rows 2 and 4: Knit to end.

Short-row 3: P1, p2tog, purl to 4 (4, 4, 4, 4, 5) sts before wrapped st, w&t—1 st dec'd.

Next row: (WS) P1, p2tog, purl to end, picking up wraps and working them tog with the sts they wrap—11 (12, 12, 13, 13, 14) sts rem. Place rem sts onto holder or waste yarn.

Pockets

LEFT POCKET

With larger needle, CO 34 (34, 36, 36, 40, 40) sts.

Beg with a WS row, work in St st until piece measures 3" (7.5 cm) from beg, ending with a WS row.

Shape pocket

Next row: (RS) BO 6 sts, knit to end—28 (28, 30, 30, 34, 34) sts rem.

SIZES 31¾ (35, 38, 41½)" (80.5 [89, 96.5, 105.5] CM) ONLY:
Dec Row 1: (WS) Purl to last 3 sts, ssp, k1—1 st dec'd.

Dec Row 2: K1, ssk, knit to end—1 st dec'd.

Rep last 2 rows twice more— 22 (22, 24, 24) sts rem.

ALL SIZES:
Next (dec) row: (WS) Purl to last 3 sts, ssp, p1—1 st dec'd.

Rep Dec Row every WS row 18 (18, 20, 20, 30, 30) more times—3 sts rem. End with a RS row. Cut yarn, leaving a 6" (15 cm) tail, draw tail through rem 3 sts, pull tight to fasten off.

Pocket edging

With shorter, smaller cir needle and RS facing, pick up and knit 1 st in each BO st along BO edge, and 1 st for every 2 rows along shaped edge.

Knit 9 (9, 11, 11, 13, 13) rows. BO all sts kwise.

RIGHT POCKET

With larger needle, CO 34 (34, 36, 36, 40, 40) sts.

Beg with a RS row and work in St st until piece measures 3" (7.5 cm) from beg, ending with a RS row.

Shape pocket

Next row: (WS) BO 6 sts, purl to end—28 (28, 30, 30, 34, 34) sts rem.

SIZES 31¾ (35, 38, 41½)" (80.5 [89, 96.5, 105.5] CM) ONLY:
Dec Row 1: (RS) Knit to last 3 sts, k2tog, k1—1 st dec'd.

Dec Row 2: P1, p2tog, purl to end—1 st dec'd.

Rep last 2 rows twice more—22 (22, 24, 24) sts rem.

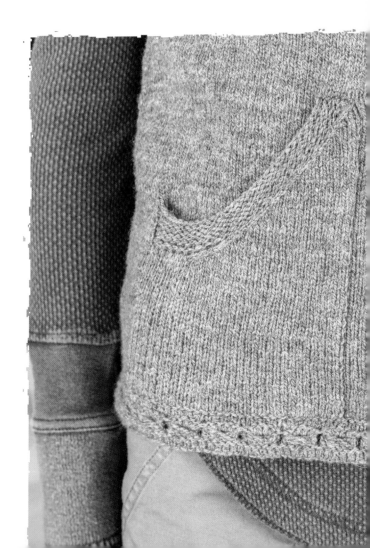

ALL SIZES:

Next (dec) row: (RS) Knit to last 3 sts, k2tog, k1—1 st dec'd.

Rep Dec Row every RS row 18 (18, 20, 20, 30, 30) times—3 sts rem. End with a WS row. Cut yarn, leaving a 6" (15 cm) tail, draw tail through rem 3 sts, pull tight to fasten off.

Pocket edging

With shorter, smaller cir needle and RS facing, pick up and knit 1 st for every 2 rows along shaped edge, and 1 st in each BO st along BO edge.

Knit 9 (9, 11, 11, 13, 13) rows. BO all sts kwise.

Finishing

Weave in all ends. Wet -block pieces, pinning to measurements (see Techniques). Allow to dry completely.

Join shoulders using three-needle bind-off (see Techniques). Sew side seams using mattress stitch (see Techniques).

ARMHOLE EDGINGS

With shorter, smaller cir needle and RS facing, beg at center of armhole BO, pick up and knit 1 st for every BO st and 1 st for every 2 rows around armhole. Pm for beg of rnd and join for working in rnds.

Work 10 (10, 12, 12, 14, 14) rnds in garter st (purl 1 rnd, knit 1 rnd). BO alls sts loosely in patt.

FRONT BANDS AND SHAWL COLLAR

With longer, smaller cir needle and RS facing, pick up and knit 73 sts from bottom edge of right front to beg of neck shaping, pm (marker 1), pick up and knit 45 (48, 51, 51, 54, 54) sts along shaped right front neck edge, 4 sts along shaped right back neck edge, pm (marker 2), 41 (45, 47, 49, 50, 53) sts along back neck edge, pm (marker 3), 4 sts along shaped left back neck edge, 45 (48, 51, 51, 54, 54) sts along shaped left front neck edge, pm (marker 4), then 73 (73, 72, 72, 73, 72) sts along left front edge to bottom edge—285 (295, 302, 304, 312, 314) sts.

Shape collar

Short-row 1: (WS) Knit to marker 2 at right back neck, sm, w&t.

Short-row 2: (RS) Sm, knit to marker 3 at left back neck, sm, w&t.

Short-row 3: Sm, knit to marker, sm, pick up wrap and knit tog with the st it wraps, k2, w&t.

Short-row 4: [Knit to marker, sm] twice, pick up wrap and knit tog with the st it wraps, k2, w&t.

Short-row 5: [Knit to marker, sm] twice, knit to wrapped st, pick up wrap and knit tog with the st it wraps, k2, w&t.

Rep Short Row 5 until all sts between m1 and m4 have been worked.

Next 2 rows: Knit to end, picking up rem wrap and knitting it tog with the st it wraps.

Knit 3 (3, 5, 5, 7, 7) rows over all sts.

Next (buttonhole) row: (RS) K3, *work one-row buttonhole (see page 40) over next 4 sts, knit until there are 12 sts past buttonhole; rep from * 3 more times, work one-row buttonhole over next 4 sts, knit to end.

Knit 3 (3, 3,5, 5, 7) rows. BO all sts loosely kwise.

SEW POCKETS TO FRONTS

Count 8 sts from front-band pick-up row and sew CO edge of pocket to front directly above hem using mattress st. Sew long straight edge, top of pocket (along side of garter edging) to front, then short side edge to front.

Sew buttons to butttonband opposite buttonholes.

Sew side edges of hems tog using mattress st.

Weave in rem ends. Block again if necessary.

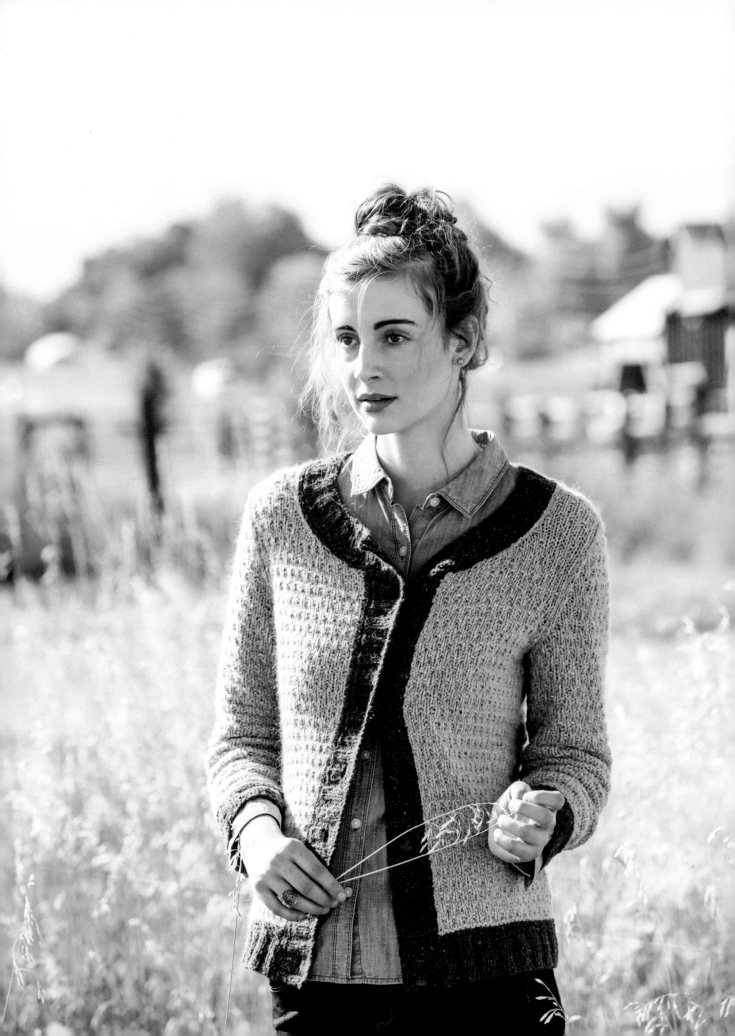

ELDERBERRY ROAD
CARDIGAN

This classic cardigan will be a timeless addition to your wardrobe. Color blocking adds visual interest to a highly textured fabric. Small details such as a shaped neckband and garter-stitch ridges between the edges and the main body of the sweater make this piece particularly special. Set-in sleeves and waist shaping contribute to the fitted silhouette.

Notes

Cardigan is worked from the bottom up. The body is worked first, dividing for the fronts and back at the armholes, and shoulders are joined using mattress-stitch seams. Then the sleeves are worked in the round to the underarms. Sleeve caps are worked back and forth in rows and are sewn to the body using mattress-stitch seams. Neckband and cardigan front bands are picked up and worked after the pieces are joined.

Finished Size

32¾ (36¾, 40¾, 44¾, 48¾ 53¾)" (83 [93.5, 103.5, 113.5, 124, 136.5] cm) bust circumference with 2 (2, 2¼, 2¼, 2¾, 2¾)" (5 [5, 5.5, 5.5, 7, 7] cm) overlap and 23¾ (24, 24¾, 25¼, 26¼, 26¾)" (60.5 [61, 63, 64, 66.5, 68] cm) long.

Intended to be worn with 1–3" (2.5–7.5 cm) of positive ease.

Shown in size 36¾" (93.5 cm).

Yarn

Worsted weight (#4 medium).

Main Color (MC): 702 (790, 876, 964, 1,053, 1,162) yd (642 [722, 801, 881, 963, 1,062] m).

Contrast Color (CC): 234 (262, 291, 322, 351, 387) yd (214 [239, 266, 294, 321, 354] m).

Shown here: Berroco Blackstone Tweed (65% wool, 25% mohair, 10% angora; 130 yd [119 m]/50 g skein): colors #2601 Clover Honey (MC), 6 (7, 7, 8, 8, 9) balls; #2646 Saltwater (CC), 2 (3, 3, 3, 3, 3) balls.

Needles

Size U.S. 6 (4 mm): 32" (80 cm) circular (cir) and set of 4 or 5 double-pointed (dpn).

Size U.S. 5 (3.75 mm): 32" (80 cm) circular (cir).

Size U.S. 4 (3.5 mm): 32" (80 cm) circular (cir).

Adjust needle sizes if necessary to obtain the correct gauge.

Notions

Markers (m); stitch holders or waste yarn; tapestry needle; eight ¾" (20 mm) buttons.

Gauge

16½ sts and 28 rows = 4" (10 cm) over Textured patt using size U.S. 7 (4.5 mm) needles.

Textured Pattern

Worked in the round

(multiple of 2 sts + 1)

Rnds 1 and 2: Knit.

Rnds 3 and 4: K1, *k1, p1; rep from *.

Rnds 5 and 6: Rep Rnds 1 and 2.

Rnds 7 and 8: K1, *p1, k1; rep from *.

Rep Rnds 1–8 for patt.

Worked back and forth

Row 1: (RS) Knit.

Row 2: (WS) Purl.

Row 3: K1, *k1, p1; rep from * to last st, k1.

Row 4: Knit the knit sts and purl the purl sts of the previous row.

Rows 5 and 6: Rep Rows 1 and 2.

Row 7: K1, *p1, k1; rep from * to last st, k1.

Row 8: Knit the knit sts and purl the purl sts of the previous row.

Rep Rows 1–8 for patt.

Lower body

With largest cir needle and CC, CO 128 (144, 160, 176, 192, 212) sts. Do not join.

HEM

Row 1: (WS) P1, *p2, k2; rep from * to last 3 sts, p3.

Row 2: (RS) K1, *k2, p2; rep from * to last 3 sts, k3.

Rep last 2 rows until piece measures 2 (2, 2¼, 2¼, 2½, 2½)" (5 [5, 5.5, 5.5, 6.5, 6.5] cm) from beg, ending with a RS row.

Knit 4 rows.

Change to mC.

Set-up row: (WS) K31 (35, 39, 43, 47, 52), place marker (pm) for left side, k32 (36, 40, 44, 48, 53), k2tog, k32 (36, 40, 44, 48, 53), pm for right side, knit to end—127 (143, 159, 175, 191, 211) sts rem; 31 (35,

39, 43, 47, 52) sts for each front, and 65 (73, 81, 89, 97, 107) sts for back.

MAIN BODY SECTION

Row 1: (RS) *K1, work Row 1 of Textured patt to m, sm; rep from * once more, work Row 1 of Textured patt to last st, k1.

Row 2: *P1, work Row 2 of Textured patt to m, sm; rep from * once more, work Row 2 of Textured patt to last st, p1.

Cont in established patt until piece measures 6¼ (6¼, 6½, 6½, 6¾, 6¾)" (16 [16, 16.5, 16.5, 17, 17] cm) from beg, ending with a WS row.

Shape waist

Dec row: (RS) *Work in established patt to 2 sts before m, k2tog, sm, k1, ssk; rep from * once more, work to end—4 sts dec'd.

Work 25 rows even.

Rep Dec Row—119 (135, 151, 167, 183, 203) sts rem; 29 (33, 37, 41, 45, 50) sts for each front, and 61 (69, 77, 85, 93, 103) for back.

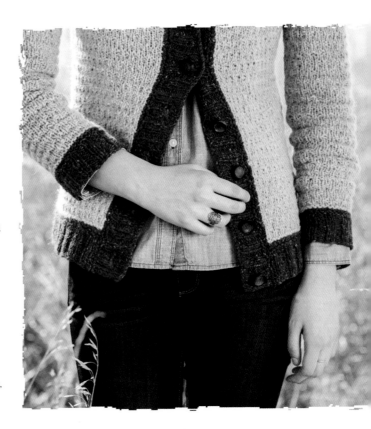

Shape bust

Work 14 rows even.

Inc Row: (RS) *K1, work in pattern to m, m1, sm, k1, m1; rep from * once more, work to end—4 sts inc'd.

Work 13 rows even.

Rep Inc Row—127 (143, 159, 175, 191, 211) sts; 31 (35, 39, 43, 47, 52) for each front, and 65 (73, 81, 89, 97, 107) for back.

Cont even until piece measures about 15¼ (15¼, 15½, 15¾, 16, 16¼)" (38.5 [38.5, 39.5, 40, 40.5, 41.5] cm) from beg, ending with a WS row.

Upper body

DIVIDE FRONTS AND BACK

Next row: (RS) Work in established patt to 3 (4, 5, 6, 7, 7) sts before m, BO next 7 (9, 11, 12, 14, 15) sts for armhole, removing m, work in pattern to 4 (5, 6, 6, 7, 8) sts before m, BO next 7 (9, 11, 12, 14, 15) sts for armhole, removing m, then work to end—28 (31, 34, 37, 40,

45) sts rem for each front, and 57 (63, 69, 77, 83, 91) sts rem for back. Place sts for right front and back onto holders or waste yarn.

LEFT FRONT
Shape armhole
SIZES 44¾ (48¾, 53¾)" (113.5 [124, 136.5] CM) ONLY:
Dec Row 1: (WS) Work in established patt to last 3 sts, ssp, p1—1 st dec'd.

Dec Row 2: (RS) K1, ssk, work to end—1 st dec'd.

Rep last 2 rows 1 (2, 3) more time(s), ending with a RS row—33 (34, 37) sts rem.

ALL SIZES:
Work 1 WS row even.

Dec row: (RS) K1, ssk, work to end—1 st dec'd.

Rep Dec Row every RS row 2 (3, 5, 4, 5, 5) more times—25 (27, 28, 28, 28, 31) sts rem.

Cont even until armhole measures about 3 (3¼, 3½, 3½, 3¾, 4)" (7.5 [8.5, 9, 9, 9.5, 10] cm), ending with a RS row.

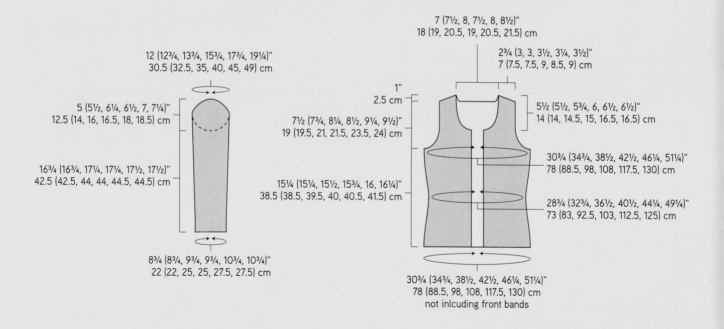

12 (12¾, 13¾, 15¾, 17¾, 19¼)"
30.5 (32.5, 35, 40, 45, 49) cm

5 (5½, 6¼, 6½, 7, 7¼)"
12.5 (14, 16, 16.5, 18, 18.5) cm

16¾ (16¾, 17¼, 17¼, 17½, 17½)"
42.5 (42.5, 44, 44, 44.5, 44.5) cm

8¾ (8¾, 9¾, 9¾, 10¾, 10¾)"
22 (22, 25, 25, 27.5, 27.5) cm

1"
2.5 cm

7½ (7¾, 8¼, 8½, 9¼, 9½)"
19 (19.5, 21, 21.5, 23.5, 24) cm

15¼ (15¼, 15½, 15¾, 16, 16¼)"
38.5 (38.5, 39.5, 40, 40.5, 41.5) cm

7 (7½, 8, 7½, 8, 8½)"
18 (19, 20.5, 19, 20.5, 21.5) cm

2¾ (3, 3, 3½, 3¼, 3½)"
7 (7.5, 7.5, 9, 8.5, 9) cm

5½ (5½, 5¾, 6, 6½, 6½)"
14 (14, 14.5, 15, 16.5, 16.5) cm

30¾ (34¾, 38½, 42½, 46¼, 51¼)"
78 (88.5, 98, 108, 117.5, 130) cm

28¾ (32¾, 36½, 40½, 44¼, 49¼)"
73 (83, 92.5, 103, 112.5, 125) cm

30¾ (34¾, 38½, 42½, 46¼, 51¼)"
78 (88.5, 98, 108, 117.5, 130) cm
not inlcuding front bands

Shape neck

BO at beg of WS rows 4 sts once, 3 sts once, then 2 sts once—16 (18, 19, 19, 19, 22) sts rem.

Dec Row 1: (RS) Work in established patt to last 3 sts, k2tog, k1—1 st dec'd.

Dec Row 2: (WS) P1, p2tog, work to end—1 st dec'd.

Rep last 2 rows 0 (1, 1, 0, 1, 1) more time(s), then rep Dec Row 1 every RS row 3 (2, 3, 3, 2, 4) more times—11 (12, 12, 14, 13, 14) sts rem.

Cont even until armhole measures 7½ (7¾, 8¼, 8½, 9¼, 9½)" (19 [19.5, 21, 21.5, 23.5, 24] cm), ending with a WS row.

Shape shoulder

BO at beg of RS rows 3 sts 3 (4, 4, 2, 3, 2) times, then 2 (0, 0, 4, 4, 4) sts 1 (0, 0, 2, 1, 2) time(s).

RIGHT FRONT

Return held 28 (31, 34, 37, 40, 45) sts for right front to largest cir needle. With WS facing, join mC at armhole.

Shape armhole

SIZES 44¾ (48¾, 53¾)" (113.5 [124, 136.5] CM) ONLY:

Dec Row 1: (WS) P1, p2tog, work in established patt to end—1 st dec'd.

Dec Row 2: (RS) Work in established patt to last 3 sts, k2tog, k1—1 st dec'd.

Rep last 2 rows 1 (2, 3) more time(s), ending with a RS row—33 (34, 37) sts rem.

All Sizes:

Work 1 WS row even.

Dec row: (RS) Work in established patt to last 3 sts, k2tog, k1—1 st dec'd.

Rep Dec Row every RS row 2 (3, 5, 4, 5, 5) more times—25 (27, 28, 28, 28, 31) sts rem.

Cont even until armhole measures about 3 (3¼, 3½, 3½, 3¾, 4)" (7.5 [8.5, 9, 9, 9.5, 10] cm), ending with a WS row.

Shape neck

BO at beg of RS rows 4 sts once, 3 sts once, then 2 sts once—16 (18, 19, 19, 19, 22) sts rem.

CROSSOVER STITCH PATTERN

end 2-st beg
repeat

Note: When working in the round, read all chart rows from right to left. When working back and forth, read RS rows from right to left and WS rows from left to right.

☐ k on RS, p on WS

• p on RS, k on WS

☐ pattern repeat

Dec Row 1: (WS) Work in established patt to last 3 sts, ssp, p1—1 st dec'd.

Dec Row 2: (RS) K1, ssk, work to end—1 st dec'd.

Rep last 2 rows 0 (1, 1, 0, 1, 1) more time(s), then rep Dec Row 2 every RS row 3 (2, 3, 3, 2, 4) more times—11 (12, 12, 14, 13, 14) sts rem.

Cont even until armhole measures 7½ (7¾, 8¼, 8½, 9¼, 9½)" (19 [19.5, 21, 21.5, 23.5, 24] cm), ending with a RS row.

Shape shoulder

BO at beg of WS rows 3 sts 3 (4, 4, 2, 3, 2) times, then 2 (0, 0, 4, 4, 4) sts 1 (0, 0, 2, 1, 2) time(s).

BACK

Return held 57 (63, 69, 77, 83, 91) sts to largest cir needle. With WS facing, join yarn at armhole edge.

Shape armholes

SIZES 44¾ (48¾, 53¾)" (113.5 [124, 136.5] CM) ONLY:

Dec Row 1: (WS) P1, p2tog, work in established patt to last 3 sts, ssp, p1—2 sts dec'd.

Dec Row 2: (RS) K1, ssk, work in established patt to last 3 sts, k2tog, k1—2 sts dec'd.

Rep last 2 rows 1 (2, 3) more time(s), ending with a RS row—69 (71, 75) sts rem.

ALL SIZES:

Work 1 WS row even.

Dec row: (RS) K1, ssk, work in established patt to last 3 sts, k2tog, k1—2 sts dec'd.

Rep Dec Row every RS row 2 (3, 5, 4, 5, 5) more times—51 (55, 57, 59, 59, 63) sts rem.

Cont even until armholes measure about 7½ (7¾, 8¼, 8½, 9¼, 9½)" (19 [19.5, 21, 21.5, 23.5, 24] cm), ending with a WS row.

Shape shoulders and neck

Mark center 23 (25, 27, 25, 27, 29) sts for neck.

Next row: (RS) Work in established patt to m, join a second ball of mC and BO marked sts, work to end—14 (15, 15, 17, 16, 17) sts rem for each shoulder.

BO 3 sts at beg of next 6 (8, 8, 4, 6, 4) rows, then 2 (0, 0, 4, 4, 4) at beg of next 2 (0, 0, 4, 2, 4) rows, and *at the same time*, dec 1 st each neck edge every RS row 3 times.

Sleeves

CUFF

With dpn and CC, CO 36 (36, 40, 40, 44, 44) sts. Pm for beg of rnd and join for working in rnds, being careful not to twist sts.

Rnd 1: *K2, p2; rep from *.

Cont in established ribbing until piece measures 2 (2, 2¼, 2¼, 2½, 2½)" (5 [5, 5.5, 5.5, 6.5, 6.5] cm) from beg.

Purl 1 rnd. Knit 1 Rnd. Purl 1 rnd.

Change to mC and knit 1 rnd.

Set-up rnd: m1, purl to end—37 (37, 41, 41, 45, 45) sts.

MAIN SLEEVE SECTION

Next rnd: K1, work rnd 1 of Textured patt to end.

Work 14 (10, 10, 6, 6, 4) more rnds in established patt.

SHAPE SLEEVE

Inc rnd: K1, m1, work in patt to end, m1—2 sts inc'd.

Rep Inc Rnd every 16 (12, 12, 8, 8, 6) rnds 2 (4, 4, 9, 4, 12) more times, then every 14 (10, 10, 6, 6, 4) rnds 3 (3, 3, 2, 9, 4) times—49 (53, 57, 65, 73, 79) sts. Work new sts into patt.

Work even until piece measures about 16¾ (16¾, 17¼, 17¼, 17½, 17½)" (42.5 [42.5, 44, 44, 44.5, 44.5] cm) from beg, ending with an odd-numbered rnd of patt rep.

SLEEVE CAP

Armhole BO rnd: K1, work in established pattern to last 3 (4, 5, 6, 7, 7) sts, BO next 7 (9, 11, 13, 15, 15) in pattern, removing m as you come to it, work in patt to end—

42 (44, 46, 52, 58, 64) sts rem. Cont working back and forth, beg with a WS row.

Shape cap

Dec Row 1: (WS) P1, p2tog, work in established patt to last 3 sts, ssp, p1—2 sts dec'd.

Dec Row 2: (RS) K1, ssk, work in established patt to last 3 sts, k2tog, k1—2 sts dec'd.

Rep Dec Row 2 every RS row 3 (3, 3, 3, 3, 7) more times, every 4 rows 4 (5, 6, 5, 6, 4) times, then every RS row 3 (4, 4, 7, 6, 7) times—18 (16, 16, 18, 24, 24) sts rem.

Rep Dec Rows every row 3 (1, 1, 1, 3, 3) more times—12 (14, 14, 16, 18, 18) sts rem.

BO rem sts.

Finishing

Weave in all ends. Wet-block pieces to measurements (see Techniques).

Sew shoulders using mattress stitch (see Techniques). Sew in sleeves using mattress stitch, easing sleeve caps into armholes.

BUTTONBAND

With largest cir needle and CC with RS facing, pick up and knit 90 (90, 94, 94, 98, 102) sts evenly spaced along left front edge from neck to bottom edge (pick up sts at a rate of about 2 sts for every 3 rows). Do not join.

Knit 3 rows.

Next row: (RS) K2, *p2, k2; rep from * to end.

Cont in established ribbing until buttonband measures 2 (2, 2¼, 2¼, 2¾, 2¾)" (5 [5, 5.5, 5.5, 7, 7] cm) from pick-up row, ending with a RS row.

BO all sts kwise on WS.

BUTTONHOLE BAND

With largest cir needle and CC, with RS facing, pick up and knit 90 (90, 94, 94, 98, 102) sts evenly spaced along right front edge from bottom edge to neck. Do not join.

Knit 3 rows.

Next row: (RS) K2, *p2, k2; rep from * to end.

Work 5 (5, 5, 5, 7, 7) more rows in established ribbing.

Next (buttonhole) row: (RS) Work 5 (5, 4, 4, 6, 5) sts in established ribbing, *work buttonhole over next 3 sts (see Techniques), work until there are 10 (10, 11, 11, 11, 12) sts past buttonhole gap; rep from * 5 more times, work buttonhole over next 3 sts, work in patt to end.

Work even in established ribbing until buttonhole band measures 2 (2, 2¼, 2¼, 2¾, 2¾)" (5 [5, 5.5, 5.5, 7, 7] cm) from pick-up row, ending with a RS row.

BO all sts kwise on WS.

NECKBAND

With largest cir needle and CC, with RS facing, pick up and knit 10 (10, 11 (11, 13, 13) sts along edge of buttonhole band, 31 (32, 34, 34, 36, 36) sts evenly along right front neck, 32 (34, 36, 36, 36, 36) sts along back neck, 31 (32, 34, 34, 36, 36) sts along left front neck, then 10 (10, 11, 11, 13, 13) sts along edge of buttonband—114 (118, 126, 126, 134, 134) sts. Do not join.

Knit 3 rows.

Change to size U.S. 5 (3.75 mm) cir needle.

Next row: (RS) K2, *p2, k2; rep from * to end.

Work 5 (5, 5, 5, 7, 7) more rows in established rib.

Change to size U.S. 4 (3.5 mm) cir needle.

Next (buttonhole) row: Work 3 (3, 3, 3, 4, 4) sts in established ribbing, work buttonhole over next 3 sts, work to end.

Work even in established ribbing until neckband measures 2 (2, 2¼, 2¼, 2¾, 2¾)" (5 [5, 5.5, 5.5, 7, 7] cm), ending with a RS row.

BO all sts kwise on WS.

Weave in rem ends. Sew buttons to buttonband opposite buttonholes.

Steam all edgings or wet-block entire garment again if necessary.

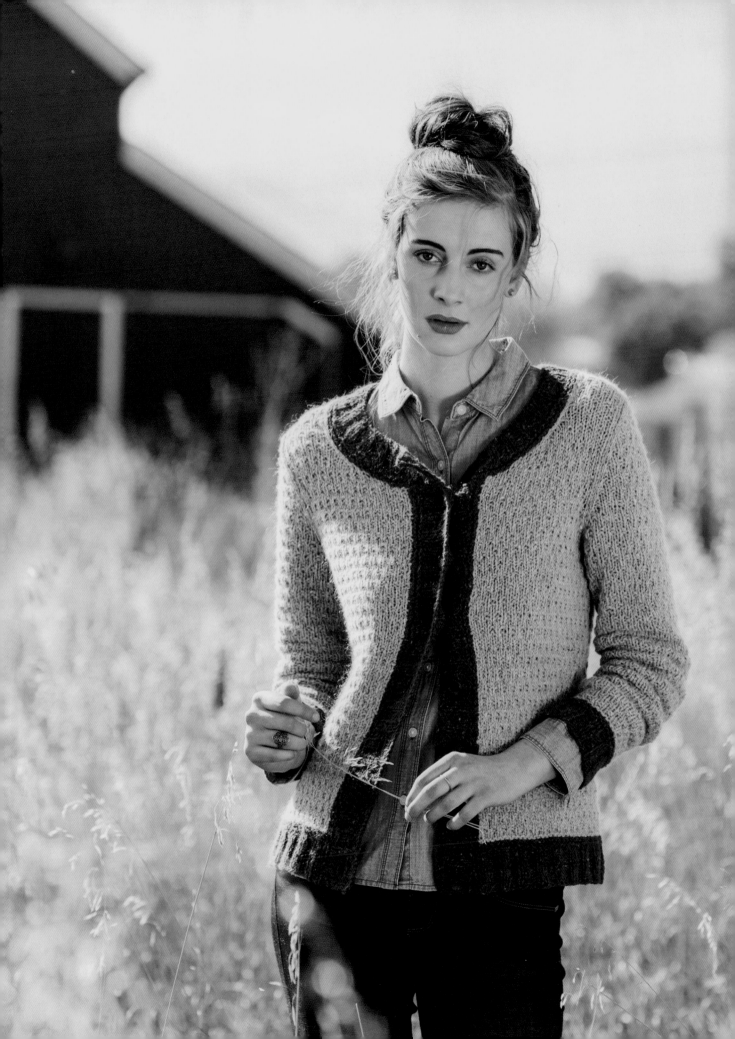

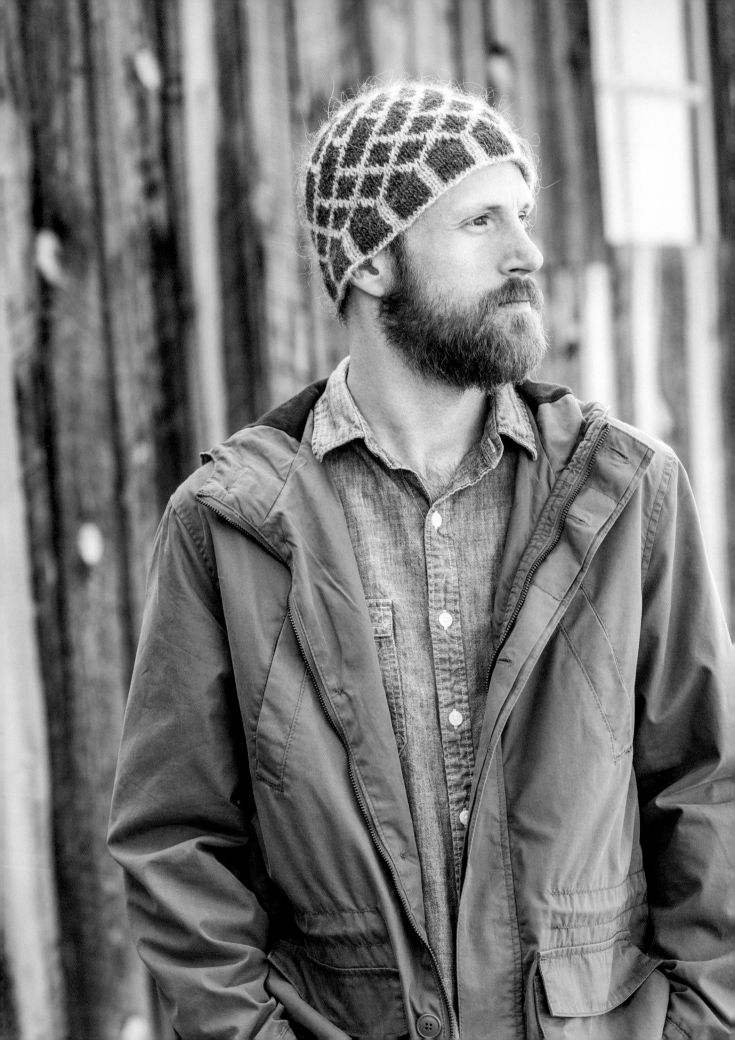

PASSING GLACIER

HAT

The ultimate winter cap, Passing Glacier uses a knit-in hem combined with stranded colorwork to make a thick woolly fabric. A luscious and luxurious cashmere/alpaca/ silk blend makes up the inside of the hem, while rustic Lettlopi offers durability as well as wind and water resistance. Wear this on your snowy adventures for years to come. This cap works equally well for men and women.

Finished Size
19¼ (20¾, 22½)" (49 [52.5, 57] cm) head circumference and 7½" (19 cm) long.

Shown in size 20¾" (52.5 cm)

Yarn
Worsted weight (#4 medium):

Main Color (MC): 67 (72, 78) yd (61 [66, 71] m).

Contrast Color 1 (CC1): 41 (45, 48) yd (37 [41, 44] m).

Shown here: Ístex Lettlopi (100% wool; 109 yd [100 m]/50 g): colors #0053 Acorn Heather (MC), 1 skein; #0054 Light Ash Heather (CC1), 1 skein.

Sportweight (#2 Fine): 26 (28, 30) yd (24 [25, 27] m).

Shown here: The Fibre Company Road to China Light (65% baby alpaca, 15% silk, 10% camel, 10% cashmere; 159 yd [145 m]/50 g): color #710 Riverstone (CC2), 1 skein

Needles
Size U.S. 4 (3.5 mm): 16" (40 cm) circular (cir).

Size U.S. 5 (3.75 mm): 16" (40 cm) circular (cir) and set of 4 or 5 double-pointed (dpn).

Size U.S. 7 (4.5 mm): 16" (40 cm) circular (cir) and set of 4 or 5 double-pointed (dpn).

Adjust needle sizes if necessary to obtain the correct gauge.

Notions
Markers (m); size U.S. E-4 (3.5 mm) crochet hook; waste yarn; tapestry needle.

Gauge
20 sts and 22 = 4" (10 cm) over chart using largest needles.

Hat

INSIDE HEM

Using crochet hook, smallest cir needle, and waste yarn, CO 96 (104, 112) sts using the crochet provisional cast-on (see Techniques).

Change to CC2 and knit 1 row. Do not turn.
Place marker (pm) for beg of rnd and join for working in rnds, being careful not to twist sts. Knit 8 rnds.

OUTSIDE HEM

Change to CC1 and size U.S. 5 (3.75 mm) cir needle.

Knit 1 rnd, then purl 1 rnd for turning rnd.

Change to largest cir needle.

Work Rnds 1–7 of chart.

JOIN HEM

Carefully remove provisional CO and place resulting sts onto smallest cir needle. Fold piece at purl turning rnd so WS are touching, and smallest cir needle held behind largest cir needle. Work Rnd 8 of chart as foll: *knit tog 1 st from each needle; rep from *—96 (104, 112) sts.

MAIN BODY OF HAT AND CROWN

Cont in est patt, work Rnds 9–41 of chart, changing to largest dpn when there are too few sts to work comfortably on cir needle—12 (13, 14) sts rem.

Next (dec) rnd: (K2tog) to last 0 (1, 0) st(s), k0 (1, 0)—6 (7, 7) sts rem.

Cut yarn, leaving a 6" (15 cm) tail, thread tail through rem sts, pull tightly to close hole, fasten off on WS.

Finishing

Weave in ends. Block to measurements.

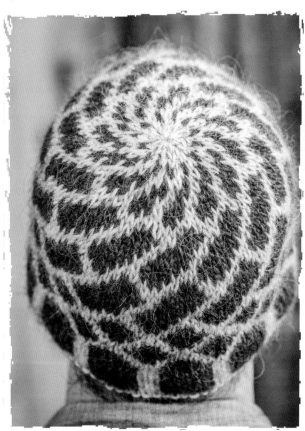

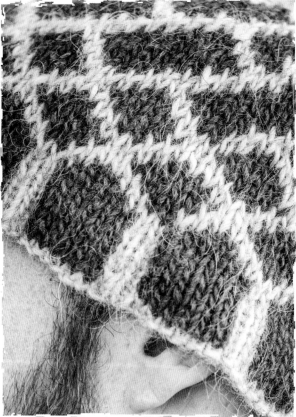

COLORWORK PATTERN

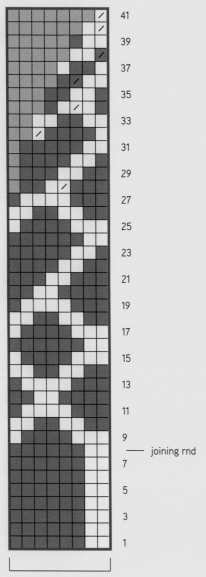

41
39
37
35
33
31
29
27
25
23
21
19
17
15
13
11
9 — joining rnd
7
5
3
1

8-st rep
work 12 (13, 14) times

■ MC ▨ no stitch

□ CC1 ▢ pattern repeat

⁄ k2tog

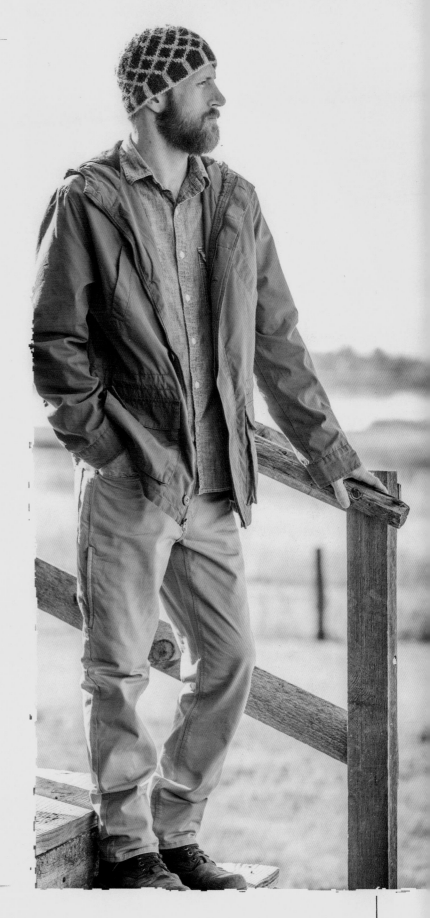

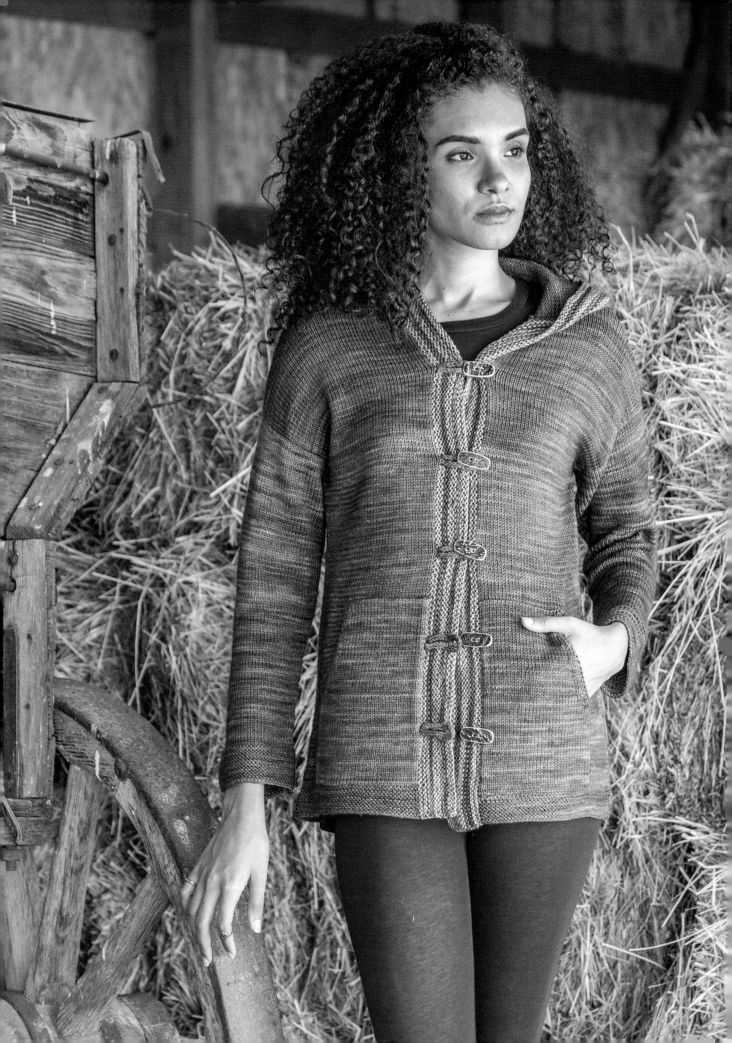

WRAP-UP

HOODIE

This is the knitted version of your favorite hoodie—made in pieces, it's got a roomy fit and drop-shoulder construction to keep it casual and comfortable, with big functional slant pockets and neat garter edgings. Waist shaping makes for a flattering fit. The seams add structure and long-term durability to the hoodie, so you can wear it for years. Contrasting stripes along the front and hood edgings add just enough interest while keeping this piece versatile and wearable.

Finished Size

38 (41¼, 45½, 48¾, 52½, 56¼)" (96.5 (105, 115.5, 124, 133.5, 143) cm) bust circumference with 1¾ (1¾, 1¾, 2¾, 2¾, 2¾)" (4.5 (4.5, 4.5, 7, 7, 7] cm) overlap and 26 (26¼, 26¾, 27¾, 28¾, 2912)" (66 [66.5, 68, 70.5, 73, 75] cm) long.

Intended to be worn with 8–10" (20.5–25.5 cm) of positive ease.

Shown in size 41¼" (105 cm).

Yarn

DK weight (#3 Light).

Shown here: Baah Sonoma (100% super-wash merino wool; 234 yd [214 m]/100 g): color Pecan (MC), 6 (7, 8, 8, 9, 9) skeins.

Main Color (MC): 1626 (1774, 1951, 2066, 2230, 2408) yd (1487 [1622, 1784, 1889, 2039, 2202] m).

Contrast Color (CC): 86 (86, 87, 133, 136, 138) yd (78 [78, 79, 121, 124, 126] m).

Contrast Color CC: Hazel Knits Lively DK (90% merino wool, 10% nylon; 275 yd [251 m]/130 g); color White Wing Dove (CC), 1 skein.

Needles

Size U.S. 4 (3.5 mm) straight, 60" (150 cm) long circular (cir), and pair of double-pointed (dpn).

Size U.S. 5 (3.75 mm) straight and 24" (60 cm) long circular (cir).

Adjust needle sizes if necessary to obtain the correct gauge.

Notions

Markers (m); tapestry needle; five 1½" (38 mm) toggle buttons.

Gauge

22 sts and 34 rows = 4" (10 cm) over St st using larger needles.

Notes

Cardigan is worked in pieces with drop shoulders. Following seaming, stitches are picked up for the hood, which is joined at the top using three-needle bind-off. Edging is picked up and worked along the fronts and hood edge. Pockets are knit separately and sewn on.

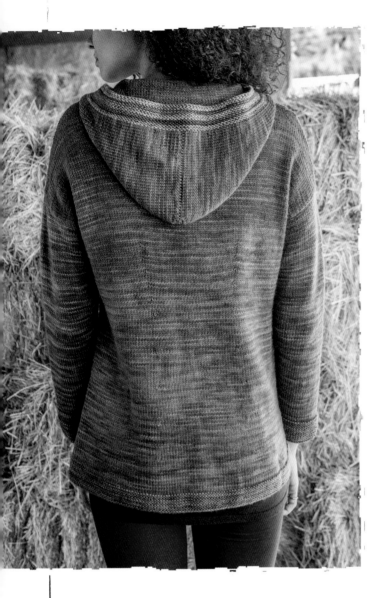

Set-up row: (WS) P36 (40, 42, 46, 50, 54), place marker (pm), p36 (38, 44, 46, 50, 52), pm, purl to end.

Dec row: (RS) Knit to m, sm, k2tog, knit to 2 sts before m, ssk, sm, knit to end—2 sts dec'd.

Rep Dec Row every 20 (20, 20, 20, 16, 16) rows 2 (2, 3 3, 4, 4) more times, then every 18 rows 2 (2, 0, 0, 0, 0) times—98 (108, 120, 130, 140, 150) sts rem.

SHAPE BUST

Work 7 rows even.

Inc row: (RS) Knit to m, sm, m1R, knit to m, m1L, sm, knit to end—2 sts inc'd.

Rep Inc Row every 6 (6, 8, 8, 6, 6) rows 4 (4, 3, 3, 4, 4) more times—108 (118, 128, 138, 150, 160) sts.

Cont even until piece measures about 17" (43 cm) from CO, removing m on first row.

UPPER BACK

Place removable m at each edge to mark beg of armholes.

Cont even until armholes measure 6¾ (7, 7½, 8½, 9½, 10¼)" (17 [18, 19, 21.5, 24, 26] cm), ending with a WS row.

SHAPE SHOULDERS USING SHORT-ROWS

Short-row 1: (RS) Knit to last 4 (6, 5, 7, 6, 8) sts, w&t.

Short-row 2: (WS) Purl to last 4 (6, 5, 7, 6, 8) sts, w&t.

Short-row 3: Knit to 4 (6, 5, 7, 6, 8) sts before wrapped st, w&t.

Short-row 4: Purl to 4 (6, 5, 7, 6, 8) sts before wrapped st, w&t.

Short-row 5: Knit to 4 (4, 5, 5, 6, 6) sts before wrapped st, w&t.

Short-row 6: Purl to 4 (4, 5, 5, 6, 6) sts before wrapped st, w&t.

Rep Short-rows 5 and 6 six more times.

Next row: (RS) Knit to end, picking up wraps and knitting them tog with the sts they wrap.

Back

GARTER HEM

With smaller straight needles and mC, CO 108 (118, 128, 138, 150, 160) sts. Work in garter st (knit every row) until piece measures about 1¾ (1¾, 2¼, 2¼, 3, 3)" (4.5 [4.5, 5.5, 5.5, 7.5, 7.5] cm) from CO.

SHAPE WAIST

Change to larger straight needles. Beg with a RS row, work 17 (17, 23, 23, 19, 19) rows in St st (knit RS rows, purl WS rows), ending with a RS row.

Next row: Purl to end, picking up wraps and purling them tog with the sts they wrap.

BO all sts.

Right Front

HEM

With smaller straight needles and mC, CO 46 (50, 56, 58, 62, 68) sts. Work in garter st until pieces measures about 1¾ (1¾, 2¼, 2¼, 3, 3)" (4.5 [4.5, 5.5, 5.5, 7.5, 7.5] cm) from CO.

SHAPE WAIST

Change to larger straight needles. Beg with a RS row, work 18 (18, 24, 24, 20, 20) rows in St st, ending with a WS row.

Dec row: (RS) Knit to last 4 sts, k2tog, k2—1 st dec'd.

Rep Dec Row every 20 (20, 20, 20, 16, 16) rows 2 (2, 3 3, 4, 4) more times, then every 18 rows 2 (2, 0, 0, 0, 0) times—41 (45, 52, 54, 57, 63) sts rem.

SHAPE BUST

Work 7 rows even.

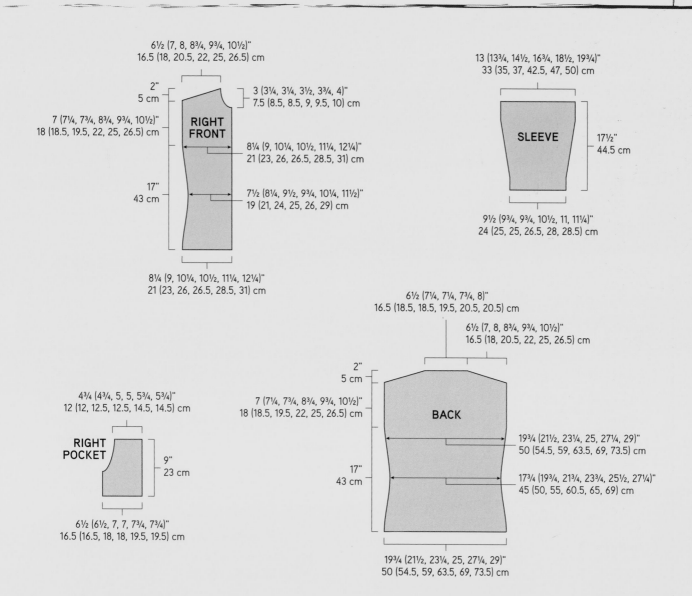

RIGHT FRONT

6½ (7, 8, 8¾, 9¾, 10½)"
16.5 (18, 20.5, 22, 25, 26.5) cm

2"
5 cm

3 (3¼, 3¼, 3½, 3¾, 4)"
7.5 (8.5, 8.5, 9, 9.5, 10) cm

7 (7¼, 7¾, 8¾, 9¾, 10½)"
18 (18.5, 19.5, 22, 25, 26.5) cm

8¼ (9, 10¼, 10½, 11¼, 12¼)"
21 (23, 26, 26.5, 28.5, 31) cm

17"
43 cm

7½ (8¼, 9½, 9¾, 10¼, 11½)"
19 (21, 24, 25, 26, 29) cm

8¼ (9, 10¼, 10½, 11¼, 12¼)"
21 (23, 26, 26.5, 28.5, 31) cm

SLEEVE

13 (13¾, 14½, 16¾, 18½, 19¾)"
33 (35, 37, 42.5, 47, 50) cm

17½"
44.5 cm

9½ (9¾, 9¾, 10½, 11, 11¼)"
24 (25, 25, 26.5, 28, 28.5) cm

RIGHT POCKET

4¾ (4¾, 5, 5, 5¾, 5¾)"
12 (12, 12.5, 12.5, 14.5, 14.5) cm

9"
23 cm

6½ (6½, 7, 7, 7¾, 7¾)"
16.5 (16.5, 18, 18, 19.5, 19.5) cm

BACK

6½ (7¼, 7¼, 7¾, 8)"
16.5 (18.5, 18.5, 19.5, 20.5, 20.5) cm

6½ (7, 8, 8¾, 9¾, 10½)"
16.5 (18, 20.5, 22, 25, 26.5) cm

2"
5 cm

7 (7¼, 7¾, 8¾, 9¾, 10½)"
18 (18.5, 19.5, 22, 25, 26.5) cm

19¾ (21½, 23¼, 25, 27¼, 29)"
50 (54.5, 59, 63.5, 69, 73.5) cm

17"
43 cm

17¾ (19¾, 21¾, 23¾, 25½, 27¼)"
45 (50, 55, 60.5, 65, 69) cm

19¾ (21½, 23¼, 25, 27¼, 29)"
50 (54.5, 59, 63.5, 69, 73.5) cm

Inc row: (RS) Knit to last 2 sts, m1L, k2—1 st inc'd.

Rep Inc Row every 6 (6, 8, 8, 6, 6) rows 4 (4, 3, 3, 4, 4) more times—46 (50, 56, 58, 62, 68) sts.

Cont even until piece measures about 17" (43 cm) from CO.

UPPER FRONT

Place removable m at end of RS row to mark beg of armhole.

Cont even until piece measures 6 (6, 6½, 7¼, 8, 8½)" (15 [15, 16.5, 18.5, 20.5, 21.5] cm) from armhole m, ending with a WS row.

Shape neck and shoulder

BO at beg of RS rows 3 sts once, then 2 sts once—41 (45, 51, 53, 57, 63) sts rem.

Dec Row 1: (WS) Purl to last 3 sts, p2tog, p1—1 st dec'd.

Dec Row 2: (RS) K1, ssk, knit to end—1 st dec'd.

Rep last 2 rows 0 (1, 1, 0, 0, 0) more time(s), then rep Dec Row 2 every RS row 3 (2, 3, 3, 2, 3) times—36 (39, 44, 48, 53, 58) sts rem.

At the same time, when piece measures 6¾ (7, 7½, 8½, 9½, 10¼" (17 [18, 19, 21.5, 24, 26] cm) from armhole m, end with a WS row.

Short-row 1: (RS) Knit to last 4 (6, 5, 7, 6, 8) sts, w&t.

Short-row 2: Purl to neck edge.

Short-row 3: Knit to 4 (6, 5, 7, 6, 8) sts before wrapped st, w&t.

Short-row 4: Purl to neck edge.

Short-row 5: Knit to 4 (4, 5, 5, 6, 6) sts before wrapped st, w&t.

Short-row 6: Purl to neck edge.

Rep Short-rows 5 and 6 five more times.

Next row: (RS) Knit to end, picking up wraps and working them tog with the sts they wrap.

Next row: Purl.

BO all sts.

Left front

HEM
Work hem same as for Right Front.

SHAPE WAIST
Change to larger straight needles. Beg with a RS row, work 18 (18, 24, 24, 20, 20) rows in St st, ending with a WS row.

Dec row: (RS) K2, ssk, knit to end—1 st dec'd.

Rep Dec Row every 20 (20, 20, 20, 16, 16) rows 2 (2, 3 3, 4, 4) more times, then every 18 rows 2 (2, 0, 0, 0, 0) times—41 (45, 52, 54, 57, 63) sts rem.

SHAPE BUST
Work 7 rows even.

Inc row: (RS) K2, m1R, knit to end—1 st inc'd.

Rep Inc Row every 6 (6, 8, 8, 6, 6) rows 4 (4, 3, 3, 4, 4) more times—46 (50, 56, 58, 62, 68) sts.

Cont even until piece measures about 17" (43 cm) from CO.

UPPER FRONT

Place removable m at beg of RS row to mark beg of armhole.

Cont even until piece measures 6 (6, 6½, 7¼, 8, 8½)" (15 [15, 16.5, 18.5, 20.5, 21.5] cm) from armhole m, ending with a RS row.

Shape neck and shoulder

BO at beg of WS rows 3 sts once, then 2 sts once—41 (45, 51, 53, 57, 63) sts rem.

Dec Row 1: (RS) Knit to last 3 sts, k2tog, k1—1 st dec'd.

Dec Row 2: (WS) P1, p2tog, purl to end—1 st dec'd.

Rep last 2 rows 0 (1, 1, 0, 0, 0) more time(s), then rep Dec Row 1 every RS row 3 (2, 3, 3, 2, 3) times—36 (39, 44, 48, 53, 58) sts rem.

At the same time, when piece measures 6¾ (7, 7½, 8½, 9½, 10¼")" (17 [18, 19, 21.5, 24, 26] cm) from armhole m, end with a RS row.

Short-row 1: (WS) Purl to last 4 (6, 5, 7, 6, 8) sts, w&t.

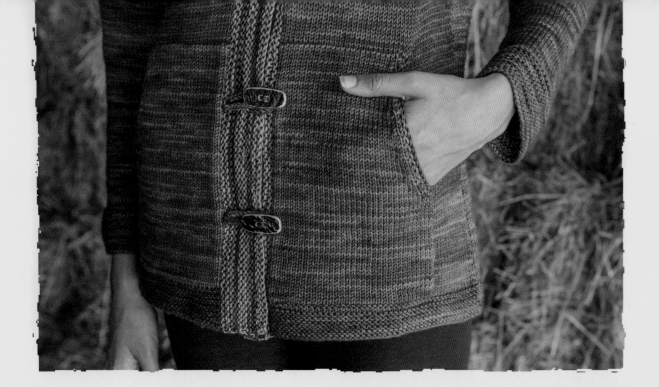

Short-row 2: (RS) Knit to neck edge.

Short-row 3: Purl to 4 (6, 5, 7, 6, 8) sts before wrapped st, w&t.

Short -row 4: Knit to neck edge.

Short-row 5: Purl to 4 (4, 5, 5, 6, 6) sts before wrapped st, w&t.

Short-row 6: Knit to neck edge.

Rep Short-rows 5 and 6 five more times.

Next row: (WS) Purl to end, picking up wraps and working them tog with the st they wrap.

BO all sts.

Sleeves

CUFF

With smaller straight needles and mC, CO 52 (54, 54, 58, 60, 62) sts. Work in garter st until measures about 2 (2, 2¼, 2¼, 2½, 2½)" (5 [5. 5.5, 5.5, 6.5, 6.5] cm) from CO.

SHAPE SLEEVE

Change to larger straight needles. Beg with a RS row, work 10 (10, 8, 6, 4, 4) rows in St st, ending with a WS row.

Inc row: (RS) K2, m1L, knit to last 2 sts, m1R, k2—2 sts inc'd.

Rep Inc Row every 12 (12, 8, 6, 4, 4) rows 9 (9, 2, 9, 5, 10) more times, then every 0 (0, 10, 8, 6, 6) rows 0 (0, 10, 7, 15, 12) times—72 (76, 80, 92, 102, 108) sts.

Cont even until piece measures 17½" (44.5 cm) from CO.

BO all sts.

Pockets

LEFT POCKET

With larger straight needles and mC, CO 36 (36, 38, 38, 42, 42) sts. Beg with a RS row, work in St st until piece measures 4" (10 cm), ending with a WS row.

Shape pocket

Next row: (RS) BO 3, knit to end—33 (33, 35, 35, 39, 39) sts rem.

Work 3 rows even.

Dec row: (RS) K2, k2tog, knit to end—1 st dec'd.

Rep Dec Row every 4 rows once more, then every 6 rows 5 times—26 (26, 28, 28, 32, 32) sts rem.

Work 3 rows even, ending with a WS row.

BO all sts.

RIGHT POCKET

Work same as for Left Pocket until piece measures 4" (10 cm), ending with a RS row.

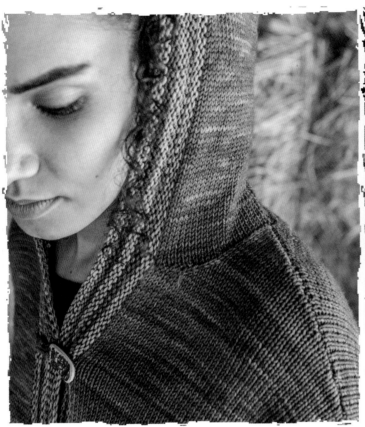
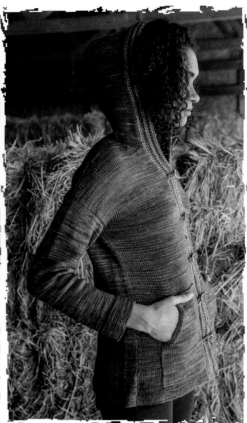

Shape pocket

Next row: (WS) BO 3, purl to end—33 (33, 35, 35, 39, 39) sts rem.

Work 2 rows even.

Dec row: (RS) Knit to last 4 sts, ssk, k2—1 st dec'd.

Rep Dec Row every 4 rows once more, then every 6 rows 5 times—26 (26, 28, 28, 32, 32) sts rem.

Work 3 rows even, ending with a WS row.

BO all sts.

POCKET EDGINGS

With smaller straight needles, mC and RS facing, pick up and knit 1 st in each BO st and 2 sts for every 3 rows along shaped edge.

Knit 1 row. BO all sts kwise on WS.

Repeat for second pocket.

Finishing

Weave in loose ends. Wet-block all pieces to measurements (see Techniques). Allow to dry completely.

Using mattress st (see Techniques), sew shoulder seams. Sew in sleeves. Sew side and sleeves seams.

ATTACH POCKETS

Sew pockets to fronts, starting with the bottom of the pocket directly above garter hem, then sew the sides and top of pockets. *Note*: The inside edge of each pocket should be 1 stitch from the front edge of the front opening to allow a selvedge stitch for picking up the front edging.

HOOD

With larger cir needle, mC and RS facing, pick up and knit 20 (22, 22, 24, 25, 25) sts along right front neck, 38 (40, 40, 42, 44, 46) sts along back neck, then 20 (22, 22, 24, 25, 25) sts along left front neck—78 (84, 84, 90, 94, 96) sts.

Beg with a WS row, work 12 rows in St st, ending with a RS row.

Shape hood

Set-up row: (WS) P39 (42, 42, 45, 47, 48), pm, purl to end.

Inc row: (RS): Knit to 1 st before m, m1L, k1, sm, k1, m1R, knit to end—2 sts inc'd.

Rep Inc Row every 14 rows twice more—84 (90, 90, 96, 100, 102) sts.

Cont even until hood measures 10¾ (10½, 10½, 10½, 10¼, 10¼)" (27.5 [26.5, 26.5, 26.5, 26, 26] cm), ending with a WS row.

Dec Row 1: (RS) Knit to 3 sts before m, ssk, k1, sm, k1, k2tog, knit to end—2 sts dec'd.

Rep Dec Row every RS row 3 (4, 4, 4, 5, 5) more times—76 (80, 80, 86, 88, 90) sts rem.

Next (dec) row: Rep Dec Row 1—2 sts dec'd.

Dec Row 2: (WS) Purl to 3 sts before m, p2tog, p1, sm, p1, ssp, purl to end—2 sts dec'd.

Rep last 2 rows 2 more times—64 (68, 68, 74, 76, 78) sts rem.

Join top

Divide sts evenly with 32 (34, 34, 37, 38, 39) sts each on left needle tip and right needle tip. Turn hood with WS facing. With larger straight needle, join hood using three-needle bind-off (see Techniques).

FRONT EDGING

With longer smaller cir needle, CC and RS facing, beg at bottom of right front and pick up and knit 1 st for every 2 rows along front edges and hood to bottom of left front.

Knit 3 (3, 3, 5, 5, 5) rows. Change to mC but do not cut CC (carry unused yarn loosely up along WS). Knit 4 (4, 4, 6, 6, 6) rows. Change to CC and knit 4 (4, 4, 6, 6, 6) rows. Change to mC and knit 4 (4, 4, 6, 6, 6) rows. Cut mC. Change to CC and knit 3 (3, 3, 5, 5, 5) rows. BO all sts knitwise on WS.

BUTTON PLACEMENT & BUTTON LOOPS

Button loops (make 5)

With dpn and mC, CO 3 sts. Work I-cord as foll:

Row 1: K3. Do not turn. Slide sts to right end of dpn.

Row 2: Bring yarn across back of work, k3. Slide sts to right end of dpn.

Rep last row until cord measures 4 (4, 4, 6, 6, 6)" (10 [10, 10, 15, 15, 15] cm). Cut yarn, leaving a 6" (15 cm) tail, thread tail through sts, pull tightly, fasten off. Do not cut tail.

Sew buttons to left front edging pick-up, placing bottom button 4" (10 cm) above CO edge, top button 4" (10 cm) down from neck edge, then sew rem buttons evenly spaced in between.

Sew button loops to right front opposite buttons, using tails to sew ends at front edging pick-up. Using mC, tack down button loops to mC stripe closest to BO edge of front edging to create a smaller loop that will stay closed on the button.

Weave in all ends.

Wet-block again to smooth seams, pockets, and front edging, and relax hood.

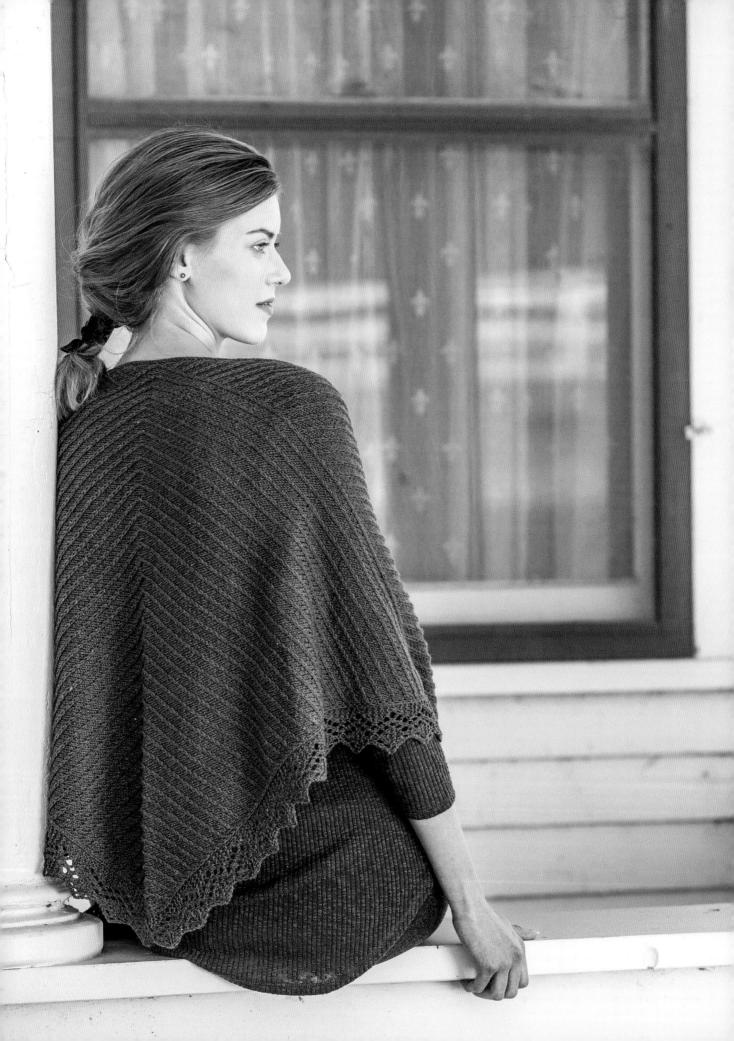

CEDAR BOUGH
SHAWL

Clean lines and a delicate lace edging make this shallow triangular shawl a striking addition to your winter wardrobe. This generously sized wrap gives warmth and rugged sophistication to your holiday party dress, jeans and flannel, or even business casual. It's worked from side to side in an intuitive allover twisted stitch pattern with an I-cord edging that's picked up and added at the end for a perfect finish.

Finished Size
71" (180.5 cm) wide and 24¾" (63 cm) long.

Yarn
1215 yd (1111 m) fingering weight (#1 Super Fine).

Shown here: Quince & Co. Tern (75% American wool, 25% silk; 221 yd [202 m]/50 g): color #404 Seaweed, 6 skeins.

Needles
Size U.S. 5 (3.75 mm): 32" (80 cm) long circular (cir).

Size U.S. 4 (3.5 mm) pair of double-pointed (dpn) for I-cord edging.

Adjust needle size if necessary to obtain the correct gauge.

Notions
Markers (m); tapestry needle; blocking wires.

Gauge
28 sts and 35 rows = 4" (10 cm) over Twisted Sts patt (Charts 1–8) using larger needles, blocked.

Notes
Triangular shawl is worked from side to side. Increases are worked for the first half and decreases for the second half to create the shallow triangular shape.

Shawl

SET-UP

With cir needle, CO 12 sts. Do not join. Work back and forth.

Set-up row 1: (WS) K9, place marker (pm), p3.

Set-up row 2: (RS) K2, M1, k1, sm, knit to end—13 sts.

Set-up row 3: Knit to m, sm, sl 1, purl to end.

CHART 1

Row 1: Work Row 1 of Chart 1 over first 4 sts, sm, work Row 1 of Lace Chart over next 9 sts—15 sts; 5 sts in Twisted Sts patt, and 10 sts in lace.

Work Rows 2–8 of charts as established—19 sts; 8 sts in Twisted Sts patt, and 11 sts in lace.

CHART 2

Next row: Work Row 1 of Chart 2 to m as foll, work 1 st at right edge of chart, 4-st rep to 3 sts before m, work 4 sts at left edge of chart, sm, work next row of Lace Chart to end—19 sts; 9 sts in Twisted Sts patt, and 10 sts in lace.

Cont as est, work Rows 2–8 of Chart 2, then rep Rows 1–8 seventeen more times—91 sts; 80 sts in Twisted Sts patt, and 11 sts in lace. Work 1 additional st between rep and m every RS row until 8 rows have been worked, then include the extra 4 sts into the 4-st rep each time the 8-row rep is worked.

CHART 3

Next row: Work Row 1 of Chart 3 to m as foll, work 1 st at right edge of chart, 4-st rep to 7 sts before m, work 8 sts at left edge of chart, sm, work next row of Lace

Chart to end—91 sts; 81 sts in Twisted Sts patt, and 10 sts in lace.

Cont as est, work Rows 2–8 of Chart 3—95 sts; 84 sts in Twisted Sts patt, and 11 sts in lace.

CHART 4

Next row: Work Row 1 of Chart 4 to m as foll, work 1 st at right edge of chart, 4-st left-slanting rep to 11 sts before m, work next 4 sts, 4-st right-slanting rep over next 4 sts, then 2 sts at left edge of chart, sm, work next row of Lace Chart to end—97 sts; 85 sts in Twisted Sts patt, and 12 sts in lace.

Cont as est, work Rows 2–8 of Chart 4, then rep Rows 1–8 sixteen more times, working 1 fewer left-slanting rep and 1 more right-slanting rep every 8 rows—163 sts; 152 sts in Twisted Sts patt, and 11 sts in lace.

CHART 5

Next row: Work Row 1 of Chart 5 to m as foll, work 7 sts at right edge of chart, 4-st rep to 1 st before m, then 2 sts at left edge of chart, sm, work next row of Lace Chart to end—163 sts; 153 sts in Twisted Sts patt, and 10 sts in lace.

Cont as est, work Rows 2–18 of Chart 5—163 sts rem; 153 sts in Twisted Sts patt, and 10 sts in lace.

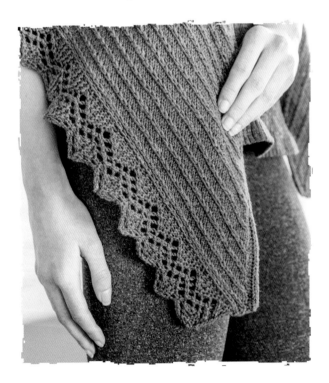

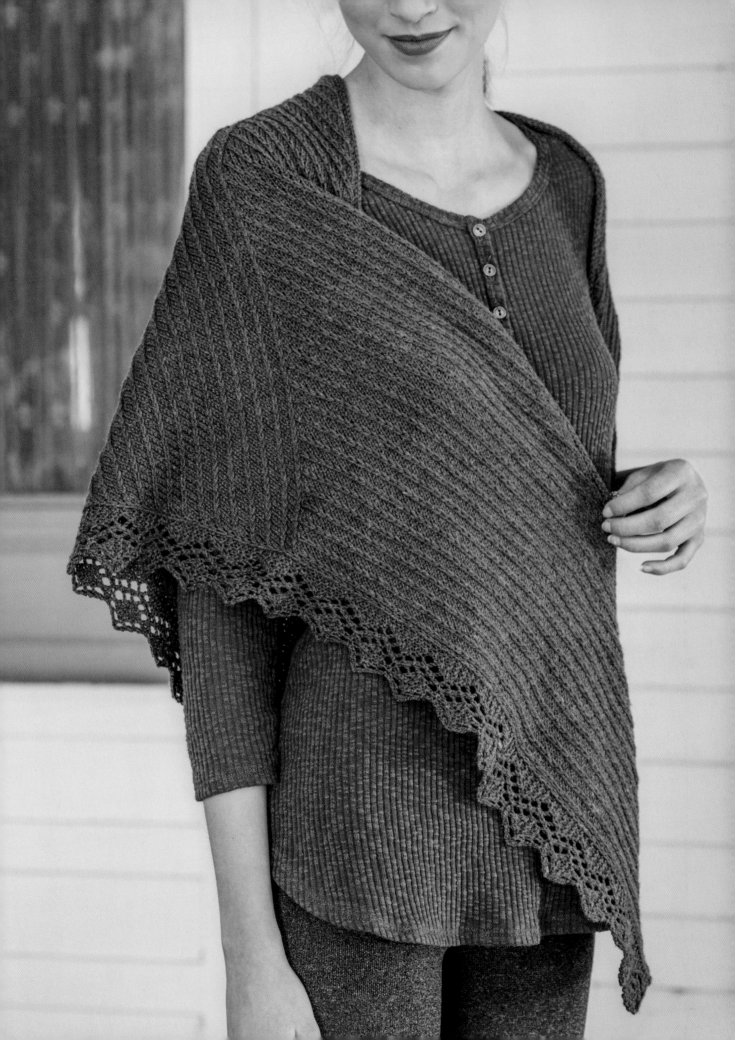

CHART 1

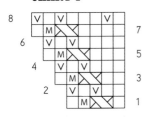

end beg

CHART 2

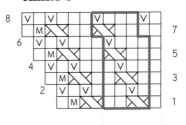

end 4-st rep beg

CHART 3

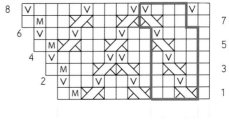

end 4-st rep beg

CHART 4

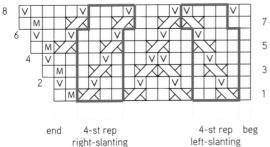

end 4-st rep 4-st rep beg
 right-slanting left-slanting

CHART 5

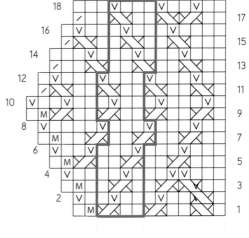

end 4-st rep beg

CHART 6

Next row: Work Row 1 of Chart 6 to m as foll, work 1 st at right edge of chart, 4 st left-slanting rep once, work next 4 sts, 4-st right-slanting rep to 4 sts before m, then 4 sts at left edge of chart, sm, work next row of Lace Chart to end—163 sts rem; 152 sts in Twisted Sts patt, and 11 sts in lace.

Cont as est, work Rows 2–8 of Chart 6, then rep Rows 1–8 sixteen more times, working 1 fewer right-slanting rep and 1 more left slanting rep every 8 rows—97 sts rem; 85 sts in Twisted Sts patt, and 12 sts in lace.

CHART 7

Next row: Work Row 1 of Chart 7 to m as foll, work 3 sts at right edge of chart, 4-st rep to 6 sts before m, then 5 sts at left edge of chart, sm, work next row of Lace Chart to end—95 sts rem; 84 sts in Twisted Sts patt, and 11 sts in lace.

Cont as est, work Rows 2–8 of Chart 7, then rep Rows 1–8 eighteen more times—19 sts rem; 9 sts in Twisted Sts patt, and 10 sts in lace.

CHART 8

Next row: Work Row 1 of Chart 8 to m, sm, work next row of Lace Chart—19 sts; 8 sts in Twisted Sts patt, and 11 sts in lace.

Cont as est, work Rows 2–9 of Chart 8—13 sts rem; 4 sts in Twisted Sts patt, and 9 sts in lace.

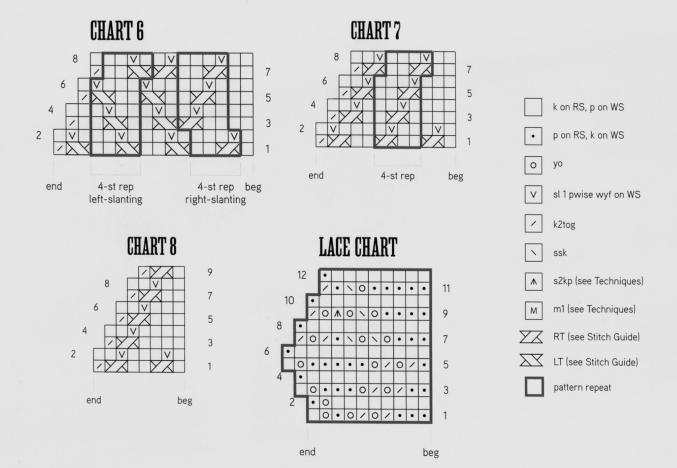

CHART 6

8
6
4
2

7
5
3
1

end | 4-st rep left-slanting | 4-st rep right-slanting | beg

CHART 7

8
6
4
2

7
5
3
1

end | 4-st rep | beg

CHART 8

8
6
4
2

9
7
5
3
1

end | beg

LACE CHART

12
10
8
6
4
2

11
9
7
5
3
1

end | beg

	k on RS, p on WS
•	p on RS, k on WS
o	yo
V	sl 1 pwise wyf on WS
/	k2tog
\	ssk
∧	s2kp (see Techniques)
M	m1 (see Techniques)
⋊⋉	RT (see Stitch Guide)
⋉⋊	LT (see Stitch Guide)
▢	pattern repeat

FINISHING ROWS

Finishing Row 1: (WS) Knit to m, sm, sl 1, purl to end.

Finishing Row 2: K2, k2tog, sm, knit to end—12 sts rem.

Finishing Row 3: Knit to m, sm, sl 1, purl to end.

BO rem sts.

Finishing

ATTACH I-CORD EDGING

With dpn, CO 4 sts. Do not join.

Row 1: K3, sl 1, with WS of shawl facing, beg at right end and pick up and p1 st in top edge of shawl, working from the right edge of the shawl to the left, psso—4 sts.

Do not turn. Slide sts to right end of needle.

Rep Row 1, picking up about 2 sts for every 3 rows along top edge of shawl to end. Cut yarn, leaving a 6" (15 cm) tail, thread tail through rem 4 sts, pull tightly to gather sts, fasten off.

Weave in ends. Block using blocking wires threaded along top edge, pinning out each lace point to open up the lace.

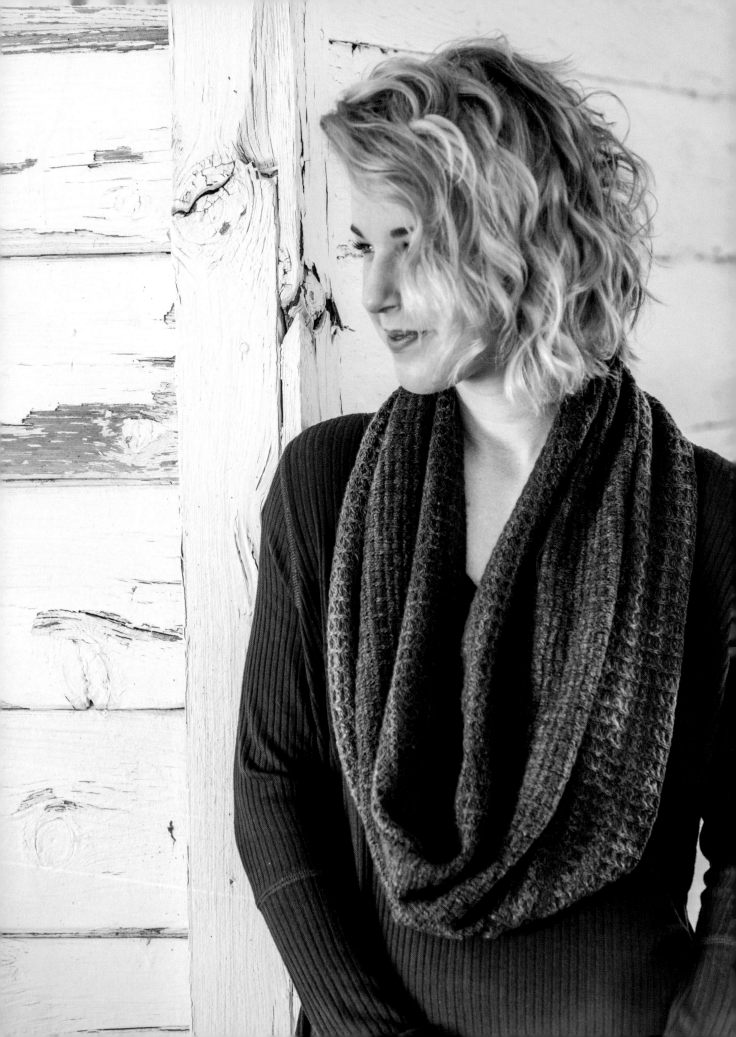

LILAC SKY

INFINITY SCARF

This chic loop is the scarf you'll grab from October all the way through March. The luxurious, lightweight fabric is created with a subtle but beautiful (and clever!) stitch pattern. It's just long enough to wrap around twice if the temperature dips, and its draping fabric makes it just the thing whether you're headed for the office, a woodland hike, or an evening party. It's worked entirely in the round for minimal finishing.

Finished Size

About 44½" (113 cm) in circumference and 16" (40.5 cm) long.

Yarn

1344 yd (1229 m) laceweight (#0 Lace).

Shown here: Malabrigo Lace (100% merino wool, 470 yd [430 m]/50 g): color #52 Paris Night, 3 skeins.

Needles

Size U.S. 3 (3.25 mm): 40" (100 cm) circular (cir).

Adjust needle size if necessary to obtain the correct gauge.

Notions

Markers (m); tapestry needle.

Gauge

24½ sts and 79 rnds = 4" (10 cm) over Dropped St Stockinette patt.

Notes

The row gauge is compressed vertically due to the dropped stitches. The pattern is pleasing on both right and wrong sides and can be worn with either side out.

Dropped Stitch Ribbing

(multiple of 3 sts)

Rnds 1–5: *K1, p2; rep from *.

Rnd 6: *Drop 1 st off left needle tip and let it ravel down 4 rows, insert right needle tip into dropped st and knit, catching horizontal strands from raveled rows, p2; rep from *.

Rep Rnds 1–6 for patt.

Dropped Stitch Stockinette

(multiple of 3 sts)

Rnds 1–5: Knit.

Rnd 6: *Drop 1 st off left needle tip and let it ravel down 4 rows, insert right needle tip into dropped st and knit, catching horizontal strands from raveled rows, k2; rep from *.

Rep Rnds 1–6 for patt.

Edging

CO 273 sts. Place marker (pm) for beg of rnd, and join for working in rnds, being careful not to twist sts.

Work Rnds 1–6 of Dropped St Ribbing until piece measures 3¾" (9.5 cm) from beg, ending with a complete rep.

Body of scarf

Work Rnds 1–6 of Dropped St Stockinette until piece measures 12¼" (31 cm) from beg, ending with a complete rep.

Edging

Work Rnds 1–6 of Dropped St Ribbing until piece measures 16" (40.5 cm) from beg, ending with a complete rep. BO all sts loosely in patt.

Finishing

Weave in ends. Block to measurements.

DROP ST RIBBING

3-st rep

DROP ST STOCKINETTE

3-st rep

☐ knit

• purl

↓ Drop 1 st from LH needle tip, ravel 4 rows, insert RH needle tip and knit, catching horizontal strands from raveled rows

☐ pattern repeat

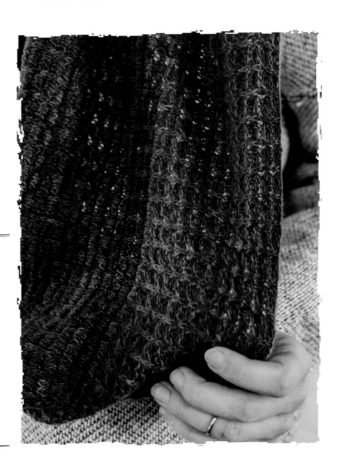

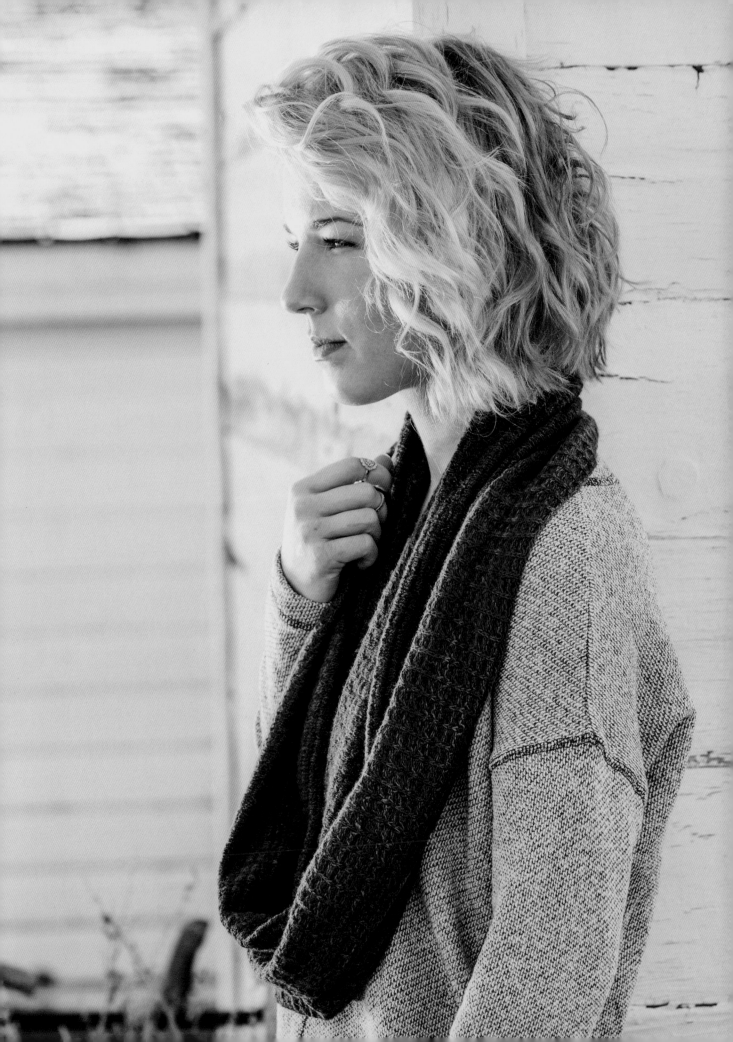

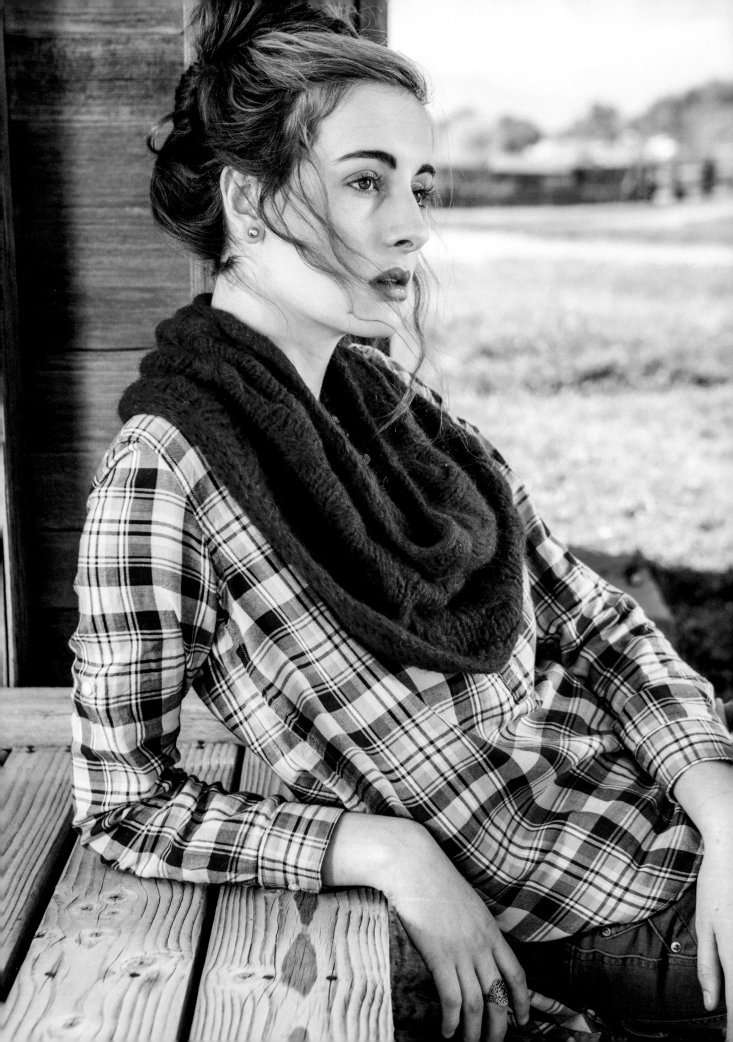

BLACKBERRY GROVE

COWL

Gentle cables make a luscious fabric with a light, fluffy yarn such as Berroco Kodiak. This piece can be worn elegantly draped around the neck cowl-style or pulled over the shoulders for a sweet capelet look.

Finished Size

27½" (70 cm) top circumference, 40" (101.5 cm) bottom circumference, and 11½" (29 cm) long.

Yarn

253 yd (231 m) bulky weight (#5 Bulky).

Shown here: Berroco Kodiak (61% baby alpaca, 24% nylon, 15% merino wool; 125 yd [115 m]/50 g): color #7020 Crowberry, 3 balls.

Needles

Size U.S. 7 (4.5 mm): 24" (60 cm) circular (cir) and pair of double-pointed (dpn).

Size U.S. 9 (5.5 mm): 24" (60 cm) circular (cir).

Size U.S. 10½ (6.5 mm): 24" (60 cm) circular (cir).

Size U.S. 11 (8 mm) 32" (80 cm) circular (cir).

Adjust needle sizes if necessary to obtain the correct gauges.

Notions

Marker (m); cable needle (cn); tapestry needle.

Gauge

16 sts and 23 rnds = 4" (10 cm) over cable patt using size U.S. 9 (5.5 mm) needle.

12½ sts and 18 rnds = 4" (10 cm) over cable patt using size U.S. 11 (8 mm) needle.

Notes

Cowl is worked from the top down and is shaped by using progressively larger needles. It's finished with an I-cord bind-off and an I-cord attached at the cast-on edge.

Top edge of cowl

With smallest cir needle, use long-tail method (see Techniques) and CO 117 sts. Place marker (pm) for beg of rnd, and join for working in rnds, being careful not to twist sts.

Work Rows 1–5 of cable patt, working 9-st rep 13 times across each rnd.

Shape cowl

Change to size U.S. 9 (5.5 mm) needle. Work Rows 6–12 of cable patt, then work Rows 1–12 once more.

Change to size U.S. 10½ (6.5 mm) needle. Work Rows 1–12 of cable patt once.

Change to largest cir needle. Work Rows 1–12 of cable patt once, then work Rows 1–5 once more.

BO all sts using I-cord BO as follows:

With working needle, CO 4 sts using cable CO method (see Techniques).

Row 1: K3, k2tog tbl (last st of I-cord with next st of cowl). Sl 4 sts back to left needle tip.

Rep Row 1 until all cowl sts have been BO and only 4 I-cord sts rem. BO rem 4 sts.

Finishing

Sew ends of I-cord BO tog using mattress st (see Techniques).

ATTACH I-CORD AT CO EDGE
With 2 dpn, CO 4 sts.

Row 1: K3, sl 1 pwise wyib, pick up and k1 st along CO edge, psso. Slide sts back to right end of dpn.

Rep Row 1 along CO edge. BO rem sts. Sew ends of attached I-cord using mattress st.

Weave in ends. Block to measurements, making sure to pin top edge to help prevent rolling.

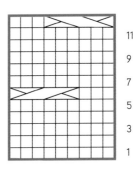

	knit
	3/3 LC (see Stitch Guide)
	3/3 RC (see Stitch Guide)
	pattern repeat

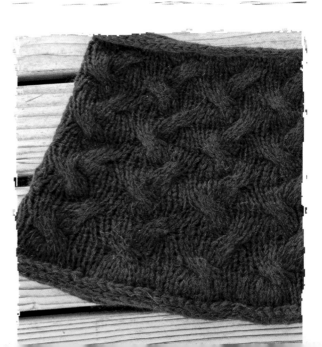

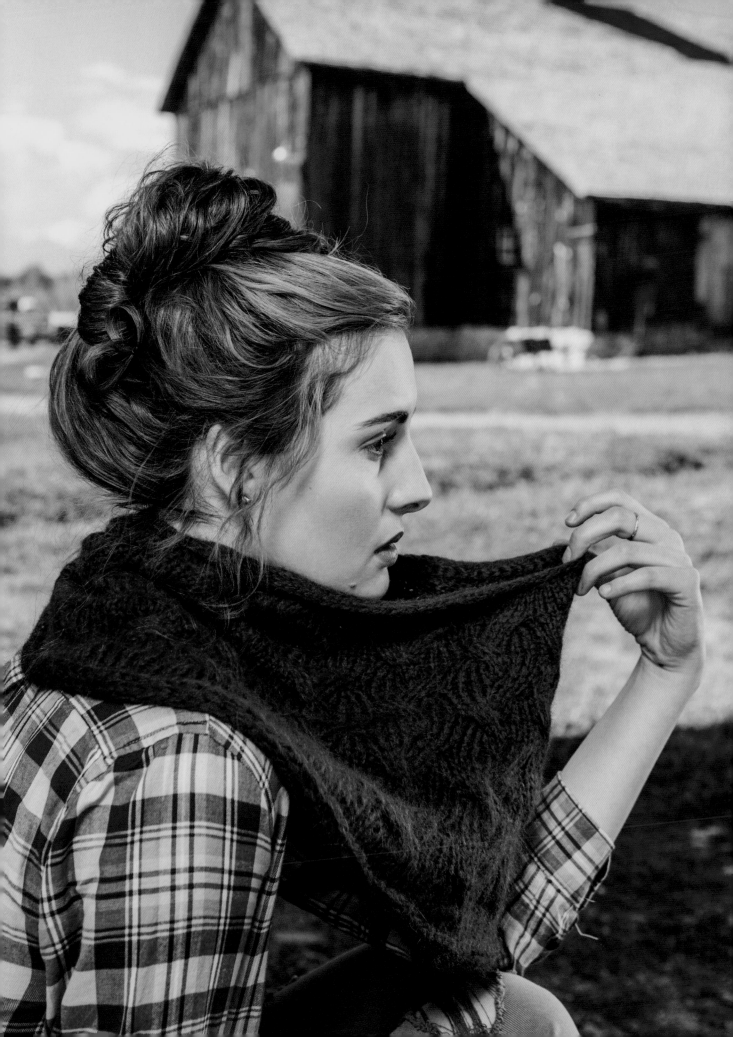

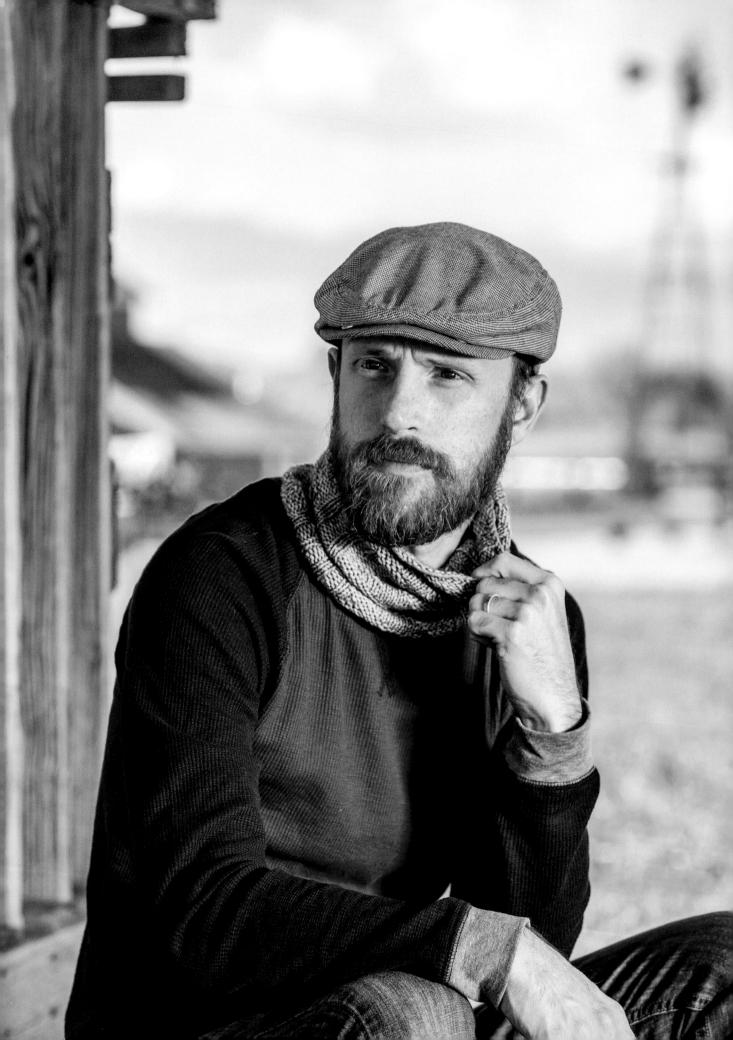

PATHFINDER

BUFF

Knits and purls make a subtle, graphic texture, while shaping creates a cowl that slips over your head and flares at the bottom to fit perfectly under your coat or hoodie. Make it in a semisolid gray for a wardrobe staple or pick your favorite bright hand-dyed DK weight to add a pop of color to your outfit. It's worked from the top down and can easily be modified to be longer.

Finished Measurements
17¾" (45 cm) top circumference, 19" (48.5 cm) bottom circumference, and 10" (25.5 cm) long.

Yarn
159 yd (145 m) DK weight (#3 Light).

Shown here: Hazel Knits Lively DK (90% superwash merino, 10% nylon; 275 yd [251 m]/130 g): color White Wing Dove, 1 skein.

Needles
Size U.S. 5 (3.75 mm): 16" (40 cm) circular (cir).

Adjust needle size if necessary to obtain the correct gauge.

Notions
Marker (m); tapestry needle.

Gauge
19 sts and 29 rnds = 4" (10 cm) over chart patt.

Notes
Cowl is worked from the top down, with increases used to shape the lower portion of the cowl. Stitch pattern is charted only.

STITCH GUIDE

See charts. Read all chart rounds from right to left.

Top edge of cowl

Using long-tail method (see Techniques), CO 84 sts. Place marker (pm) for beg of rnd, and join for working in rnds, being careful not to twist sts.

Work Rnds 1–18 of Chart A twice, then work Rnds 1–9 once more, working 28-st rep 3 times across each rnd.

Shape cowl

Work Rnds 1–27 of Chart B once, working inc on Rnds 1 and 10—90 sts.

Note: To make a longer cowl, repeat rnds 10–27 of Chart B, omitting the additional increase.

BO all sts loosely in patt.

Finishing

Weave in ends. Block to measurements.

CHART A

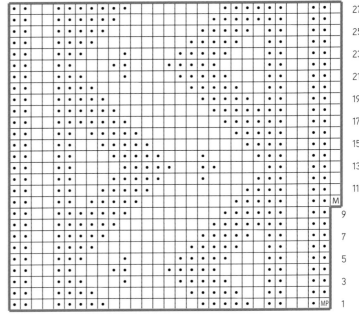

CHART B

knit

• purl

M lifted inc (see Techniques)

MP lifted purl inc (see Techniques)

pattern repeat

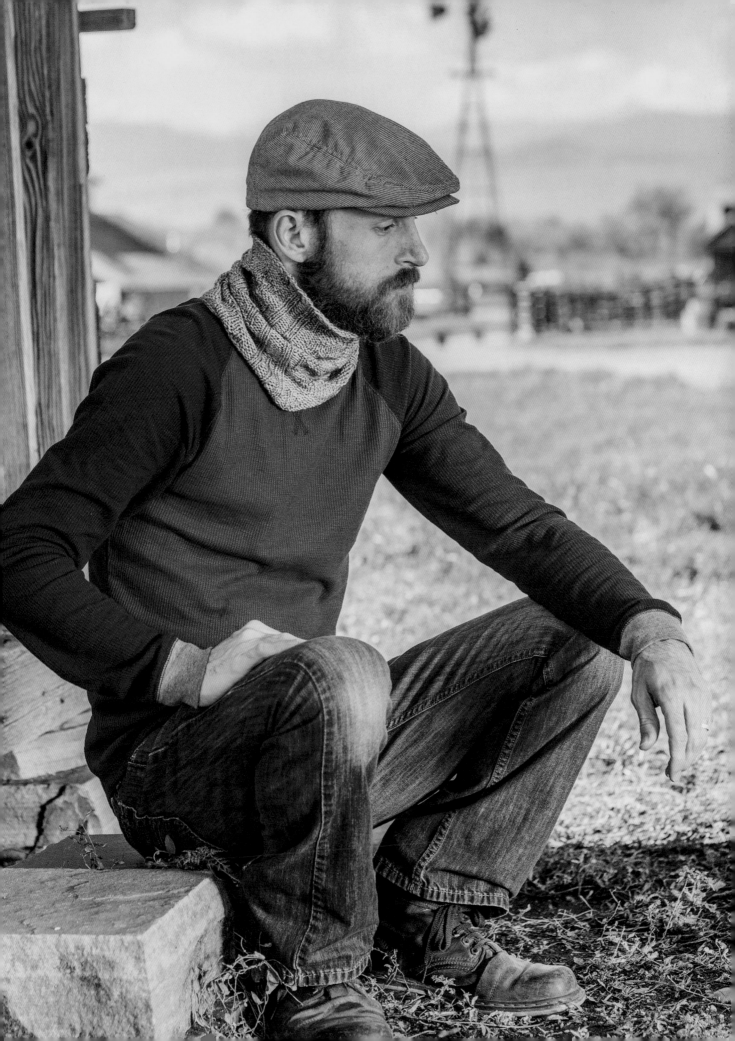

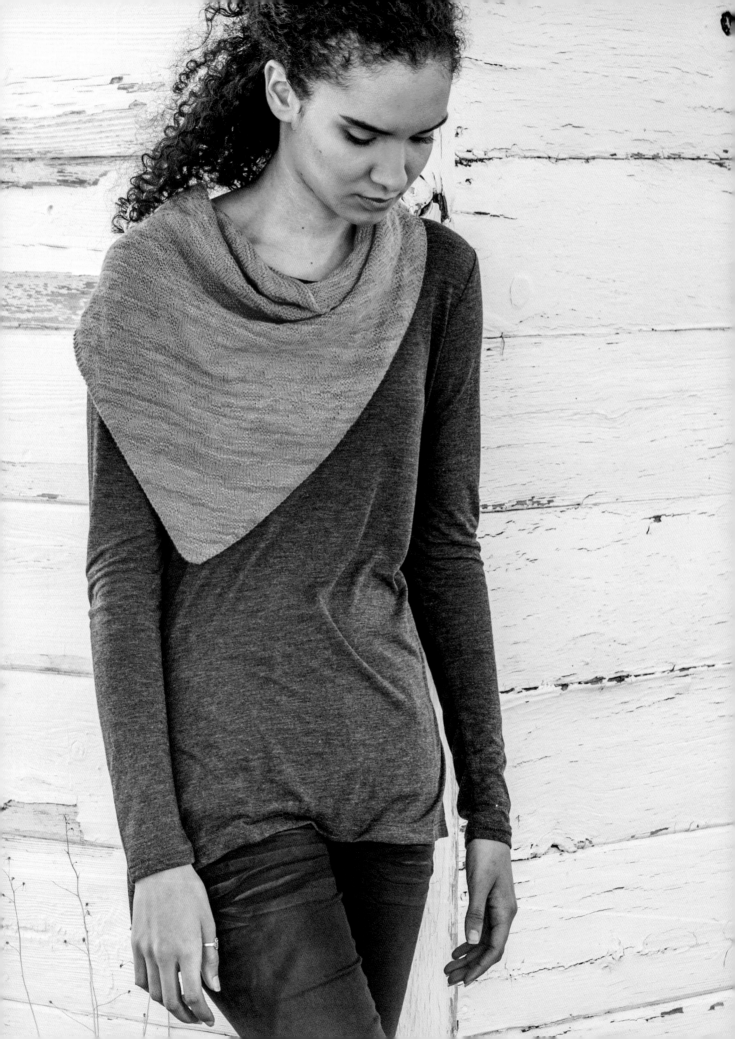

SUN FLARE
SHAWL

Tie this richly textured kerchief on for an evening around the campfire. The nubbly stitch pattern and simple construction make for a fun, engaging knit that will add warmth and color to any outfit. It's worked from the point upward, so you can make it as small or as large as you like.

Finished Size
About 41" (104 cm) wide and 19¾" (50 cm) long.

Yarn
541 yd (495 m) fingering weight (#1 Super Fine).

Shown here: Swans Island Natural Colors Fingering (100% certified organic merino wool; 525 yd [480 m]/100 g): color #YF124 Bittersweet, 1 skein (sample shown uses almost an entire skein; to ensure sufficient amount of yarn for swatching, you may consider purchasing a second skein).

Needles
Size U.S. 2 (2.75 mm): 40" (100 cm) circular (cir).

Adjust needle size if necessary to obtain the correct gauge.

Notions
Size C-2 (2.75 mm) crochet hook; markers (m); tapestry needle; blocking wires.

Gauge
28 sts and 48 rows = 4" (10 cm) over Textured Stitch patt.

Notes
Triangle shawl is worked from the bottom up, starting with the tip of the triangle. A three-stitch garter-stitch border is worked throughout.

The single crochet bind-off creates a stretchy edge. If desired, use the standard bind-off method to BO all sts loosely.

See charts. The charts show only right-side rows; work all wrong-side rows as foll: K3, purl to last 3 sts, k3.

Read chart rows from right to left.

kfbf (knit into front, back, front): Without removing st from left needle tip, knit into the front of the next stitch, then into the back of the same stitch, then into the front of the same stitch again—2 sts increased.

Bottom tip of triangle

Make a slipknot and place on needle—1 st.

Row 1: (RS) Kfbf—3 sts.

Rows 2 and 4: Knit.

Row 3: K1, M1L, k1, M1R, k1—5 sts.

Row 5: K2, M1L, k1, M1R, k2—7 sts.

Row 6: K3, p1, k3.

Body of shawl

Working from charts (see Stitch Guide), work Rows 1–40 of Chart 1—47 sts.

CHART 1

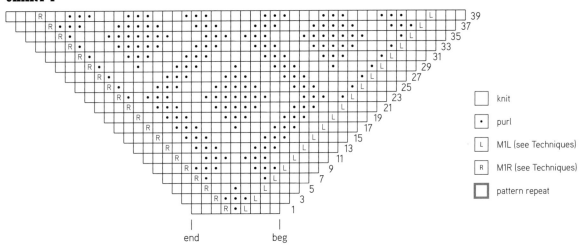

| knit

• purl

L M1L (see Techniques)

R M1R (see Techniques)

pattern repeat

CHART 2

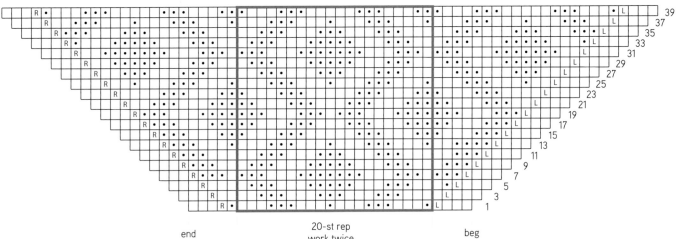

CHART 3

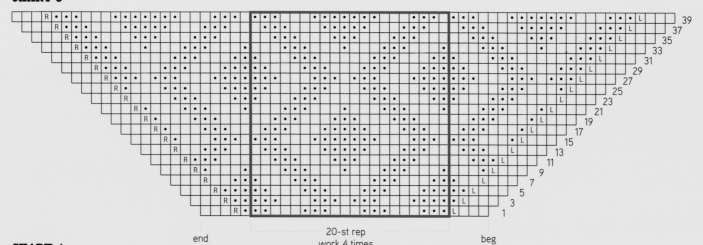

end 20-st rep
work 4 times beg

CHART 4

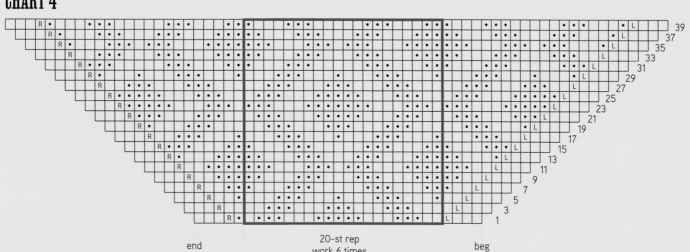

end 20-st rep
work 6 times beg

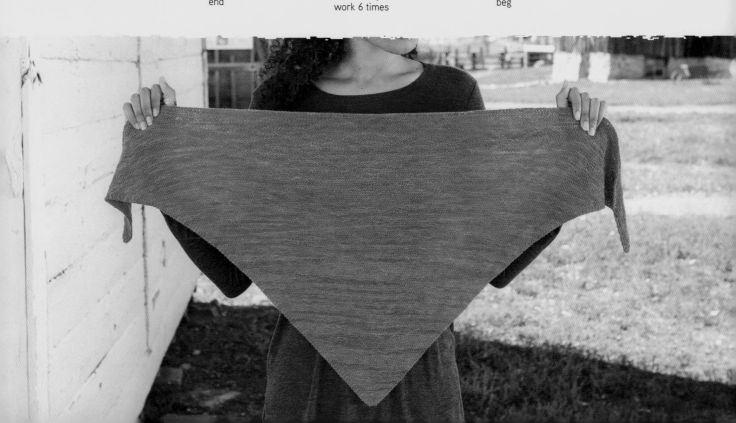

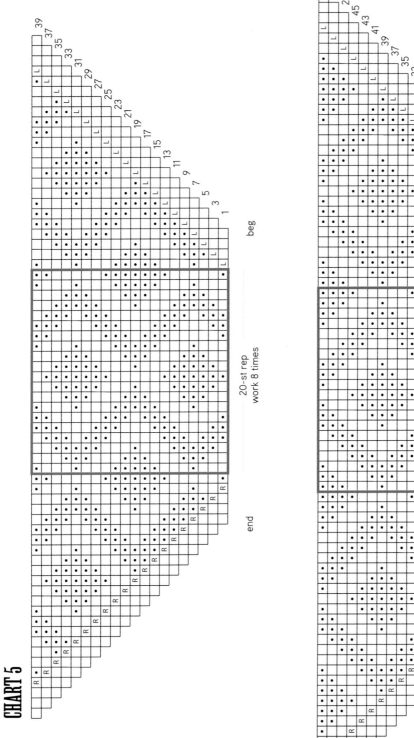

CHART 5

beg

end

20-st rep
work 8 times

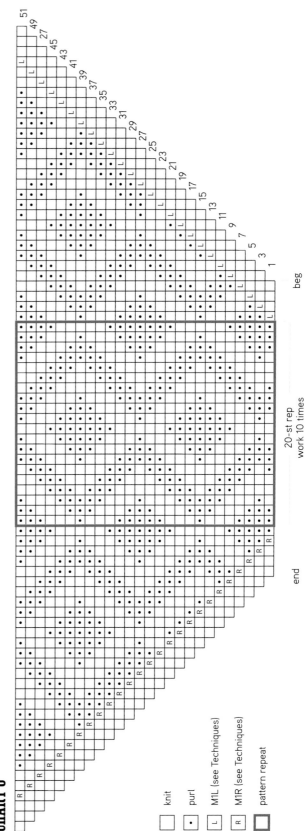

CHART 6

beg

end

20-st rep
work 10 times

□ knit

• purl

L M1L (see Techniques)

R M1R (see Techniques)

▢ pattern repeat

Work Rows 1–40 of Chart 2—87 sts.

Work Rows 1–40 of Chart 3—127 sts.

Work Rows 1–40 of Chart 4—167 sts.

Work Rows 1–40 of Chart 5—207 sts.

Work Rows 1–52 of Chart 6—259 sts.

Top edging

Knit 6 rows even. BO all sts using single crochet method as follows:

Place first st on left needle tip onto crochet hook, *insert hook into next st on left needle tip and slip it off needle (2 sts on hook), yo and draw loop through first st, yo and draw loop through both sts (1 st rem on hook); rep from * until all sts are bound off.

Finishing

Weave in all loose ends. Block aggressively using blocking wires threaded along all three sides because the measurements will relax somewhat when the pins and blocking wires are removed.

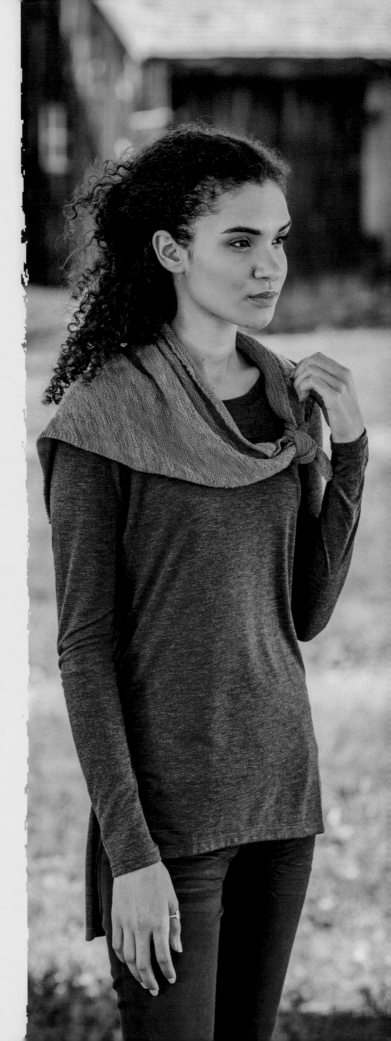

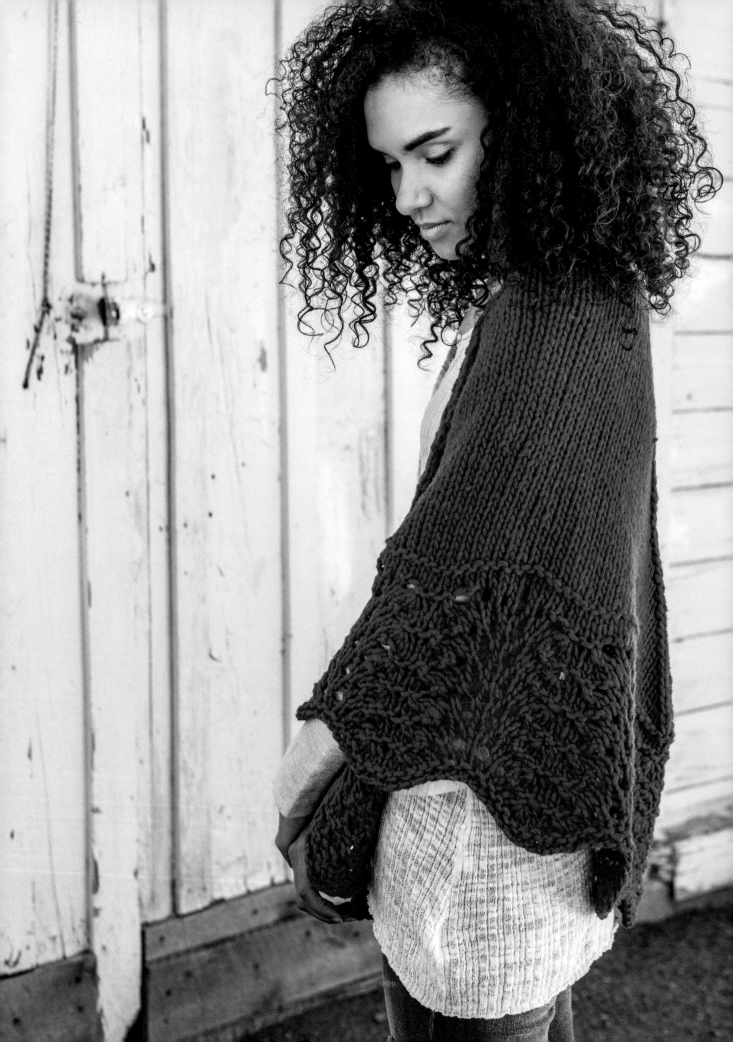

SURGING RIVER
WRAP

This blanket-like wrap is worked from the bottom up, starting with a very simple four-row lace pattern. Decreases are then worked at the edges and center to make a shallow but generous triangle. Blocking spreads out the lace edge for a large wingspan that will keep you cozy all winter. Work it up in a lofty, bulky wool such as Imperial Yarn Native Twist for a plush but lightweight shawl.

Finished Measurements
66" (167.5 cm) wide and 29" (73.5 cm) long.

Yarn
544 yd (497 m) chunky weight (#5 Super Bulky).

Shown here: Imperial Yarn Native Twist (100% wool; 150 yd/4 oz hank): color #06 Cobalt Blue, 4 hanks.

Needles
Size U.S. 13 (9 mm) 40" (100 cm) or longer circular (cir).

Adjust needle size if necessary to obtain the correct gauge.

Notions
Markers (m); removable marker; tapestry needle.

Gauge
10 sts and 15 rows = 4" (10 cm) over St st.

Notes
Shawl is worked from the bottom up, starting with the lace edging. The shaping is worked by decreasing at the beginning and end of every row and at the center of every right-side row.

The lace pattern is both written out and shown in chart form. Read RS rows from right to left and WS rows from left to right.

Feather and Fan Pattern

(multiple of 14 sts +1)

Row 1: (RS) Knit.

Row 2: (WS) Purl.

Row 3: K1, *k4tog, (yo, k1) 5 times, yo, s2k2p, k1; rep from *.

Row 4: K4, *p7, k7; rep from * to last 11 sts, p7, k4.

Rep Rows 1–4 for patt.

S2k2p: Sl 2 sts as if to knit 2 together, k2tog, pass 2 slipped sts over—3 sts dec'd.

Lace edging

Using long-tail method (see Techniques), CO 169 sts. Do not join.

Knit 2 rows.

Work Rows 1–4 of Feather and Fan 6 times, then work Rows 1–2 once more.

Shape Triangle

Set-up row: (RS) P2, place marker (pm), p82, p1 and place removable m on this st, purl to last 2 sts, pm, p2.

Dec row 1: (WS) P2, sm, p2tog, purl to last 4 sts, ssp, sm, p2—2 sts dec'd.

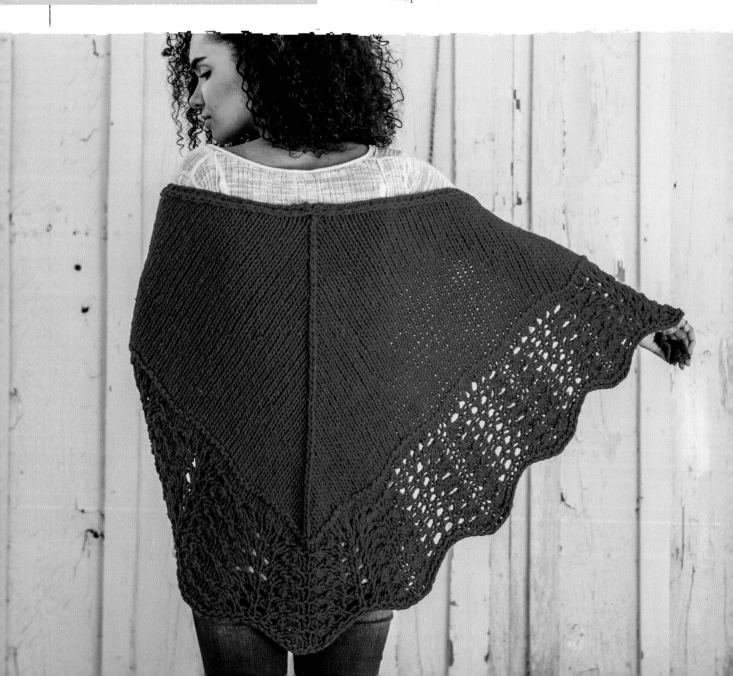

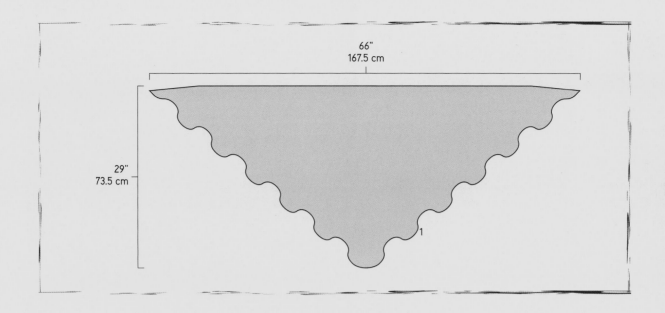

Dec row 2: P2, sm, ssk, knit to 1 st before marked center st, s2kp, knit to last 4 sts, k2tog, sm, p2—4 sts dec'd.

Rep Dec Rows 1–2 twenty-six more times, moving marker at center of row up as you work—7 sts rem.

Next (dec) row: (WS) Removing m as you work, p2, p3tog, p2—5 sts rem.

Next (dec) row: P1, p2tog, p2—4 sts rem. Cut yarn, leaving 8" (20.5 cm) long tail.

Divide sts with first 2 sts on right needle tip and last 2 sts on left needle tip. Thread tail onto tapestry needle and graft sts together using Kitchener st (see Techniques).

Finishing

Weave in ends. Wet-block to measurements (see Techniques).

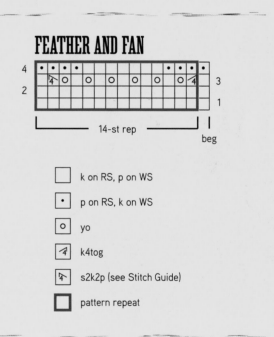

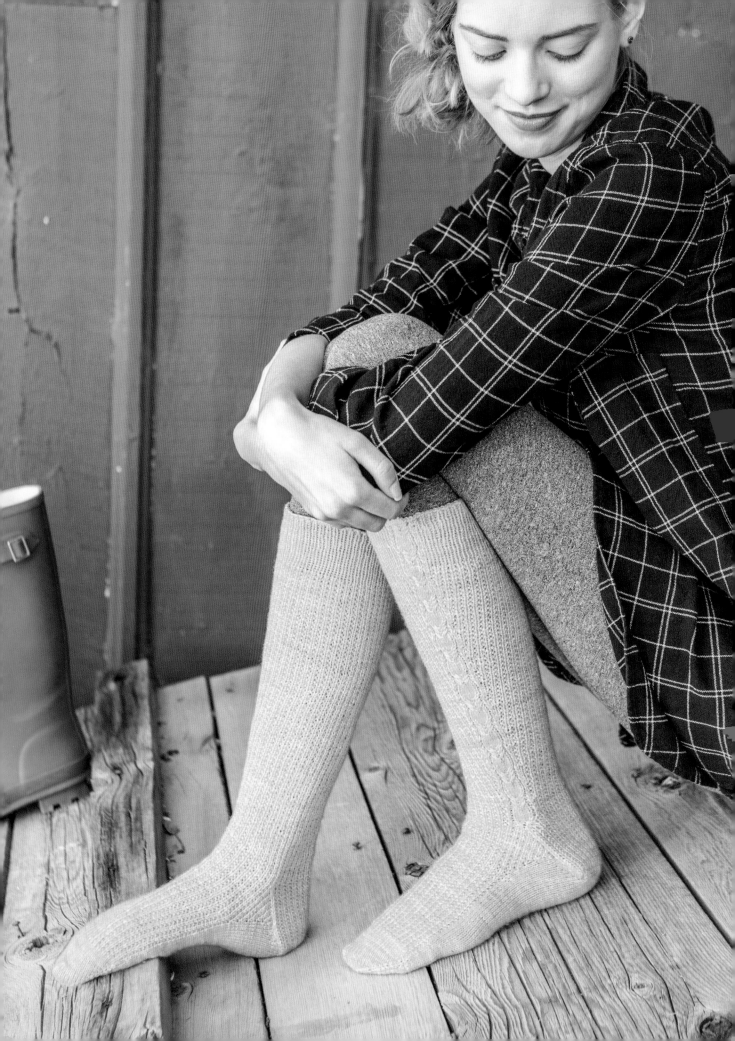

LILY TOES

SOCKS

Rich and bright, these textured knee socks can take you on any adventure. An eye-catching and unusual cable travels up the outside of the shaped leg, while the dense, waffled fabric is durable and looks great with boots. The socks are worked from the toe up, so you can adjust the calf length to your liking without running out of yarn. They also feature a shaped gusset, heel flap, and ribbed cuff for a snug, comfortable fit.

Finished Sizes
7 (8, 8¾, 9¾)" (18 [20.5, 22, 25] cm) foot circumference and 15½" (39.5 cm) long.

Shown in size 8" (20.5 cm).

Yarn
629 (679, 732, 782) yd (575 [621, 669, 715] m) fingering weight (#1 Super Fine).

Shown here: Hazel Knits Artisan Sock (90% superwash merino wool, 10% nylon; 400 yd [366 m]/120 g): color Midas, 2 (2, 2, 3) skeins.

Needles
Size U.S. 2 (2.75 mm) set of 4 or 5 double-pointed (dpn), long circular (cir), two short circular needles, or other needles preferred for small-circumference circular knitting.

Adjust needle size if necessary to obtain the correct gauge.

Notions
Markers (m); cable needle (cn); tapestry needle.

Gauge
34 sts and 51 rnds = 4" (10 cm) over St st.

33 sts and 52 rnds = 4" (10 cm) over Broken Rib.

Notes
Socks are worked from the toe up with short-rows and heel flaps. To adjust the leg length, work more (or fewer) rounds between increases when shaping the leg or work more (or fewer) rounds after the last increase round.

Triple Gulls Cable

(panel of 10 sts)

Rnd 1: K1-tbl, p3, sl 2 pwise wyb, p3, k1-tbl.

Rnd 2: K1-tbl, p1, 1/2 RC, 1/2 LC, p1, k1-tbl.

Rnds 3–8: K1-tbl, p1, k6, p1, k1-tbl.

Rnds 9, 11, and 13: K1-tbl, p1, k2, sl 2 pwise wyb, k2, p1, k1-tbl.

Rnds 10 and 12: K1-tbl, p1, 1/2 RC, 1/2 LC, p1, k1-tbl.

Rep Rnds 2–13 for patt.

1/2 RC (1 over 2 right cross): Sl 2 sts onto cn and hold to back of work, k1, k2 from cn.

1/2 LC (1 over 2 left cross): Sl 1 st onto cn and hold to front of work, k2, k1 from cn.

Toe

Using Judy's magic cast-on (see Techniques), CO 12 (14, 14, 16) sts. Place marker (pm) for beg of rnd and join for working in rnds, taking care not to twist sts.

Set-up rnd: K6 (7, 7, 8), pm, knit to end.

Inc rnd: *K1f/b, knit to 1 st before m, k1f/b, sm; rep from * once more—4 sts inc'd.

Rep Inc Rnd every rnd 3 (3, 4, 5) more times, then every other rnd 7 (9, 10, 10) times—56 (66, 74, 80) sts.

SIZE 7 (9¾)" (18 [25] CM) ONLY:
Inc rnd: *K1f/b, knit to m, sm; rep from * once more—58 (82) sts; 29 (41) sts each for instep and sole.

SIZE 8 (8¾)" (20.5 [22] CM) ONLY:
Knit 1 rnd even—66 (74) sts; 33 (37) sts each for instep and sole.

Foot

Rnd 1: Knit to m, sm, [k1, p1] to last st, k1.

Rnd 2: Knit.

Rep last 2 rnds, working St st over sole and Broken Rib patt over instep until piece measures 5 (6, 7, 8)" (12.5 [15, 18, 20.5] cm) from CO or 3" (7.5 cm) short of desired foot length, end with rep rnd 2.

GUSSET

Inc rnd 1: Knit to m, sm, k1, M1, [p1, k1] to 2 sts before m, p1, M1, k1—2 sts inc'd over instep.

Work 2 rnds even.

Inc rnd 2: Knit to m, sm, k1, M1p, [k1, p1] to 2 sts before m, k1, M1p, k1—2 sts inc'd over instep.

Rep last 4 rnds 4 more times—78 (86, 94, 102) sts; with 49 (53, 57, 61) for instep and 29 (33, 37, 41) for sole.

		knit
•		purl
ℛ		k1-tbl
V		sl 1 wyb
⧄		1/2RC (see Stitch Guide)
⧅		1/2LC (see Stitch Guide)
		pattern repeat

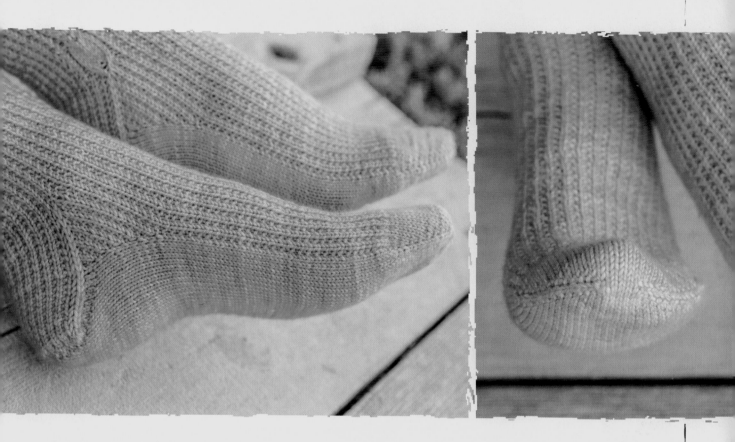

Heel

TURN HEEL

Short-row 1: (RS) Knit to 2 sts before m, M1, k1, w&t.

Short-row 2: Purl to 2 sts before m, M1p, p1, w&t.

Rep last 2 rows 8 more times—96 (104, 112, 120) sts, with 49 (53, 57, 61) sts for instep and 47 (51, 55, 59) sts for sole.

Next rnd: Knit to m, picking up wraps and working them tog with the sts they wrap, sm, work in patt to end.

Cont working in the rnd.

HEEL FLAP

Dec short-row 1: (RS) K38 (42, 46, 50), picking up rem wraps and working them tog with the sts they wrap, ssk, turn—1 st dec'd.

Dec short-row 2: Sl 1, p27 (31, 35, 39), p2tog, turn—1 st dec'd.

Dec short-row 3: Sl 1, [k1, p1] to 2 sts before gap made by previous turn, k1, ssk, turn—1 st dec'd.

Dec short-row 4: Sl 1, purl to 1 st before gap, p2tog, turn—1 st dec'd.

Rep last 2 short-rows 16 more times—60 (68, 76, 84) sts rem; 49 (53, 57, 61) sts for instep and 11 (15, 19, 23) sts for sole.

Cont working in the rnd again.

Next (dec) rnd: Sl 1, [k1, p1] to 2 sts before gap, k1, ssk, [k1, p1] to last st, k1—59 (67, 75, 83) sts rem.

Left leg

Dec rnd: K2tog, k23 (27, 31, 35), pm, work Set-up Rnd of Triple Gulls Cable over next 10 sts, knit to end—58 (66, 74, 82) sts.

Next rnd: [P1, k1] to 1 st before m, p1, sm, work Rnd 1 of Triple Gulls Cable over next 10 sts, [p1, k1] to end.

Next rnd: Knit to m, work next rnd of Triple Gulls Cable over next 10 sts, knit to end.

Work 8 more rnds in established patt.

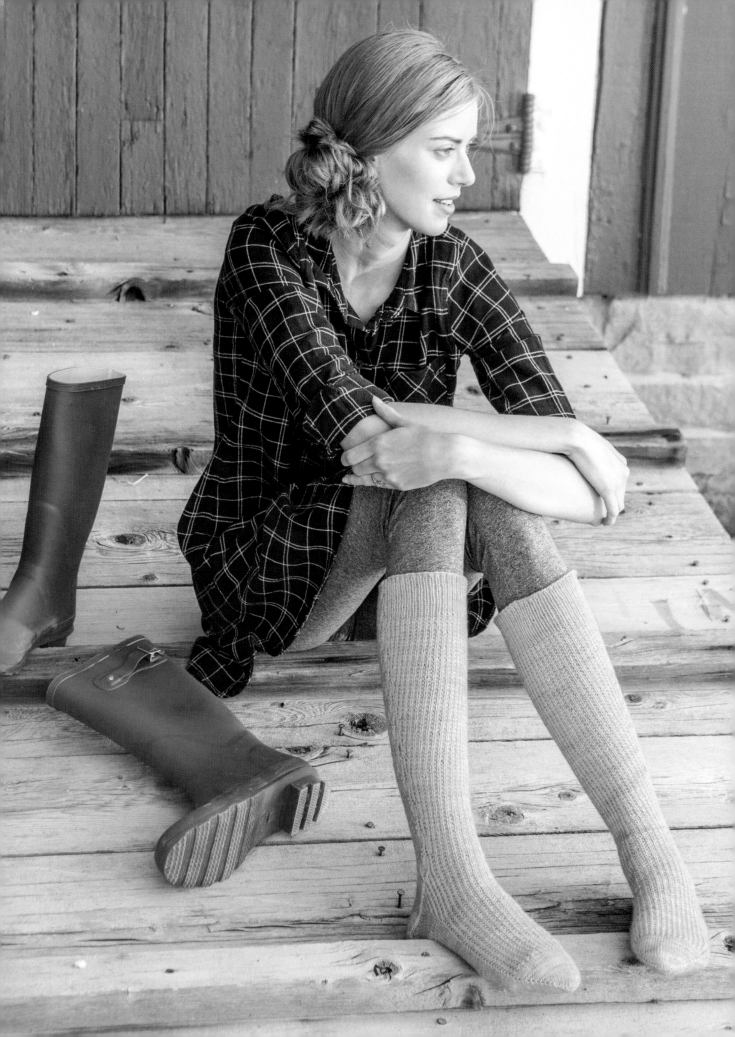

Inc rnd: Work in established patt to m, M1R, sm, work to m, sm, M1L, work in established patt to end—2 sts inc'd.

Rep Inc Rnd every 8 rnds 5 more times, then every 6 rnds 12 times—94 (102, 110, 118) sts. Work new sts into Broken Rib patt. *Note:* Every other increase should be worked as M1p to maintain the pattern.

Work even until piece measures about 13½" (34.5) cm from beg of heel flap, ending with a knit rnd of Broken Rib.

CUFF
Rnd 1: [P1, k1] to 1 st before m, p1, sm, work next rnd of Triple Gulls Cable over next 10 sts, sm, [p1, k1] to end.

Rep last rnd until cuff measures 2" (5 cm).

BO all sts loosely in patt.

Right leg
Dec rnd: K2tog, p3, k1, pm for new beg of rnd, knit to m and remove m, knit to 5 sts before new end of rnd, pm, k1, p3, k1—58 (66, 77, 82) sts.

Work right leg same as for left leg.

Finishing
Weave in all loose ends. Block to measurements.

WEATHERED MOUNTAIN
HAT

I'm always looking for slim, lightweight hats that look good and work under my bike helmet. This tweedy, textured toque features an understated waffle-stitch pattern that's equally fetching on men and women. It's worked bottom-up with square crown shaping.

Finished Sizes
About 18½ (20, 21¼, 22¾)" (47 [51, 54, 58] cm) circumference and 7 (7¼, 7½, 7¾)" (18 [18.5, 19, 19.5] cm) long.

Example A shown on woman in size 18½" (47 cm).

Example B shown on man in size 21¼" (54 cm).

Yarn
154 (170, 181, 192) yd (141 [155, 165, 175] m) sock weight (#1 Super Fine).

Shown here: Brooklyn Tweed Loft (100% Targhee-Columbia wool; 275 yd [251 m]/50 g): color Sap (Example A); Artifact (Example B), 1 (1, 1, 1) skein.

Needles
Size U.S. 3 (3.25 mm): 16" (40 cm) circular (cir) and set of 5 double-pointed (dpn).

Adjust needle size if necessary to obtain the correct gauge.

Notions
Markers (m); tapestry needle.

Gauge
22½ sts and 43 rnds = 4" (10 cm) in Dots Textured st.

Notes
Hat is worked in the round from the bottom up with square crown shaping. The Dots Textured st pattern is maintained through crown shaping.

Dots Textured Stitch

(multiple of 8 sts)

Rnds 1 and 8: *P2, k4, p2; rep from *.

Rnds 2 and 7: *P1, k6, p1; rep from *.

Rnds 3 and 6: *K3, p2, k3; rep from *.

Rnds 4 and 5: *K2, p4, k2; rep from *.

Rep Rnds 1–8 for patt.

Brim

With cir needle, CO 104 (112, 120, 128) sts. Place marker (pm) for beg of rnd and join for working in rnds, being careful not to twist sts.

Rnd 1: [K2, p2] around.

Rep last rnd until piece measures 1 (1, 1¼, 1¼)" (2.5 [2.5, 3.2, 3.2] cm) from beg.

Body of hat

Work Rnds 1–8 of Dots Textured st 5 times; piece should measure about 4¾ (4¾, 5, 5)" (12 [12, 12.5, 12.5] cm) from beg.

Crown

Set-up rnd: *Work 26 (28, 30, 32) sts in est patt, pm; rep from * 2 more times, then work to end.

SHAPE CROWN

Change to dpn when too few sts rem to work comfortably on cir needle.

Dec rnd: *K1, k2tog, work in est patt to 3 sts before m, ssk, k1; rep from * to end—8 sts dec'd.

Next rnd: *K1, work in est patt to 1 st before m, k1; rep from * to end.

Rep last 2 rnds 10 (11, 12, 13) more times—16 sts rem.

Dec rnd: *K2tog, ssk; rep from * to end—8 sts rem.

Cut yarn, leaving a 6" (15 cm) long tail, draw tail through rem sts, and pull tight to close hole. *Note:* Loft is a delicate yarn and may break if pulled too forcefully.

Finishing

Weave in ends. Block to measurements.

	knit
•	purl
☐	pattern repeat

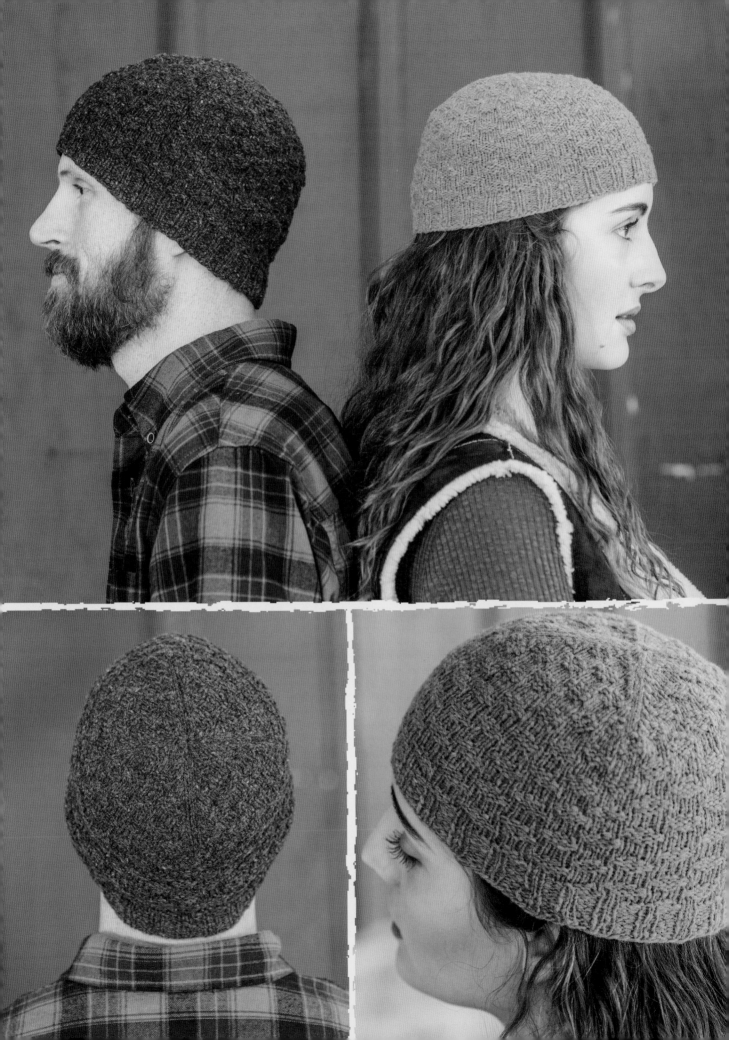

BLUEBERRY PAWS
MITTS

Outdoor pursuits demand free fingers, so I love fingerless mitts for keeping me cozy and capable. These mitts combine a durable waffle-stitch pattern with a lush merino wool/cashmere/nylon-blend yarn for the ideal combination of practical luxury. Delicate cables are placed on the outside of each hand; a gusseted thumb makes for a comfortable, attractive fit.

Finished Size
To fit a hand circumference of 6–7 (7–8)" (15–18 [18–20.5] cm), mitts measure about 5½ (6¼)" (14 [16] cm) in circumference and 6½ (7½)" (16.5 [19] cm) long.

Shown in size 5½" (14 cm).

Yarn
117 (153) yd (107 [140] m) sock weight (#1 Super Fine).

Shown here: Hazel Knits Entice MCN (70% superwash merino wool, 20% cashmere, 10% nylon; 400 yd[366 m]/115 g): color Laguna, 1 skein.

Needles
Size U.S. 3 (3.25 mm) set of 4 or 5 double-pointed (dpn).

Adjust needle size if necessary to obtain the correct gauge.

Notions
Markers (m); stitch holder or waste yarn; tapestry needle.

Gauge
28 sts and 44 rows = 4" (10 cm) over Broken Rib.

12-st cable panel = about 1¼" (3.2 cm) wide.

Notes
Mitts are worked from the bottom up, from the wrist to the fingers. The cables in the cable panel can be worked without a cable needle; the method is on page 113.

Triple Gull Stitch
(panel of 12 sts)

Rnds 1, 3, and 11: K1-tbl, p2, k6, p2, k1-tbl.

Rnds 2, 10, and 12: K1, p2, k6, p2, k1.

Rnds 4, 6, and 8: K1, p2, k2, sl 2 wyb, k2, p2, k1.

Rnds 5, 7, and 9: K1-tbl, p2, 1/2 RC, 1/2 LC, p2, k1-tbl.

Rep Rnds 1–12 for patt.

1/2 RC (1 over 2 right cross): Sl 2 sts to cable needle (cn) and hold in back of work, k1, k2 from cn.

1/2 LC (1 over 2 left cross): Sl 1 st to cn and hold in front of work, k2, k1 from cn.

Right mitt

WRIST CUFF

CO 41 (47) sts. Divide sts over 3 or 4 dpn, with 12 sts on needle 1, and rem sts evenly spaced over rem needles. Place marker (pm) and join for working in rnds, being careful not to twist sts.

Rnd 1: Work Rnd 1 of Triple Gull st over first 12 sts, [p1, k1] to last st, p1.

Cont in est patt until piece measures 2½" (6.5 cm) from beg.

THUMB GUSSET

Begin working Broken Rib patt and thumb gusset as follows:

Rnd 1 (inc): Work 12 sts in est patt, [p1, k1] 5 (7) times, pm, m1, k1, m1, [k1, p1] to end—43 (49) sts, with 3 sts between m for gusset.

Rnds 2 and 4: Work 12 sts in est patt, knit to end, slipping markers as you come to them.

Rnd 3: Work 12 sts in est patt, [p1, k1] to m, sm, knit to m, sm, [k1, p1] to end.

Rep last 4 rnds 5 (6) more times—53 (61) sts, with 13 (15) sts between m for gusset.

Next rnd: Work in est patt to m, remove m, and place next 13 (15) sts onto holder or waste yarn, remove m, CO 1 st over gap using backward-loop method (see Techniques), then work to end—41 (47) sts rem.

HAND CUFF

Work in est patts until piece measures 6½ (7½)" (16.5 [19] cm) from beg. BO all sts in patt.

Left mitt

Work left wrist cuff same as right.

WORK GUSSET AS FOLLOWS:

Rnd 1: Work 12 sts in established patt, [p1, k1] 9 (10) times, pm, m1, k1, m1, [k1, p1] to end—43 (49) sts, with 3 sts between m for gusset.

	knit
•	purl
ℓ	k1-tbl
V	sl 1 wyb
⟋	1/2RC (see Stitch Guide)
⟍	1/2LC (see Stitch Guide)
	pattern repeat

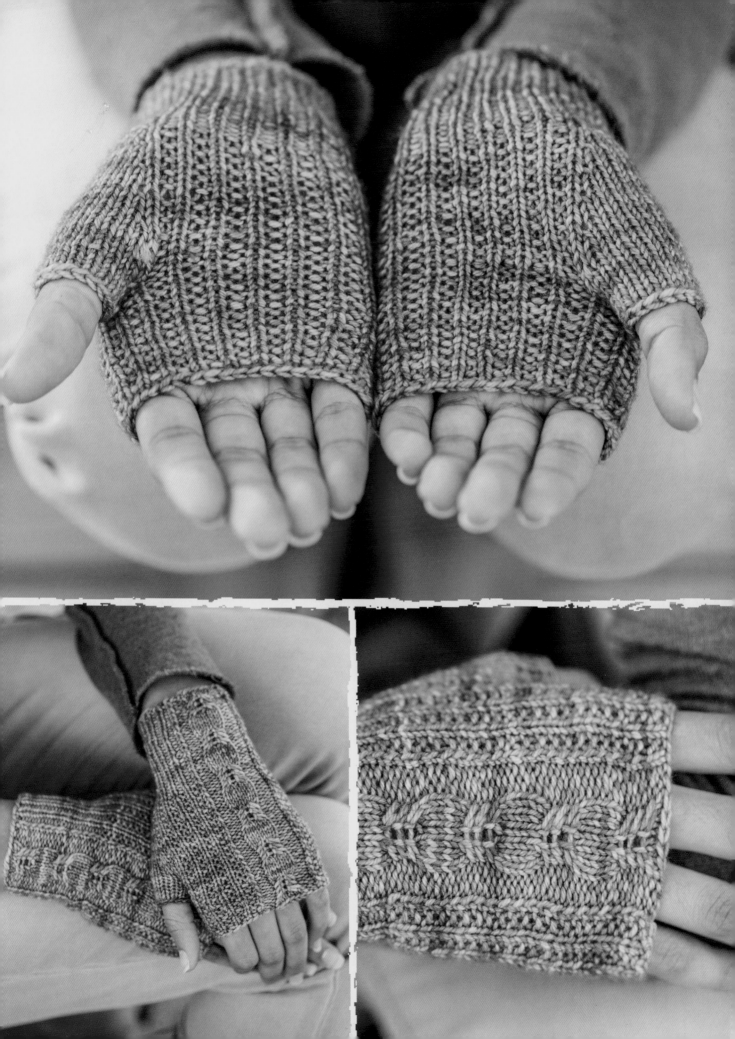

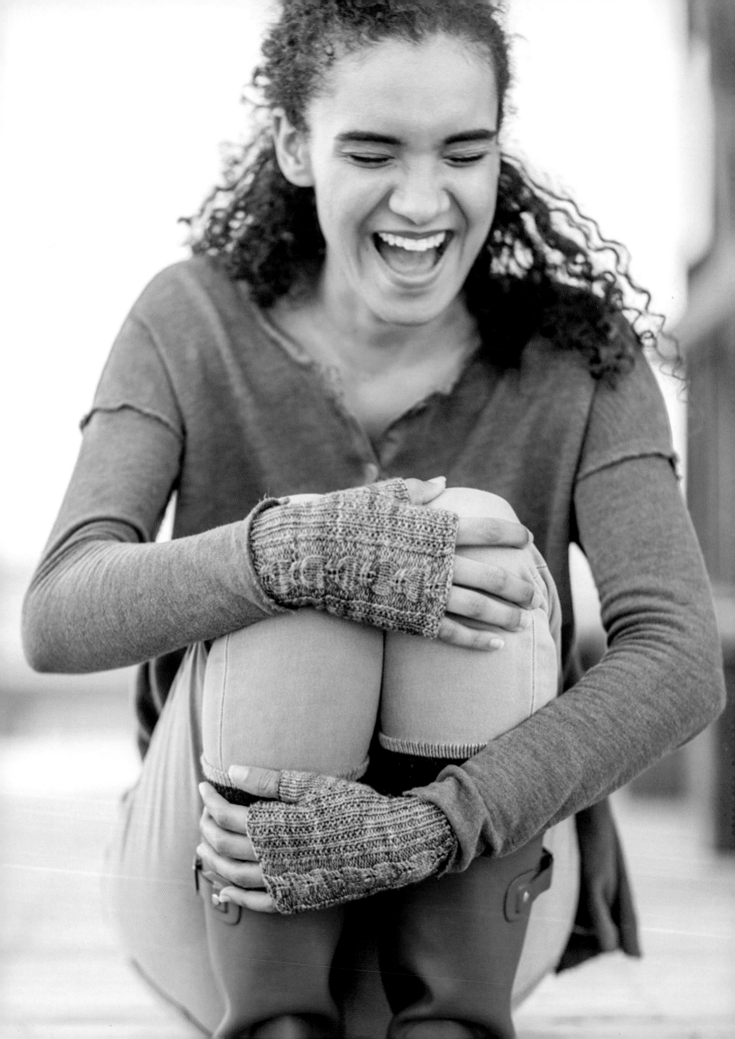

Work in patt to sts to be crossed. Slip next st on left needle tip from needle, and hold in front for right cross, or back for left cross.

Slip next st to right needle tip.

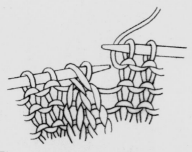

Place dropped st back on left needle tip, then return slipped st to left needle tip.

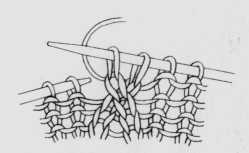

Knit the stitches to complete the cable.

Rnds 2–4: Work 12 sts in est patt, [p1, k1] to m, sm, knit to m, sm, [k1, p1] to end.

Rep last 4 rnds 5 (6) more times—53 (61) sts, with 13 (15) sts between m for gusset.

Next rnd: Work in est patt to m, remove m, and place next 13 (15) sts onto holder or waste yarn, remove m, CO 1 st over gap, then work to end—41 (47) sts rem.

LEFT HAND CUFF

Work same as for right-hand cuff.

Thumbs

Return held sts to dpn. With RS facing, pick up and k1 st in gap at top of opening, k13 (15) thumb sts, pick up and k1 st in gap at top of opening—15 (17) sts. Pm for beg of rnd and join for working in rnds.

Knit 6 (8) rnds even. BO all sts.

Finishing

Weave in loose ends. Block to measurements.

BOREAL
TOQUE

When you need a little extra warmth, go for this colorwork toque. The fingering-weight yarn creates a fabric that's not too heavy to fit under your climbing or bike helmet, but you'll love the extra squishy layer of color over your ears. The tweedy, rustic style looks great on men and women, and the possible color combinations are endless. Since the color pattern is fairly simple, this is a great introduction for those new to stranded colorwork.

Finished Size
About 20¼ (21, 22)" (51.5 [53.5, 56] cm) head circumference and 7½ (7¾, 8¼)" (19 [19.5, 21] cm) long.

Example A shown on woman in size 21" (53.5 cm).

Example B shown on man in size 22" (56 cm).

Yarn
Sock weight (#1 Super Fine).

Main Color (MC): 119 (128, 137) m.

Contrast Color (CC): 36 (46, 55) m.

Shown here: Brooklyn Tweed Loft (100% Targhee-Columbia wool; 275 yd [251 m]/50 g): colors for Example A: Old World (MC), 1 skein; Snowbound (CC), 1 skein; colors for Example B: Pumpernickel (MC), 1 skein; Hayloft (CC), 1 skein.

Needles
Size U.S. 3 (3.25 mm): 16" (40 cm) circular (cir) and set of 4 or 5 double-pointed (dpn).

Size U.S. 5 (3.75) mm 16" (40 cm) circular (cir).

Adjust needle sizes if necessary to obtain the correct gauges.

Notions
Markers (m); tapestry needle.

Gauge
25 sts and 36 sts = 4" (10 cm) over St st using smaller needle.

25 sts and 31 sts = 4" (10 cm) over color chart using larger needle.

Notes
Hat is worked in the round from the bottom up with square crown shaping. Many knitters work more tightly in stranded colorwork than in plain stockinette, so I recommend using a needle two sizes larger than the needle used for ribbing and plain stockinette. Be sure to swatch in both plain stockinette and the color chart to see what needle sizes are appropriate for you.

Brim

With smaller cir needle and MC, CO 126 (132, 138) sts. Place marker (pm) for beg of rnd and join for working in rnds, being careful not to twist sts.

Rnd 1: *K3, p3; rep from * around.

Rep last rnd until piece measures ¾ (¾, 1)" (2 [2, 2.5] cm) from beg.

Knit 1 rnd.

Body of hat

Change to larger cir needle. Work Rnds 1–27 of color chart. Piece measures about 4¼ (4¼, 4½)" (11 [11, 11.5] cm). Cut CC.

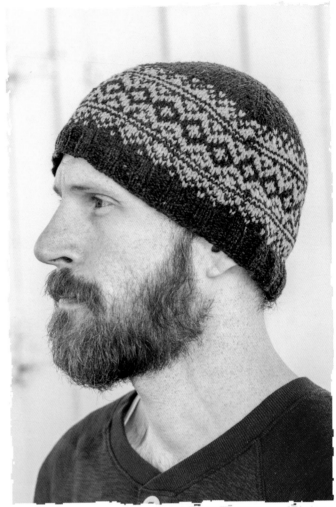

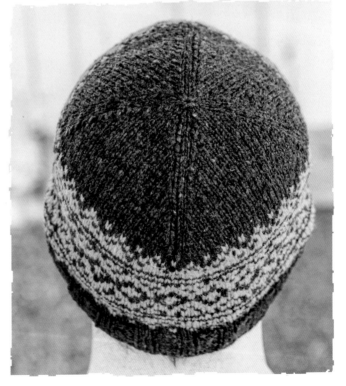

COLOR CHART

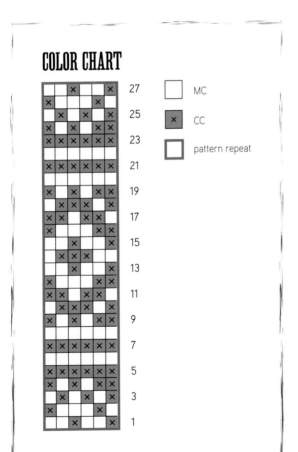

☐ MC

☒ CC

☐ pattern repeat

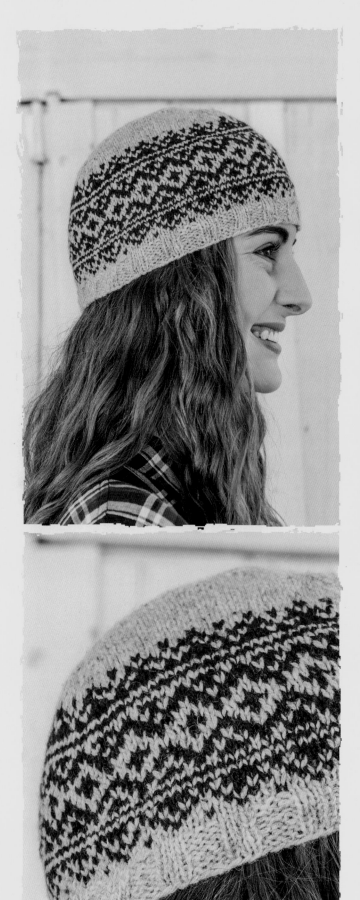

Crown

Change to smaller cir needle. Knit 1 rnd.

Dec rnd: *K19 (31, 67), k2tog; rep from * to end—
120 (128, 136) sts rem.

Set-up rnd: *K30 (32, 34), pm; rep from * 2 more
times, then work to end.

SHAPE CROWN

Change to dpn when too few sts rem to work com-
fortably on cir needle.

Dec rnd: *K1, k2tog, knit to 3 sts before m, ssk, k1;
rep from * to end—8 sts dec'd.

Next rnd: Knit.

Rep last 2 rnds 12 (13, 14) more times—16 sts rem.

Dec rnd: *K2tog, ssk; rep from * to end—8 sts rem.

Cut yarn, leaving a 6" (15 cm) long tail, draw tail
through rem sts, and pull tight to close hole. *Note:*
Loft is a delicate yarn and may break if pulled too
forcefully.

Finishing

Weave in ends. Block to measurements.

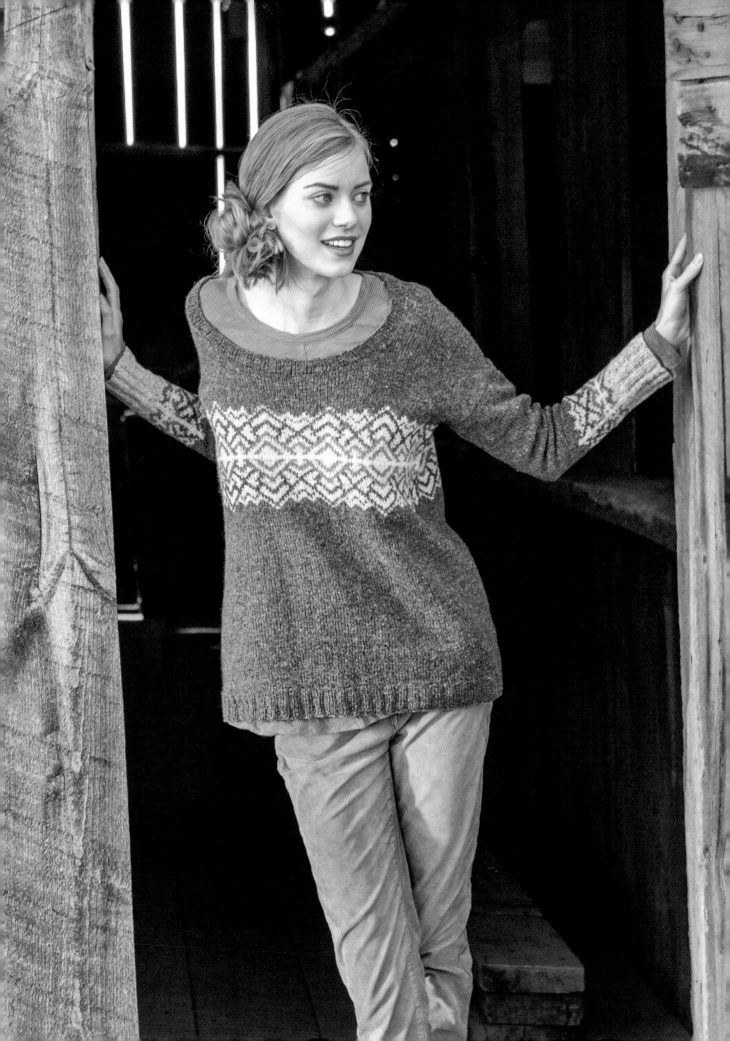

GLEAMING HORIZON
SWEATER

This is the sweater for all your outdoor activities this fall and for many years to come. The drop-shoulder construction leaves plenty of room to move, whether you're cycling, hiking, or just getting things done in the backyard. The striking colorwork adds a pop to any outfit, and the woolen-spun yarn creates a lightweight, draping, warm fabric. Gentle waist shaping, slender sleeves, and a deep scoop neck give this oversized pullover feminine flare. It's worked in the round from the bottom up, the shaped shoulders are joined using three-needle bind-off, and sleeves are sewn in using mattress stitch. The colorwork employs three colors at once over a few of the rounds, so it's best for knitters with some colorwork experience.

Notes

Body is worked in the round from the bottom up to the armholes, then the front and back are worked separately back and forth. Shoulders are shaped using short-rows, then joined with three-needle bind-off. Sleeves are worked entirely in the round, then seamed into the armholes using mattress stitch. Ribbed neckband is picked up and worked after joining shoulders.

Many knitters work more tightly in stranded colorwork than in plain stockinette stitch or ribbing; a larger needle is recommended for colorwork. Swatch in color pattern and plain stockinette to determine if a larger needle is necessary.

Read all chart rows from right to left every round.

Finished Size

38 (42, 46, 50, 54, 58)" (91.5 [106.5, 117, 127, 137, 147.5] cm) bust circumference and 26¾ (27, 28, 29¼, 30½, 31½)" (68 [68.5, 71, 74.5, 77.5, 80] cm) long.

Intended to be worn with 8–10" (20.5–25.5 cm) of positive ease.

Shown in size 42" (106.5 cm).

Yarn

Fingering weight (#1 Super Fine).

Main Color (MC): 1210 (1336, 1479, 1622, 1771, 1914) yd (1106 [1222, 1352, 1483, 1619, 1750] m).

Contrast Color 1 (CC1): 236 (259, 285, 310, 334, 359) yd (216 [237, 260, 283, 305, 328] m).

Contrast Color 2 (CC2): 81 (89, 97, 106, 114, 122) yd (74 [81, 89, 97, 104, 112] m).

Contrast Color 3 (CC3): 17 (19, 21, 23, 25, 27) yd (16 [17, 19, 21, 23, 25] m).

Shown here: Brooklyn Tweed Loft (100% Targhee-Columbia wool; 275 yd [251 m]/50 g skein): colors Soot (MC), 5 (6, 6, 7, 7, 8) skeins; Snowbound (CC1), 1 (1, 2, 2, 2, 2) skein(s); Hayloft (CC2), 1 skein; Fossil (CC3), 1 skein.

Needles

Size U.S. 4 (3.5 mm) 16" and 32" (40 and 80 cm) circular (cir) and set of 4 or 5 double-pointed (dpn).

Size U.S. 6 (4 mm) 16" and 32" (40 and 80 cm) circular (cir) and set of 4 or 5 double-pointed (dpn).

Adjust needle sizes if necessary to obtain the correct gauges.

Notions

Markers (m); tapestry needle.

Gauge

24 sts and 41 rows = 4" (10 cm) over St st using smaller needles.

24 sts and 30 rnds = 4" (10 cm) over chart patt using larger needles.

Body

With longer, smaller cir needle and MC, CO 228 (252, 276, 300, 324, 348) sts. Place marker (pm) and join for working in rnds, being careful not to twist sts.

HEM

Rnd 1: *K2, p2; rep from *.

Cont in established rib patt until piece measures 1¾ (1¾, 2, 2¼, 2½, 2¾)" (4.5 [4.5, 5, 5.5, 6.5, 7] cm) from beg.

SHAPE WAIST

Set-up rnd: K114 (126, 138, 150, 162, 174), pm for right side, k114 (126, 138, 150, 162, 174).

Cont in St st (knit every rnd), slipping m as you come to them, until piece measures 6¼ (6¼, 6½, 6¾, 7, 7¼)" (16 [16, 16.5, 17, 18, 18.5] cm) from beg.

Next (dec) rnd: *K1, ssk knit to 3 sts before m, k2tog, k1, sm; rep from * once more—4 sts dec'd.

Rep Dec Rnd every 24 rnds twice more—216 (240, 264, 288, 312, 336) sts rem.

SHAPE BUST

Knit 15 rnds even.

Next (inc) rnd: *K1, yo, knit to 1 st before m, yo, k1, sm; rep from * once more—4 sts inc'd.

Next rnd: K1, k1-tbl, knit to 2 sts before m, k1-tbl, k1, sm; rep from * once more.

Knit 3 rnds even, slipping m as you come to them.

Change to larger, longer cir needle.

Next rnd: Join CC1 and k1 with MC, beg at right edge of chart for your size and work 4 (0, 6, 2, 8, 4) sts, work 20-st rep 5 (6, 6, 7, 7, 8) times, k1 with MC, then k4 (0, 6, 2, 8, 4) sts at left edge of chart.

Cont in established patt, working st before and st after m in MC on rnds 2–16 and 27–42, in CC1 on rnds 17–20 and 23–26. Change to longer, smaller cir needle for rnds 21 and 22. *At the same time*, cont inc as established on rnds 13 and 29 of chart—228 (252, 276, 300, 324, 348) sts after rnd 29.

Piece should measure about 18½ (18½, 18¾, 19, 19¼, 19½)" (47 [47, 47.5, 48.5, 49, 49.5] cm) from beg.

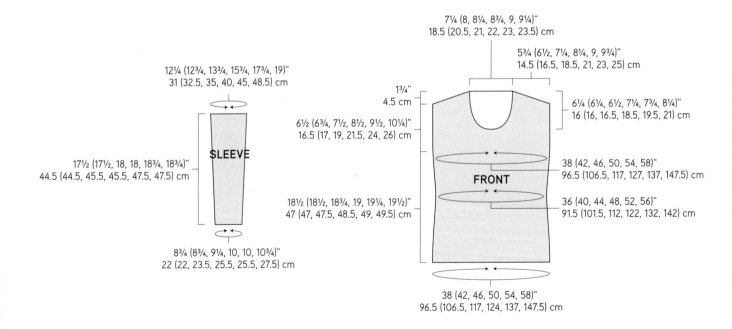

12¼ (12¾, 13¾, 15¾, 17¾, 19)"
31 (32.5, 35, 40, 45, 48.5) cm

17½ (17½, 18, 18, 18¾, 18¾)"
44.5 (44.5, 45.5, 45.5, 47.5, 47.5) cm

SLEEVE

8¾ (8¾, 9¼, 10, 10, 10¾)"
22 (22, 23.5, 25.5, 25.5, 27.5) cm

7¼ (8, 8¼, 8¾, 9, 9¼)"
18.5 (20.5, 21, 22, 23, 23.5) cm

5¾ (6½, 7¼, 8¼, 9, 9¾)"
14.5 (16.5, 18.5, 21, 23, 25) cm

1¾"
4.5 cm

6½ (6¾, 7½, 8½, 9½, 10¼)"
16.5 (17, 19, 21.5, 24, 26) cm

6¼ (6¼, 6½, 7¼, 7¾, 8¼)"
16 (16, 16.5, 18.5, 19.5, 21) cm

38 (42, 46, 50, 54, 58)"
96.5 (106.5, 117, 127, 137, 147.5) cm

FRONT

36 (40, 44, 48, 52, 56)"
91.5 (101.5, 112, 122, 132, 142) cm

18½ (18½, 18¾, 19, 19¼, 19½)"
47 (47, 47.5, 48.5, 49, 49.5) cm

38 (42, 46, 50, 54, 58)"
96.5 (106.5, 117, 124, 137, 147.5) cm

Back

Divide front and back as foll and work back and forth in rows.

Next row: (RS) Knit to m, place rem 114 (126, 138, 150, 162, 174) sts onto holder or waste yarn for front—114 (126, 138, 150, 162, 174) sts rem for back.

Cont even in St st with MC until armhole measures about 6¼ (6½, 7¼, 8¼, 9¼, 10)" (16 [16.5, 18.5, 21, 23.5, 25.5] cm), ending with a WS row.

SHAPE SHOULDERS USING SHORT-ROWS

Short-row 1: (RS) Knit to last 3 (4, 4, 5, 6, 6) sts, w&t.

Short-row 2: Purl to last 3 (4, 4, 5, 6, 6) sts, w&t.

Short-row 3: Knit to 4 (4, 5, 5, 6, 6) sts before last wrapped st, w&t.

Short-row 4: Purl to 4 (4, 5, 5, 6, 6) sts before last wrapped st, w&t.

Rep last 2 Short-rows 7 (4, 7, 3, 7, 2) more times.

SIZES 42 (50, 58)" [106.5 [127, 147.5] CM) ONLY:

Next short-row: (RS) Knit to 5 (6, 7) sts before last wrapped st, w&t.

Next short-row: Purl to 5 (6, 7) sts before last wrapped st, w&t.

Rep last 2 Short-rows 2 (3, 4) more times.

ALL SIZES:

Next row: Knit to end, picking up wraps and working them tog with the sts they wrap.

Next row: Purl to end, picking up wraps and working them tog with the sts they wrap.

Next row: K35 (39, 44, 49, 54, 59), BO 44 (48, 50, 52, 54, 56) sts for neck, knit to end—35 (39, 44, 49, 54, 59) sts rem for each shoulder.

Place rem sts onto holders or waste yarn for shoulders.

Front

Return held front sts to longer, smaller cir needle. Join MC with RS facing. Work in St st until armhole measures about 2 (2¼, 2¾, 3, 3½, 3¾)" (5 [5.5, 7, 7.5, 9, 9.5] cm), ending with a WS row.

SHAPE NECK

Next row: (RS) K46 (51, 56, 62, 67, 73) and place onto holder for left shoulder, BO 22 (24, 26, 26, 28, 28) for neck, knit to end—46 (51, 56, 62, 67, 73) sts rem for right shoulder.

Right neck and shoulder

Purl 1 WS row even.

BO at beg of every RS row 4 sts once, 3 sts once, 2 sts once. Dec 1 st, 1 st in from neck edge every RS row 2 (3, 3, 4, 4, 5) times as foll: K1, ssk, knit to end—35 (39, 44, 49, 54, 59) sts rem.

Cont even until armhole measures 6¼ (6½, 7¼, 8¼, 9¼, 10)" (16 [16.5, 18.5, 21, 23.5, 25.5] cm), ending with a WS row.

SHAPE SHOULDER USING SHORT-ROWS

Short-row 1: (RS) Knit to last 3 (4, 4, 5, 6, 6) sts, w&t.

Short-row 2 and all WS rows: Purl.

Short-row 3: Knit to 4 (4, 5, 5, 6, 6) sts before last wrapped st, w&t.

Rep last 2 Short-rows 7 (4, 7, 3, 7, 2) more times.

Next short-row: Knit to 5 (6, 7) sts before last wrapped st, w&t.

Next short-row: Purl.

Rep last 2 Short-rows 2 (3, 4) more times.

ALL SIZES:

Next row: (RS) Knit to end, picking up wraps and working them tog with the sts they wrap.

Purl 1 row over all sts.

Place sts onto holder or waste yarn.

Left neck and shoulder

Return held left front sts to shorter, smaller cir needle. With RS facing, join MC.

Knit 1 RS row even.

BO at beg of every WS row 4 sts once, 3 sts once, then 2 sts once. Dec 1 st, 1 st in from neck edge every RS row 2 (3, 3, 4, 4, 5) times as foll: Knit to last 3 sts, k2tog, k1—35 (39, 44, 49, 54, 59) sts rem.

Cont even until armhole measures 6¼ (6½, 7¼, 8¼, 9¼, 10)" (16 [16.5, 18.5, 21, 23.5, 25.5] cm), ending with a RS row.

Short-row 1: (WS) Purl to last 3 (4, 4, 5, 6, 6) sts, w&t.

Short-row 2 and all RS rows: Knit.

Short-row 3: Purl to 4 (4, 5, 5, 6, 6) sts before last wrapped st, w&t.

Rep last 2 Short-rows 7 (4, 7, 3, 7, 2) more times.

SIZES 42 (50, 58)" (106.5 [127, 147.5] CM) ONLY:

Next short-row: (RS) Purl to 5 (6, 7) sts before last wrapped st, w&t.

Next short-row: Knit.

Rep last 2 Short-rows 2 (3, 4) more times.

ALL SIZES:

Next row: (WS) Purl to end, picking up wraps and working them tog with the sts they wrap.

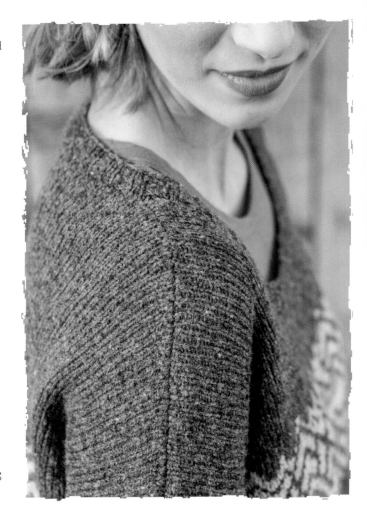

Place sts onto holder or waste yarn.

Sleeves

CUFF

With smaller dpn and CC1, CO 52 (52, 56, 60, 60, 64) sts. Pm for beg of rnd and join for working in rnds, being careful not to twist sts.

Rnd 1: *K2, p2; rep from *.

Cont in established rib until piece measures 2½ (2½, 2¾, 2¾, 3, 3)" (6.5 [6.5, 7, 7, 7.5, 7.5] cm) from beg.

MAIN SLEEVE SECTION

Knit 1 rnd.

CHART A (BODY)

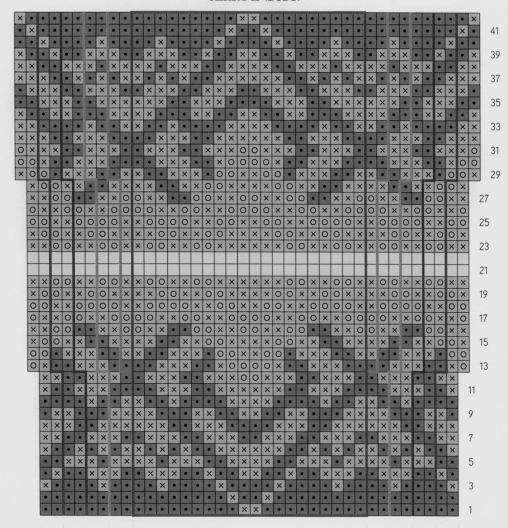

end size 54"
end size 46"
end size 38"
end size 58"
end size 50"
end size 42"

20-st rep

work 5 (6, 6, 7, 7, 8) times

beg size 54"
beg size 46"
beg size 38"
beg size 58"
beg size 50"
beg size 42"

- MC

× CC1

o CC2

CC3

☐ pattern repeat

― lines indicate shaping for
different sizes; make sure to
begin and end each round
as indicated for your size along
the bottom of the chart

CHART B (SLEEVES)

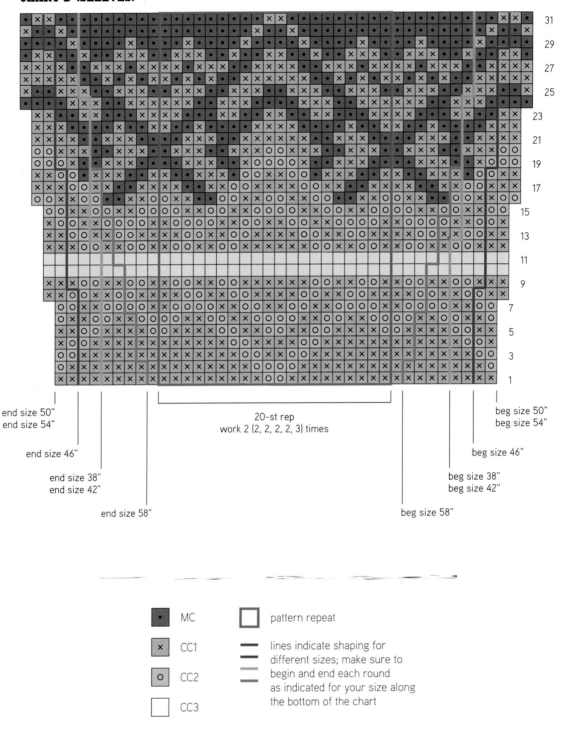

end size 50"
end size 54"

end size 46"

end size 38"
end size 42"

end size 58"

20-st rep
work 2 (2, 2, 2, 3) times

beg size 50"
beg size 54"

beg size 46"

beg size 38"
beg size 42"

beg size 58"

■ •	MC
▨ ×	CC1
▨ ○	CC2
□	CC3

▢ pattern repeat

— lines indicate shaping for
— different sizes; make sure to
═ begin and end each round
as indicated for your size along
the bottom of the chart

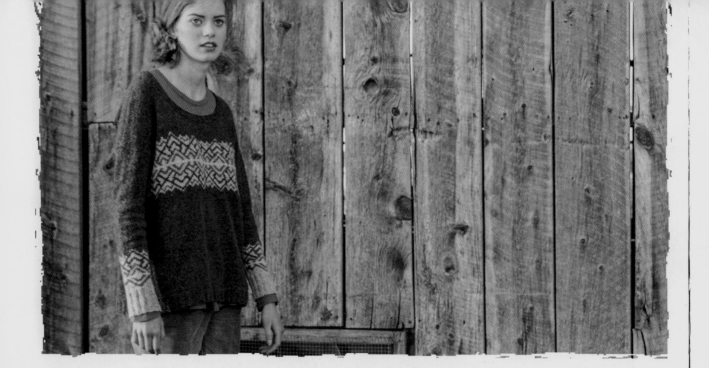

Color pattern

Change to larger dpn.

Next rnd: K1 with CC1, beg at right edge of Chart B at arrow for your size and work 5 (5, 7, 9, 9, 1) st(s), work 20-st rep 2 (2, 2, 2, 2, 3) times, work 5 (5, 7, 9, 9, 1) st(s) at left edge of chart, then k1 with CC1.

Shape sleeve

Work 9 (9, 7, 5, 5, 1) more rnd(s) in established patt.

Next (inc) rnd: K1 with CC1, yo in correct color to maintain chart patt, work in established patt to last st, yo in correct color to maintain chart patt, k1 with CC1—2 sts inc'd.

Next rnd: K1 with CC1, k1-tbl in color to maintain patt, work in established patt to last 2 sts, k1-tbl in color to maintain patt, k1 with CC1.

Rep Inc Rnd every 12 (12, 10, 8, 8, 4) rnds 10 (7, 12, 16, 3, 4) more times, then every 0 (10, 0, 0, 6, 6) rnds 0 (4, 0, 0, 19, 20) times—74 (76, 82, 94, 106, 114) sts. Work new sts into chart patt as shown. *At the same time,* when chart is complete, change to smaller dpn and MC. Cont in St st.

Work even until sleeve measures 17½ (17½, 18, 18, 18¾, 18¾)" (44.5 [44.5, 45.5, 45.5, 47.5, 47.5] cm) from beg. BO all sts.

Finishing

JOIN SHOULDERS

Turn sweater inside out and join shoulders using three-needle bind-off (see Techniques).

SEW SLEEVES INTO ARMHOLES

Sew sleeves into armholes using mattress stitch (see Techniques), beg and end at underarm.

NECKBAND

With shorter, smaller cir needle and MC, with RS facing, beg at left shoulder seam and pick up and knit 46 (50, 52, 54, 56, 58) sts along back neck, and 82 (86, 92, 98, 104, 114) sts along front neck (about 1 st for every BO st and 2 sts for every 3 rows around neck edge)—128 (136, 144, 152, 160, 172) sts. Pm for beg of rnd and join for working in rnds.

Rnd 1: *K2, p2; rep from *.

Rep last rnd until neckband measures ¾ (¾, 1, 1, 1¼, 1¼)" (2 [2, 2.5, 2.5, 3.2, 3.2] cm. BO all sts loosely in rib.

Weave in all loose ends. Block to measurements.

BRAIDED BROOK
PULLOVER

This cozy cabled pullover is truly lush. Elaborate cables pop as an allover pattern, while a generous cowl neck creates practical elegance. Use a yarn such as Berroco Ultra Alpaca for warmth, stitch definition, and a very subtle halo. The sweater is worked in pieces, resulting in seams that offer stability and allow for more portable knitting. Pair your masterpiece with jeans for winter farm chores or a tulle skirt for a holiday party.

Finished Sizes

34½ (38, 42½, 47, 51, 55)" (87.5 (96.5, 108, 119.5, 129.5, 139.5) cm) bust circumference and 24 (24½, 25½, 26, 27, 27½)" (61 [62, 65, 66, 68.5, 70] cm) long.

Intended to be worn with 3–5" (7.5–12.5 cm) of positive ease.

Shown in size 38" (96.5 cm).

Yarn

1335 (1470, 1630, 1786, 1946, 2081) yd (1220 [1344, 1490, 1633, 1779, 1903] m) worsted weight (#4 Medium).

Shown here: Berroco Ultra Alpaca (50% alpaca, 50% wool; 215 yd [197 m]/100 g): color #62111 Zephyr, 7 (7, 8, 9, 10, 10) skeins.

Needles

Size U.S. 5 (3.75 mm) straight and 24" (60 cm) long circular (cir).

Size U.S. 6 (4 mm) 24" (60 cm) long circular (cir).

Size U.S. 7 (4.5 mm) straight and 24" (60 cm) long circular (cir).

Adjust needle sizes if necessary to obtain the correct gauges.

Notions

Markers (m); cable needle (cn); tapestry needle.

Gauge

20 sts and 27 rows = 4" (10 cm) over St st using largest needles.

26 sts and 27 rows = 4" (10 cm) over side cables using largest needles.

34-st Sleeve Cable Panel = 4½" (11.5 cm) wide.

74-st Center Cable Panel = 7½" (19 cm) wide.

Notes

Pullover is worked from the bottom up. The front, back, and sleeves are worked flat in pieces and then seamed. Cowl neck is picked up and worked after assembly. Always bind off in pattern.

STITCH GUIDE

2/2 LC 2 over 2 left cross): Slip 2 sts onto cn and hold in front of work, k2, k2 from cn.

2/2 RC (2 over 2 right cross): Slip 2 sts onto cn and hold in back of work, k2, k2 from cn.

3/3 LC (3 over 3 left cross): Slip 3 sts onto cn and hold in front of work, k3, k3 from cn.

3/3 RC (3 over 3 right cross): Slip 3 sts onto cn and hold in back of work, k3, k3 from cn.

2/1 LPC (2 over 1 left purl cross): Slip 2 sts onto cn and hold in front of work, p1, k2 from cn.

2/1 RPC (2 over 1 right purl cross): Slip 1 st onto cn and hold in back of work, k2, p1 from cn.

2/2 LPC (2 over 2 left purl cross): Slip 2 sts onto cn and hold in front of work, p2, k2 from cn.

2/2 RPC (2 over 2 right purl cross): Slip 2 sts onto cn and hold in back of work, k2, p2 from cn.

3/2 LC (3 over 2 left cross): Slip 3 sts onto cn and hold in front of work, k2, k3 from cn.

3/2 RC (3 over 2 right cross): Slip 2 sts onto cn and hold in back of work, k3, k2 from cn.

3/2 LPC (3 over 2 left purl cross): Slip 3 sts onto cn and hold in front of work, p2, k3 from cn.

3/2 RPC (3 over 2 right purl cross): Slip 2 sts onto cn and hold in back of work, k3, p2 from cn.

Back

HEM

With smaller straight needles, CO 110 (122, 134, 150, 162, 174) sts.

Row 1: (WS) *P2, k2; rep from * to last 2 sts, p2.

Row 2: (RS) *K2, p2; rep from * to last 2 sts, k2.

Rep Rows 1 and 2 until piece measures 2 (2, 2½, 2½, 3, 3)" (5 [5, 6.5, 6.5, 7.5, 7.5] cm) from CO, ending with a WS row.

MAIN BODY

Next (inc) row: (RS) Knit and inc 4 (4, 6, 4, 6, 6) sts evenly spaced—114 (126, 140, 154, 168, 180) sts.

Change to larger straight needle.

Next (set-up) row: (WS) P1 (selvedge st), work Row 1 of Body Chart as foll, beg at left side of chart for your size, work 3 (1, 0, 7, 6, 4) st(s), 8-st rep 2 (3, 4, 4, 5, 6) times, center panel over next 74 sts, 8-st rep 2 (3, 4, 4, 5, 6) times, then 3 (1, 0, 7, 6, 4) st(s) at right side of chart, p1 (selvedge st).

Row 2: (RS) K1 (selvedge st), beg at right side of chart for your size and work Row 2 of chart as foll, work 3 (1, 0, 7, 6, 4) st(s), 8-st rep 2 (3, 4, 4, 5, 6) times, center panel over next 74 sts, 8-st rep 2 (3, 4, 4, 5, 6) times, then 3 (1, 0, 7, 6, 4) st(s) at left side of chart, k1 (selvedge st).

Work Rows 3–40 as est, then rep Rows 1–40 throughout. At the same time, when 15 rows have been worked, end with a WS row.

Shape waist

Decreases to shape the waist are worked in the reverse St st panels between cables. The first decreases are worked closest to the beginning and ending edges, with each of the next two decreases worked in the reverse St st panel closer to the center, leaving 3 stitches between those cables.

Dec Row 1: Work 2 (8, 7, 6, 5, 3) sts in est patt, p2tog, work in patt to last 4 (10, 9, 8, 7, 5) sts, p2tog, work in patt to end—2 sts dec'd.

Work 15 rows even.

Dec Row 2: Work 9 (15, 17, 13, 12, 10) sts in est patt, p2tog, work in patt to last 11 (17, 19, 15, 14, 12) sts, p2tog, work in patt to end—2 sts dec'd.

Work 15 rows even.

Dec Row 3: Work 16 (22, 21, 20, 19, 17) sts in est patt, p2tog, work in patt to last 18 (24, 23, 22, 21, 19) sts, p2tog, work in patt to end—108 (120, 134, 148, 162, 174) sts rem.

Shape bust

Work 5 rows even.

The first three increases are worked in the same reverse St st panels as the decreases, but in reverse order, working from the center out. The final two increases are worked at the edges between the selvedge stitches and charted pattern.

Inc Row 1: (RS) Work 17 (23, 22, 21, 20, 18) sts in est patt, M1p, work in patt to last 17 (23, 22, 21, 20, 18) sts, M1p, work to end—2 sts inc'd.

Work 5 rows even.

Inc Row 2: Work 10 (16, 18, 14, 13, 11) sts in est patt, M1p, work in patt to last 10 (16, 18, 14, 13, 11) sts, M1p, work to end—2 sts inc'd.

Work 5 rows even.

Inc Row 3: Work 3 (9, 8, 7, 6, 4) sts in est patt, M1p, work in patt to last 3 (9, 8, 7, 6, 4) sts, M1p, work to end—2 sts inc'd.

Work 5 rows even.

Inc Row 4: K1, M1p, work in est patt to last st, M1p, k1—2 sts inc'd.

Rep last 6 rows once more—118 (130, 144, 158, 172, 184) sts. Work new sts in reverse St st (purl RS rows, knit WS rows).

Cont even until piece measures about 15½ (15½, 16, 16, 16½, 16½)" (39.5 [39.5, 40.5, 40.5, 42, 42] cm) from CO, ending with a WS row.

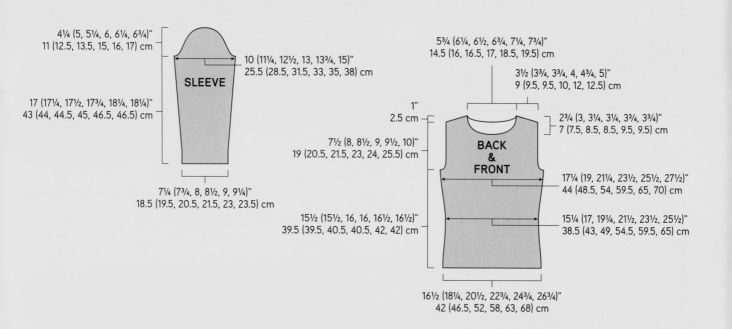

4¼ (5, 5¼, 6, 6¼, 6¾)"
11 (12.5, 13.5, 15, 16, 17) cm

10 (11¼, 12½, 13, 13¾, 15)"
25.5 (28.5, 31.5, 33, 35, 38) cm

SLEEVE

17 (17¼, 17½, 17¾, 18¼, 18¼)"
43 (44, 44.5, 45, 46.5, 46.5) cm

7½ (8, 8½, 9, 9½, 10)"
19 (20.5, 21.5, 23, 24, 25.5) cm

7¼ (7¾, 8, 8½, 9, 9¼)"
18.5 (19.5, 20.5, 21.5, 23, 23.5) cm

15½ (15½, 16, 16, 16½, 16½)"
39.5 (39.5, 40.5, 40.5, 42, 42) cm

5¾ (6¼, 6½, 6¾, 7¼, 7¾)"
14.5 (16, 16.5, 17, 18.5, 19.5) cm

3½ (3¾, 3¾, 4, 4¾, 5)"
9 (9.5, 9.5, 10, 12, 12.5) cm

1"
2.5 cm

2¾ (3, 3¼, 3¼, 3¾, 3¾)"
7 (7.5, 8.5, 8.5, 9.5, 9.5) cm

BACK & FRONT

17¼ (19, 21¼, 23½, 25½, 27½)"
44 (48.5, 54, 59.5, 65, 70) cm

15¼ (17, 19¼, 21½, 23½, 25½)"
38.5 (43, 49, 54.5, 59.5, 65) cm

16½ (18¼, 20½, 22¾, 24¾, 26¾)"
42 (46.5, 52, 58, 63, 68) cm

BODY CHART

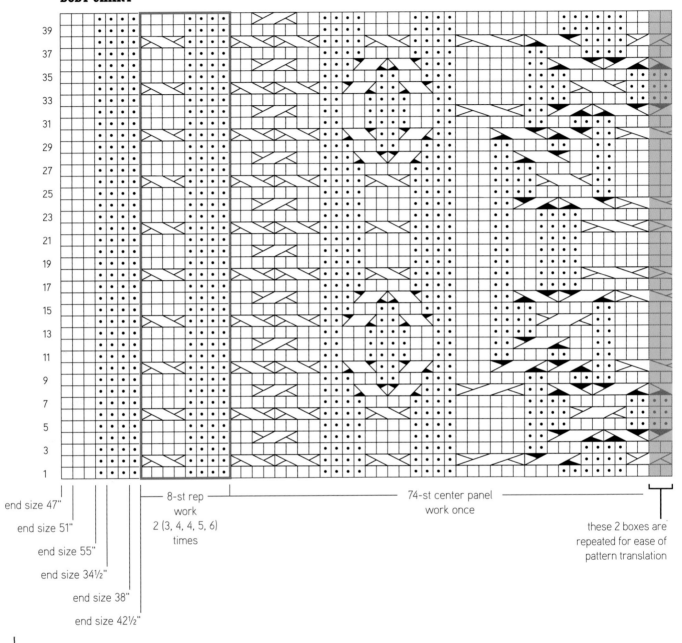

end size 47"

end size 51"

end size 55"

end size 34½"

end size 38"

end size 42½"

8-st rep
work
2 (3, 4, 4, 5, 6)
times

74-st center panel
work once

these 2 boxes are
repeated for ease of
pattern translation

SHAPE ARMHOLES

Note: When shaping the armholes, if there are not enough sts to work a cable twist, work those sts in St st instead.

BO 3 (4, 5, 6, 7, 7) sts at beg of next 2 rows—112 (122, 134, 146, 158, 170) sts rem.

Dec Row 1: (RS) K1, ssk, work in est patt to last 3 sts, k2tog, k1—2 sts dec'd.

Dec Row 2: (WS) P1, p2tog, work in est patt to last 3 sts, ssp, p1—2 sts dec'd.

Rep last 2 rows 3 (3, 4, 5, 5, 6) more times, then dec every RS row 5 (7, 8, 9, 10, 11) times—86 (92, 98, 104, 114, 120) sts rem.

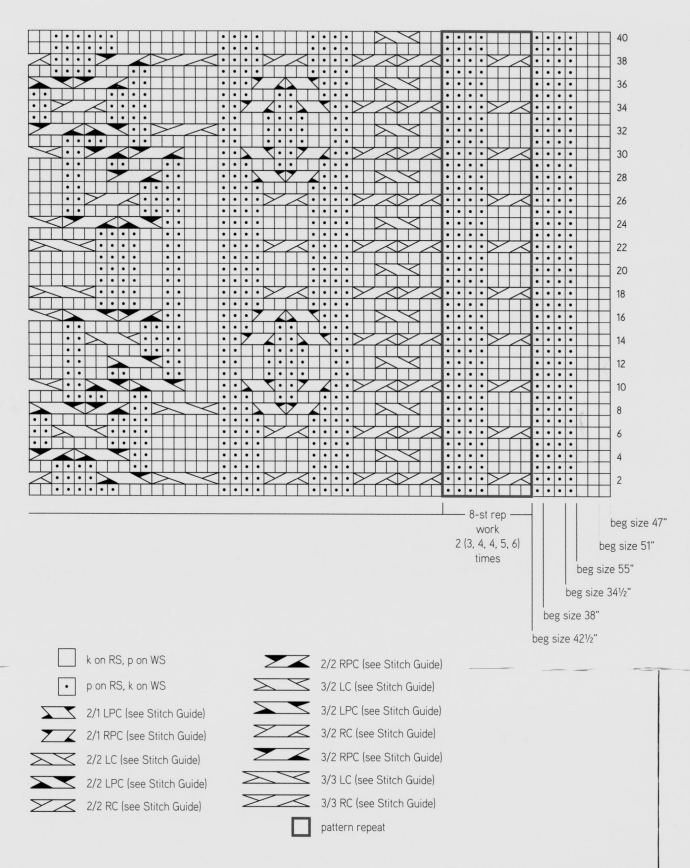

8-st rep
work
2 (3, 4, 4, 5, 6)
times

beg size 47"

beg size 51"

beg size 55"

beg size 34½"

beg size 38"

beg size 42½"

☐ k on RS, p on WS

• p on RS, k on WS

2/1 LPC (see Stitch Guide)

2/1 RPC (see Stitch Guide)

2/2 LC (see Stitch Guide)

2/2 LPC (see Stitch Guide)

2/2 RC (see Stitch Guide)

2/2 RPC (see Stitch Guide)

3/2 LC (see Stitch Guide)

3/2 LPC (see Stitch Guide)

3/2 RC (see Stitch Guide)

3/2 RPC (see Stitch Guide)

3/3 LC (see Stitch Guide)

3/3 RC (see Stitch Guide)

☐ pattern repeat

SLEEVE CHART

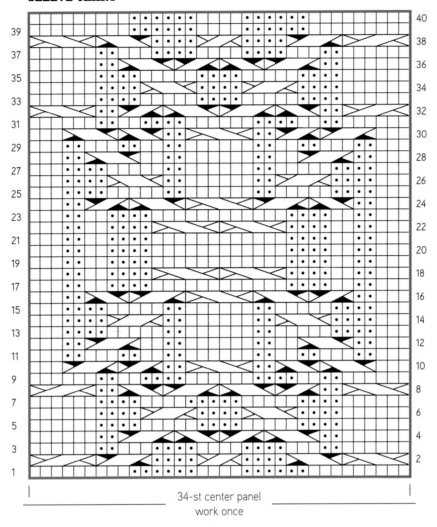

39 · 40
37 · 38
35 · 36
33 · 34
31 · 32
29 · 30
27 · 28
25 · 26
23 · 24
21 · 22
19 · 20
17 · 18
15 · 16
13 · 14
11 · 12
9 · 10
7 · 8
5 · 6
3 · 4
1 · 2

34-st center panel
work once

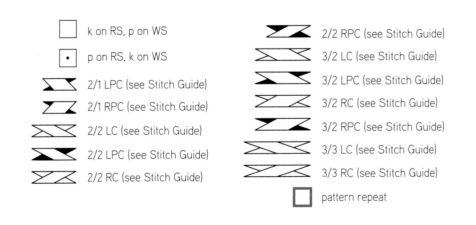

	k on RS, p on WS		2/2 RPC (see Stitch Guide)
·	p on RS, k on WS		3/2 LC (see Stitch Guide)
	2/1 LPC (see Stitch Guide)		3/2 LPC (see Stitch Guide)
	2/1 RPC (see Stitch Guide)		3/2 RC (see Stitch Guide)
	2/2 LC (see Stitch Guide)		3/2 RPC (see Stitch Guide)
	2/2 LPC (see Stitch Guide)		3/3 LC (see Stitch Guide)
	2/2 RC (see Stitch Guide)		3/3 RC (see Stitch Guide)
			pattern repeat

Keeping first 2 sts and last 2 sts in St st (knit RS rows, purl WS rows), work even until armhole measures 7½ (8, 8½, 9, 9½, 10)" (19 [20.5, 21.5, 23, 24, 25.5] cm), ending with a WS row.

SHAPE NECK AND SHOULDERS

Note: When binding off stitches to shape the shoulders, slip the first stitch to create a smoother diagonal edge.

Next row: (RS) Work 33 (35, 37, 40, 44, 46) sts in est patt and place onto holder for right shoulder, BO 20 (22, 24, 24, 26, 28) for neck, work to end—33 (35, 37, 40, 44, 46) sts rem for each shoulder.

Left shoulder

BO at beg of WS rows 8 (8, 9, 9, 11, 11) sts twice, then 7 (8, 8, 10, 10, 11) sts once. At the same time, BO at beg of RS rows 4 (4, 4, 4, 4, 5) sts once, 3 (4, 4, 4, 4, 4) sts once, then 3 (3, 3, 4, 4, 4) sts once.

Right shoulder

Return held 33 (35, 37, 40, 44, 46) sts for right shoulder to larger straight needles. Join yarn with WS facing.

BO at beg of RS rows 4 (4, 4, 4, 4, 5) once, 3 (4, 4, 4, 4, 4) sts once, then 3 (3, 3, 4, 4, 4) sts once. *At the same time,* BO at beg of WS rows 8 (8, 9, 9, 11, 11) sts twice, then 7 (8, 8, 10, 10, 11) sts once.

Front

Work same as for back until armhole measures 5¾ (6, 6¼, 6¾, 6¾, 7¼)" (14.5 [15, 16, 17, 17, 18.5] cm), ending with a WS row.

SHAPE NECK AND SHOULDERS

Next row: (RS) Work 33 (35, 37, 40, 44, 46) sts in est patt and place sts onto holder for left front, BO 20 (22, 24, 24, 26, 28) sts for neck, work to end—33 (35, 37, 40, 44, 46) sts rem for each shoulder.

Shape right neck

BO at beg of RS rows 4 sts once, 3 sts once, then 2 sts once—24 (26, 28, 31, 35, 37) sts rem.

Work 1 WS row even.

Dec row: (RS) K1, ssk, work in est patt to end—1 st dec'd.

Rep Dec Row every RS row 0 (1, 1, 2, 2, 3) more time(s)—23 (24, 26, 28, 32, 33) sts rem.

Keeping first 2 sts and last 2 sts in St st, work 4 (4, 6, 4, 8, 6) rows even, ending with a RS row.

Shape shoulder

BO at beg of WS rows 8 (8, 9, 9, 11, 11) sts twice, then 7 (8, 8, 10, 10, 11) sts once.

Left front

Return held 33 (35, 37, 40, 44, 46) sts for left shoulder to larger straight needles. Join yarn with WS facing.

BO at beg of WS rows 4 sts once, 3 sts once, then 2 sts once—24 (26, 28, 31, 35, 37) sts rem.

Dec row: (RS) Work in est patt to last 3 sts, k2tog, k1—1 st dec'd.

Rep Dec Row every RS row 0 (1, 1, 2, 2, 3) more time(s)—23 (24, 26, 28, 32, 33) sts rem.

Keeping first 2 sts and last 2 sts in St st, work 5 (5, 7, 5, 9, 7) rows even, ending with a WS row.

Shape shoulder

BO at beg of RS rows 8 (8, 9, 9, 11, 11) sts twice, then 7 (8, 8, 10, 10, 11) sts once.

Sleeves

CUFF

With smaller straight needle , CO 58 (58, 62, 62, 66, 70) sts.

Row 1: (RS) *K2, p2; rep from * to last 2 sts, k2.

Row 2: (WS) *P2, k2; rep from * to last 2 sts, p2.

Rep Rows 1 and 2 until piece measures 2 (2, 2½, 2½, 3, 3)" (5 [5, 6.5, 6.5, 7.5, 7.5] cm) from CO, ending with a WS row.

MAIN SLEEVE

Next (dec) row: (RS) Knit and dec 10 (8, 10, 8, 10, 12) sts evenly spaced—48 (50, 52, 54, 56, 58) sts rem.

Change to larger straight needle.

Next (set-up) row: (WS) P1 (selvedge st), k6 (7, 8, 9, 10, 11), place marker (pm), beg at left edge of chart, work Row 1 of Sleeve Chart over next 34 sts, pm, knit to last st, p1 (selvedge st).

Next row: (RS) K1 (selvedge st), p6 (7, 8, 9, 10, 11), sm, beg at right edge of chart, work Row 2 of Sleeve Chart over next 34 sts, sm, purl to last st, k1 (selvedge st).

Work Rows 3–40 as est, then Rep Rows 1–40 throughout. At the same time, when 12 (8, 6, 6, 6, 6) rows have been worked, end with a WS row.

SHAPE SLEEVE

Inc row: (RS) P1, M1p, purl to m, sm, work next row of Sleeve Chart as est, sm, purl to last st, M1p, k1—2 sts inc'd.

Rep Inc Row every 12 (10, 8, 8, 6, 6) rows 6 (8, 10, 10, 4, 9) more times, then every 0 (0, 0, 0, 8, 8) rows 0 (0, 0, 0, 7, 4) times—62 (68, 74, 76, 80, 86) sts. Work new sts in rev St st.

Cont even until piece measures 17 (17¼, 17½, 17¾, 18¼, 18¼)" (43 [44, 44.5, 45, 46.5, 46.5] cm) from CO, ending with a WS row.

SHAPE CAP

BO 3 (4, 5, 6, 7, 7) sts at beg of next 2 rows—56 (60, 64, 64, 66, 72) sts rem.

Dec row 1: (RS) K1, ssk, work in est patt to last 3 sts, k2tog, k1—2 sts dec'd.

Dec row 2: (WS) P1, p2tog, work in est patt to last 3 sts, ssp, p1—2 sts dec'd.

Cont dec every row 5 (3, 3, 3, 3, 1) more time(s)—42 (50, 54, 54, 56, 66) sts rem.

Work 1 WS row even.

Cont dec every RS row 7 (11, 12, 4, 2, 4) times, every 4 rows 0 (0, 0, 3, 4, 4) times, every RS row 0 (0, 0, 4, 5, 5) times—28 (28, 30, 32, 34, 40) sts rem.

Work 1 WS row even.

Dec every row 3 (2, 2, 2, 2, 4) times—22 (24, 26, 28, 30, 32) sts rem.

BO 2 at beg of next 2 rows, then BO rem 18 (20, 22, 24, 26, 28) sts in patt.

Finishing

Weave in ends. Wet-block pieces to measurements (see Techniques).

Sew shoulder seams using mattress stitch (see Techniques). Sew in sleeves, easing sleeves to fit. Sew side and sleeve seams from hem and to cuff.

COWL NECK

Note: Cowl is shaped by changing to larger needles.

With smallest cir needle and RS facing, beg at right shoulder and pick up and knit 56 (60, 62, 64, 66, 70) sts along back neck and 36 (40, 42, 44, 46, 50) sts along front neck—92 (100, 104, 108, 112, 120) sts. Pm for beg of rnd and join for working in rnds.

Rnd 1: *K2, p2; rep from * to end.

Work in est ribbing until piece measures 4" (10 cm). Change to U.S. size 6 (4 mm) cir needle. Cont in est ribbing until piece measures 6" (15 cm). Change to largest cir needle. Cont in est ribbing until piece measures 10" (25.5 cm). BO all stitches loosely in patt.

WEAVE IN ALL REM ENDS.

Wet-block garment again to relax seams and cowl.

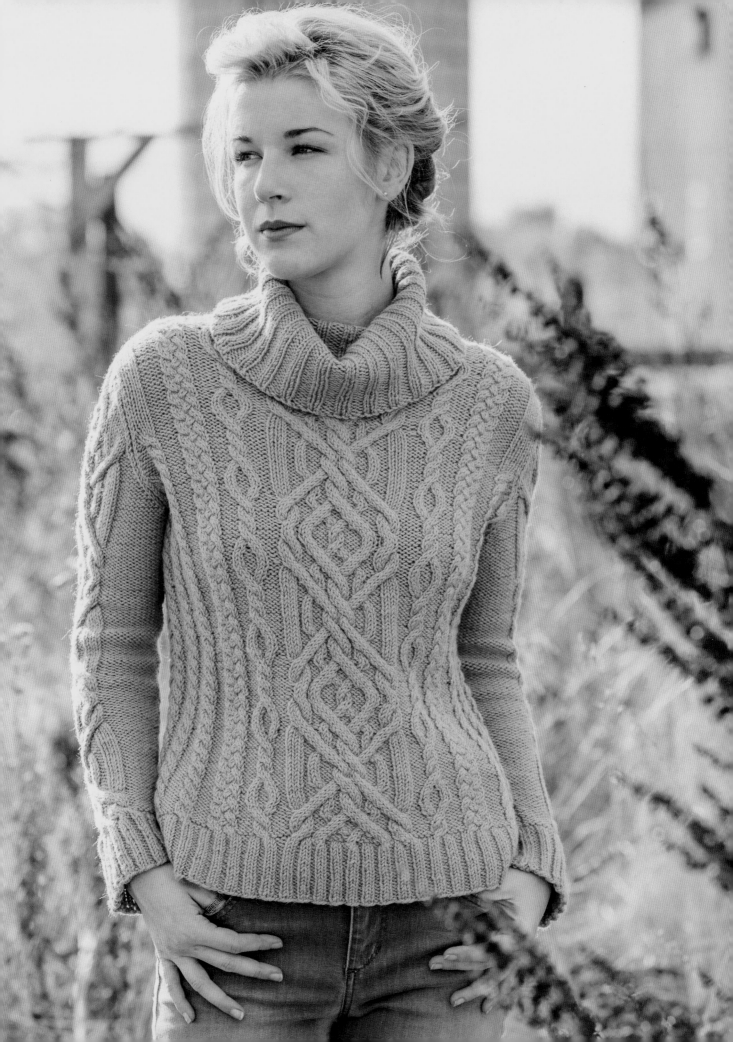

GLOSSARY

ABBREVIATIONS

beg	begin(ning)
BO	bind off
CC	contrast color
cir	circular
cm	centimeters
CO	cast on
cont	continue(ing)
dec('d)	decrease(d)
dpn	double-pointed needle(s)
g	gram(s)
inc('d)	increase(d)
k	knit
k1f&b	knit into front and back of next stitch (1 st increased)
k2tog	knit 2 together
kwise	knitwise
k2tog	knit 2 together
k3tog	knit 3 together (2 stitches decreased)
m	marker mm: millimeters
p	purl
p1f&b	purl into back and front of next stitch (1 st increased)
patt	pattern(s)
pwise	purlwise
pm	place marker rem: remain rep: repeat RS: right side
sk2p	slip 1, knit 2 together, pass slipped stitch over
sl	slip sm: slip marker
ssk	slip, slip, knit
sssk	slip, slip, slip, knit
st(s)	stitch(es)
St st	stockinette stitch
tbl	through back loop
WS	wrong side
w&t	wrap & turn (see Short-rows in Techniques section)
wyb	with yarn in back
wyf	with yarn in front
WS	wrong side
yd(s)	yard(s)
yo	yarn over

TECHNIQUES

CAST-ONS

BACKWARD-LOOP CAST-ON
*Loop working yarn and place it on needle backward so that it doesn't unwind. Repeat from *.

CABLE CAST-ON
If there are no stitches on the needles, make a slipknot of working yarn and place it on the needle, then use the knitted method to cast on one more stitch— two stitches on needle. Hold needle with working yarn in your left hand. *Insert right needle between the first two stitches on left needle (**Figure 1**), wrap yarn around needle as if to knit, draw yarn through (**Figure 2**), and place new loop on left needle (**Figure 3**) to form a new stitch. Repeat from * for the desired number of stitches, always working between the first two stitches on the left needle.

Figure 1 Figure 2 Figure 3

LONG-TAIL CAST-ON
Leaving a long tail (about ½" [1.3 cm] for each stitch to be cast on), make a slipknot and place on right needle. Place thumb and index finger of your left hand between the yarn ends so that working yarn is around your index finger and tail end is around your thumb and secure the yarn ends with your other fingers.

Figure 1 Figure 2

Hold your palm upward, making a V of yarn (**Figure 1**).
*Bring needle up through loop on thumb (Figure 2), catch
first strand around index finger, and go back down through
loop on thumb (**Figure 3**). Drop loop off thumb and, placing
thumb back in V configuration, tighten resulting stitch on
needle (**Figure 4**). Repeat from * for the desired number of
stitches.

Figure 3 Figure 4

JUDY'S MAGIC CAST-ON

This amazingly simple cast-on is named for its founder,
Judy Becker. It wraps the yarn around two parallel needles
in such a way as to mimic a row of stockinette stitch
between the two needles.

Leaving a 10" (25.5 cm) tail, drape the yarn over one needle,
then hold a second needle parallel to and below the first and
on top of the yarn tail (**Figure 1**).

Bring the tail to the back and the ball yarn to the front, then
place the thumb and index finger of your left hand between
the two strands so that the tail is over your index finger and
the ball yarn is over your thumb (**Figure 2**). This forms the
first stitch on the top needle.

*Continue to hold the two needles parallel and loop the finger
yarn over the lower needle by bringing the lower needle over
the top of the finger yarn (**Figure 3**), then bringing the finger
yarn up from below the lower needle, over the top of this
needle, then to the back between the two needles.

Point the needles downward, bring the bottom needle past
the thumb yarn, then bring the thumb yarn to the front
between the two needles and over the top needle (**Figure 4**).

Repeat from * until you have the desired number of stitches
on each needle (**Figure 5**).

Remove both yarn ends from your left hand, rotate the
needles like the hands of a clock so that the bottom needle
is now on top and both strands of yarn are at the needle tip
(**Figure 6**).

Using a third needle, knit half of the stitches from the top
needle (**Figure 7**). There will now be the same number of
stitches on two needles and twice that number of stitches on
the bottom needle.

Figure 1

Figure 2 Figure 3

Figure 4 Figure 5

Figure 6 Figure 7

TECHNIQUES

INCREASES

RAISED (M1) INCREASES

Left Slant (M1L) and Standard M1

With left needle tip, lift strand between needles from front to back (**Figure 1**). Knit lifted loop through the back (**Figure 2**).

Figure 1 Figure 2

Right Slant (M1R)

With left needle tip, lift strand between needles from back to front (**Figure 1**). Knit lifted loop through the front (**Figure 2**).

Figure 1 Figure 2

BIND-OFF

THREE-NEEDLE BIND-OFF

Place the stitches to be joined onto two separate needles and hold the needles parallel so that the right sides of knitting face together. Insert a third needle into the first stitch on each of two needles (**Figure 1**) and knit them together as one stitch (**Figure 2**), *knit the next stitch on each needle the same way, then use the left needle tip to lift the first stitch over the second and off the needle (**Figure 3**). Repeat from * until no stitches remain on first two needles. Cut yarn and pull tail through last stitch to secure.

Figure 1

Figure 2

Figure 3

SEAMS

MATTRESS STITCH SEAM

With RS of knitting facing, use threaded needle to pick up one bar between first two stitches on one piece (**Figure 1**), then corresponding bar plus the bar above it on other piece (**Figure 2**). *Pick up next two bars on first piece, then next two bars on other (**Figure 3**). Repeat from * to end of seam, finishing by picking up last bar (or pair of bars) at the top of first piece.

Figure 1 Figure 2

Figure 3

WHIPSTITCH

With right side of work facing and working one stitch in from the edge, bring threaded needle out from back to front along edge of knitted piece.

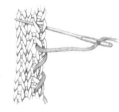

SHORT-ROWS

KNIT SIDE

Work to turning point, slip next stitch purlwise (**Figure 1**), bring the yarn to the front, then slip the same stitch back to the left needle (**Figure 2**), turn the work around and bring the yarn in position for the next stitch—one stitch has been wrapped, and the yarn is correctly positioned to work the next stitch. When you come to a wrapped stitch on a subsequent row, hide the wrap by working it together with the wrapped stitch as follows: Insert right needle tip under

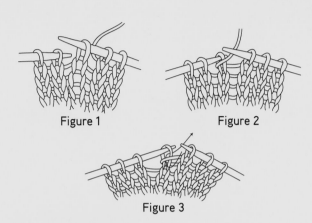

Figure 1

Figure 2

Figure 3

the wrap from the front **(Figure 3)**, then into the stitch on the needle, and work the stitch and its wrap together as a single stitch.

PURL SIDE

Work to the turning point, slip the next stitch purlwise to the right needle, bring the yarn to the back of the work **(Figure 1)**, return the slipped stitch to the left needle, bring the yarn to the front between the needles **(Figure 2)**, and turn the work so that the knit side is facing—one stitch has been wrapped, and the yarn is correctly positioned to knit the next stitch. To hide the wrap on a subsequent purl row, work to the wrapped stitch, use the tip of the right needle to pick up the wrap from the back, place it on the left needle **(Figure 3)**, then purl it together with the wrapped stitch.

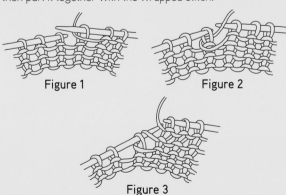

Figure 1

Figure 2

Figure 3

GRAFTING
KITCHENER STITCH

Bring threaded needle through front stitch as if to purl and leave stitch on needle **(Figure 1)**.

Bring threaded needle through back stitch as if to knit and leave stitch on needle **(Figure 2)**.

Bring threaded needle through first front stitch as if to knit and slip this stitch off needle. Bring threaded needle through next front stitch as if to purl and leave stitch on needle **(Figure 3)**.

Bring threaded needle through first back stitch as if to purl (as illustrated), slip this stitch off, bring needle through next back stitch as if to knit, leave this stitch on needle **(Figure 4)**.

Repeat Steps 3 and 4 until no stitches remain on needles.

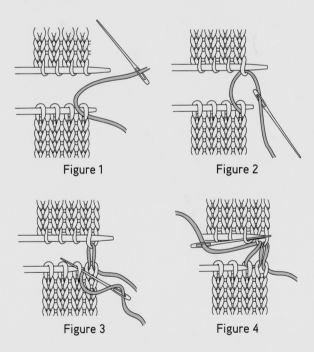

Figure 1

Figure 2

Figure 3

Figure 4

REINFORCING STEEKS USING THE CROCHET METHOD

Crochet steek reinforcements firmly bind together the sides of two adjacent stitch columns to hold the cut ends securely in place.

Begin by turning your garment sideways so that you're looking at the steek with the cast-on edge on the right-hand side and the steek itself lying horizontally. Using a crochet hook of the same or slightly smaller diameter than the working knitting needles and a contrasting strand of the knitting wool, start at the cast-on edge and insert hook into the adjoining halves of the left-flanking and center stitches in the first row of the steek (**Figure 1**).

Yarnover and draw a strand of the reinforcing yarn through the two stitch halves (**Figure 2**). Yarnover again and draw the yarn through the loop, creating a single crochet stitch. Move on to the next pair of stitches above in the steek (or to the left as you look at the steek sideways).

*Insert your hook into the adjoining pair of "legs" in this pair, yarnover, and draw up a loop (**Figure 3**). You'll now have two loops on your hook; yarnover and draw yarn through both loops, then move onto the next pair of stitches in the steek.

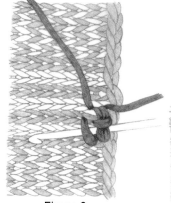

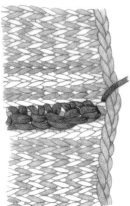

Figure 3

Figure 4

Repeat from * to the top edge of the steek; your steek should look like Figure 4. Cut the working yarn and pull it through the last crochet stitch to fasten off. To work the right half of the steek, turn the work, start at the bind-off row, and work single crochet through the adjoining halves of the right-flanking and center stitches in the same manner, back down to the cast-on edge.

WET-TOWEL BLOCKING

Run a large bath or beach towel (or two towels for larger projects) through the rinse/spin cycle of a washing machine. Roll the knitted pieces in the wet towel(s), place the roll in a plastic bag, and leave overnight so that the knitted pieces become uniformly damp. Pin the damp pieces to a blocking surface and let air-dry thoroughly.

Figure 1

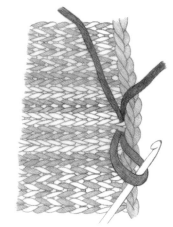

Figure 2

RESOURCES

INDEX

SOURCES FOR YARN

ANZULA LUXURY FIBERS
740 H Street
Fresno, CA 93721
anzula.com

BAAH!
baahyarn.com

BERROCO, INC.
1 Tupperware Drive, Suite 4
North Smithfield, RI 02896
berroco.com

BROOKLYN TWEED
brooklyntweed.com

THE FIBRE COMPANY
thefibreco.com

HAZEL KNITS
hazelknits.com

IMPERIAL YARN
92462 Hinton Rd.
Maupin, OR 97037
imperialyarn.com

ÍSTEX
PO Box 140
270
Mosfellsbær
Iceland

istex.is

MALABRIGO YARN
malabrigoyarn.com

QUINCE & CO.
quinceandco.com

SINCERE SHEEP
sinceresheep.com

SWANS ISLAND
swansislandcompany.com

METRIC CONVERSION CHART

To convert:	To:	Multiply by:
Inches	Centimeters	2.54
Centimeters	Inches	0.4
Feet	Centimeters	30.5
Centimeters	Feet	0.03
Yards	Meters	0.9
Meters	Yards	1.1

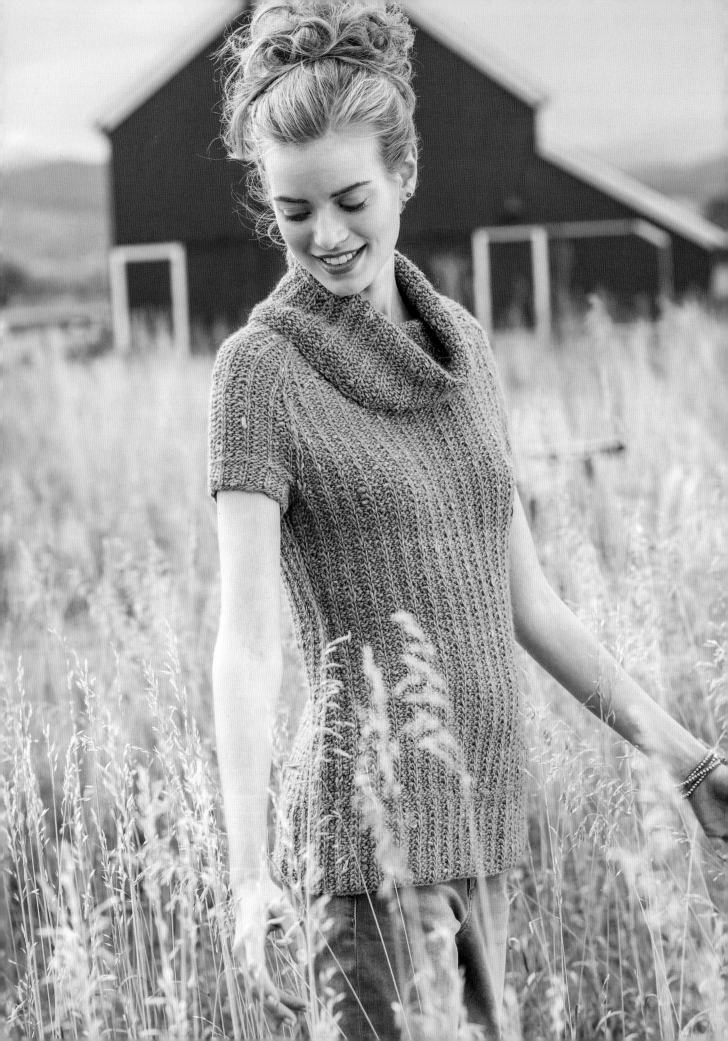

ABOUT THE AUTHOR

Andrea Rangel knits and designs in Vancouver Island. She loves the functionality and beauty of knitting and knits everything from head to toe. Her designs have been featured in Interweave Knits, Knitscene, Brooklyn Tweed Wool People, Twist Collective, and Knitty, as well as published independently. Learn about her designs at andreaknits.com or visit her on Ravelry user name andreakr.

ACKNOWLEDGMENTS

Thank you to all the people who helped make this book happen:

» Kerry Bogert, who reached out and invited me to submit to Interweave in the first place and then encouraged me and helped me on tearmy way with my submission.

» Erica Smith, my editor, who coordinated the entire project.

» Technical editor Therese Chynoweth, who checked every number on these pages and assisted me in clarifying and improving the patterns.

» Charlene Tiedemann, the book designer who helped my vision come to life.

» The whole photography team, including the photographer, stylist, hair and makeup artist, and models who captured the rugged vibe I was aiming for.

» Nalisha Rangel and Jessie Kwak, friends and fellow creative types who have been on my team for years. The supportive network we've created is priceless.

» My grandma Barbara, who taught me to knit when I was eight years old. My fingers never forgot.

» Aunt Kathy, for reminding me about knitting at the perfect time in my life, and for giving me the purple mohair yarn and knitting needles that really got me going on this journey.

» My mom, who loved everything I ever knit, even the weird hole-y scarves that were my early work.

» My husband and partner Sean, who has always supported me and challenged me to do my best work.

» The generous companies who supplied yarn for this book's samples: Brooklyn Tweed, Imperial Yarn, Ístex, Hazel Knits, the Fibre Company, Quince & Co., Swans Island, Baah, Berroco, Malabrigo, Sincere Sheep, and Anzula.

» The fellow designers and industry professionals who supported and encouraged me throughout this process and have been great allies in my design career.

» The team at Ravelry, who have made a wonderful online space that broadens and enhances the knitting world like nothing else.

» Knitters everywhere—I love being a part of your community!

Editor	ERICA SMITH
Technical Editor	THERESE CHYNOWETH
Designer	CHARLENE TIEDEMANN
Photographer	JULIA VANDENOUVER
Stylist	ALLIE LIEBGOTT
Hair/Makeup	KATHY MACKAY

a content + ecommerce company

www.fwcommunity.com

19 18 17 16 5 4 3 2 1

Distributed in Canada by Fraser Direct
100 Armstrong Avenue
Georgetown, ON, Canada L7G 5S4
Tel: (905) 877-4411

Distributed in the U.K. and Europe by F&W MEDIA INTERNATIONAL
Brunel House, Newton Abbot, Devon, TQ12 4PU, England
Tel: (+44) 1626 323200, Fax: (+44) 1626 323319
E-mail: enquiries@fwmedia.com

Distributed in Australia by Capricorn Link
P.O. Box 704, S. Windsor NSW, 2756 Australia
Tel: (02) 4560 1600, Fax: (02) 4577 5288
E-mail: books@capricornlink.com.au

SRN: 16KN03 | ISBN-13: 978-1-63250-120-2

We make every effort to ensure the accuracy of our instructions, but errors occasionally occur. Errata can be found at www.knittingdaily.com/errata.